HISTORIC PHOTOS OF
LAS VEGAS

TEXT AND CAPTIONS BY JEFF BURBANK

TURNER
PUBLISHING COMPANY
NASHVILLE, TENNESSEE PADUCAH, KENTUCKY

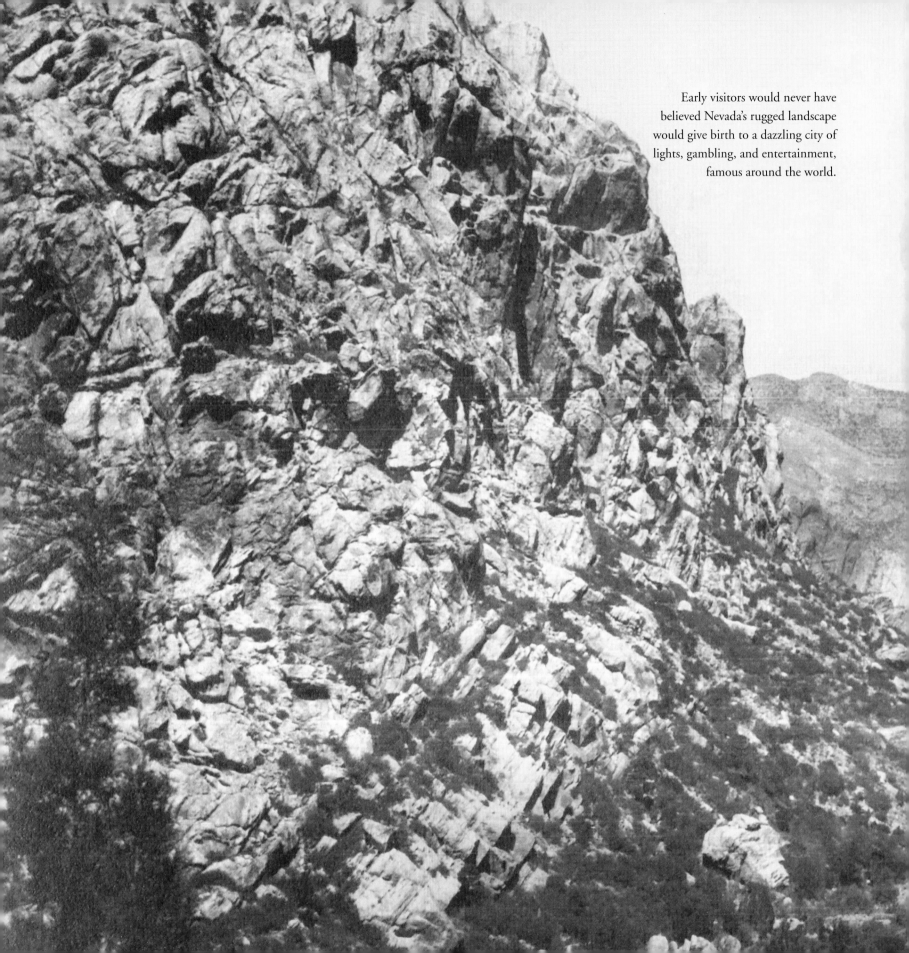

Early visitors would never have believed Nevada's rugged landscape would give birth to a dazzling city of lights, gambling, and entertainment, famous around the world.

HISTORIC PHOTOS OF
LAS VEGAS

Turner Publishing Company
200 4th Avenue North • Suite 950 412 Broadway • P.O. Box 3101
Nashville, Tennessee 37219 Paducah, Kentucky 42002-3101
(615) 255-2665 (270) 443-0121

www.turnerpublishing.com

Historic Photos of Las Vegas

Library of Congress Control Number: 2007929569

ISBN-13: 978-1-59652-380-7

Printed in the United States of America

07 08 09 10 11 12 13 14—0 9 8 7 6 5 4 3 2 1

CONTENTS

The dealer of a roulette game at the Apache bar on Fremont Street pushes
stacks of casino chips toward a winning gambler, late 1930s to 1940s.

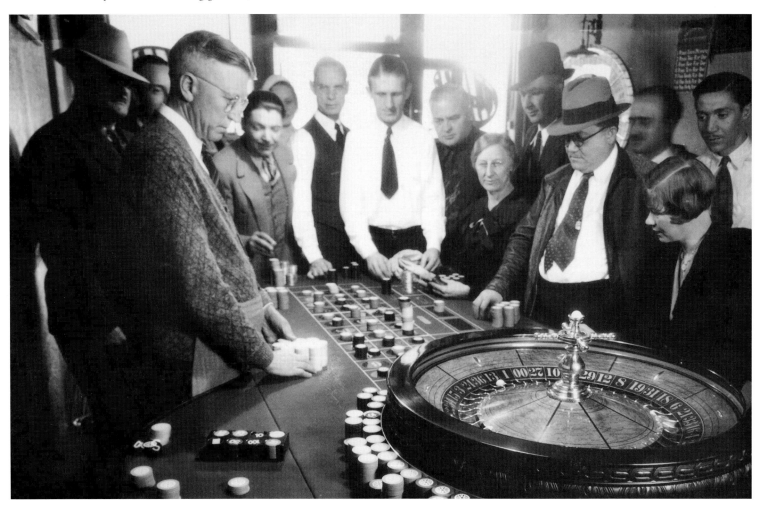

Acknowledgments

This volume, *Historic Photos of Las Vegas,* is the result of the cooperation and efforts of many individuals, organizations, and corporations. It is with great thanks that we acknowledge the valuable contribution of the following for their generous support:

University of Nevada Las Vegas Libraries, Special Collections

We would also like to thank the following individuals for valuable contributions and assistance in making this work possible:

Peter Michel, Director, University of Nevada Las Vegas Libraries, Special Collections

PREFACE

The photographs in this book are organized into four chronological sections. The first section, "Rise of a Railroad Boomtown," covers the founding years of Las Vegas, 1904 to 1910, from before the 1905 land auction that formed the town to the launch of the railroad through town and the creation of Clark County in 1909. The images depict the will and pioneer spirit of the early settlers at a time when they had to survive day-to-day in a sparse, desert environment that is alternately hot and cold. They reveal how rapidly both the McWilliams and Clark townsites were built so that the residents could begin their new lives, and how those residents coped as a community under harsh, crude living conditions.

The second section, "Before Hoover Dam: Molding a Desert Community," includes pictures taken in the years 1911 to 1929, during which Las Vegas began to mature as an incorporated city with stores, parks, schools, banks and paved streets. Residents would later experience the loss of much of their railroad supply business, but in the 1920s they experienced elation when the U.S. government decided to build the Hoover Dam project, which guaranteed the city's future expansion and prosperity.

The crucial decade of the 1930s is key to the third section, "Hoover Dam, Gaming, and the Early Las Vegas Strip," covering 1930 to 1949. In the 1930s, Hoover Dam was completed, Nevada legalized casinos, the federal government ended Prohibition, and Las Vegas truly began to take off as a relaxing spot for tourists to visit on their way to see the famous, spectacular new dam. The group of photos also reveals how Las Vegas looked in the 1940s, when military spending during World War II brought another economic boom, and the first resorts were established on the fledgling Las Vegas Strip between 1941 and 1948.

Finally, in "Modern Las Vegas Takes Shape," from 1950 to 1969, the images follow the progress the city and county

made during the resort boom of the 1950s, its contribution to—and benefits from—the Cold War, and the amazing growth of its visitor economy into the 1960s, which set up the incredible population growth and development that would come in later decades.

The Las Vegas shown in these photographs brings to light the city's changing scenery, its many booms versus few busts, and the evolution of what became the largest city in the United States to be entirely created and developed during the twentieth century.

—*Jeff Burbank, Author*

This project represents countless hours of review and research. The researchers and writer have reviewed thousands of photographs. We greatly appreciate the generous assistance of the archives listed here, without whom this project could not have been completed.

The goal in publishing the work is to provide broader access to a set of extraordinary photographs. The aim is to inspire, provide perspective, and evoke insight that might assist officials and citizens, who together are responsible for determining Las Vegas' future. In addition, the book seeks to preserve the past with respect and reverence.

The focus and clarity of many images is limited to the technology of the day and the skill of the photographer who captured them.

We encourage readers to reflect as they explore Las Vegas and stroll along its streets. It is the publisher's hope that in making use of this work, longtime residents will learn something new and that new residents will gain a perspective on where Las Vegas has been, so that each can contribute to its future.

—*Todd Bottorff, Publisher*

Members of a railroad survey party, wearing sombreros, pose in 1904 beneath trees at the Stewart Ranch, owned by Las Vegas pioneer Helen Stewart, who in 1902 sold most of her two-thousand-acre property to William Clark, a U.S. Senator from Montana. In 1905, Clark would bring in rail service and subdivide Stewart's ranch to create what today is downtown Las Vegas.

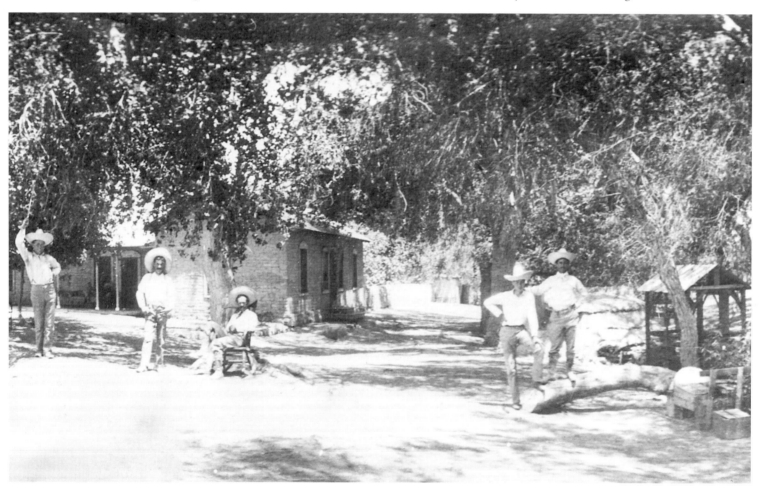

Rise of a Railroad Boomtown

(1904–1910)

After the start of the twentieth century, Las Vegas would become one of the last brand-new western towns in America created following the country's one-hundred-year spread westward. Populated by humans for about 11,000 years, the Las Vegas Valley's early residents included the Ansazi and then Paiute Indians. Western explorers became regular passersby in the then-Spanish territory of the 1830s, blazing the Old Spanish Trail through what they would call "Las Vegas," or The Meadows, for the grasslands that covered parts of it.

John C. Fremont, an American explorer and surveyor, led an expedition in 1844 through the Las Vegas area with his guide, frontiersman Kit Carson, and mentioned it in his report to Congress. Mormon missionaries from nearby Utah followed in the 1850s, but were called back to Utah because of meager farming and mining and difficult relations with the Paiutes. When Nevada became the nation's thirty-sixth state in 1864, virtually all of its population was five hundred miles northwest of Las Vegas, near Carson City. In fact, Las Vegas remained part of Arizona territory until 1867.

In 1882, Archibald Stewart acquired a ranch in the central Las Vegas Valley and took his wife, Helen, with him. When Archibald was shot dead in 1884, Helen, a mother of five, took over and courageously oversaw the two-thousand-acre, livestock and irrigated fruit ranch until 1902, when she sold most of her land. The portion she sold was used to create the town of Las Vegas.

By 1900, Las Vegas consisted of little more than Stewart's Las Vegas Ranch and an expansive, six-hundred-square-mile valley in the Mojave Desert, with a population of about thirty (plus some Native Americans not included in the census). In 1902, Montana's U.S. Senator William A. Clark, a copper-mining magnate, visited Stewart and bought most of her farm in order to expand his San Pedro, Los Angeles & Salt Lake City Railroad. Clark wanted Las Vegas to serve as staging area and company town for his rail line from Salt Lake to Los Angeles and for branch lines to mining operations in southern and central Nevada.

In 1904, while Clark readied his railroad, a Canadian engineer, John T. McWilliams, bought eighty acres from Stewart

and planned to build a town in Las Vegas before Clark could start his. McWilliams touted his town in late 1904 as the "original" townsite of Las Vegas. He sold lots and attracted fifteen hundred residents and many businesses, mostly housed in tent buildings. Early life in the canvas-walled structures was rough and makeshift.

But soon all would go Clark's way. On May 15, 1905, three thousand people showed up at a land auction he held beside his rail yard in present-day downtown Las Vegas. He guaranteed buyers access to his railroad, putting McWilliams (his failing hamlet now nicknamed "Ragtown") at a severe disadvantage. Residents moved to Clark's Las Vegas townsite in droves.

Lots for the Clark site sold briskly, and the town's first thirty blocks were mapped out, with Fremont Street (named after the early explorer) as the town's business district. About one hundred artesian water wells were discovered and tapped. Tent structures were quickly replaced with buildings made of wood planks and cement blocks. Clark's Las Vegas serviced his railroad yards and supplied the area's mining districts. Its entertainment center was known as Block 16, a red-light district lined with saloons offering liquor and gambling and, later, legal prostitution. An opera house debuted in 1907.

When Clark County was created in 1909, Las Vegas became the county seat. It looked more like an established town, with lines of wood, brick, and cement buildings—some two stories high—and ten miles of graded roads. Though it would have its temporary stops and starts, the boomtown of Las Vegas was poised to become a city.

One of the earliest pictures of the Clark Las Vegas townsite, 1905, includes a
tent structure (left) and one made of solid wood.

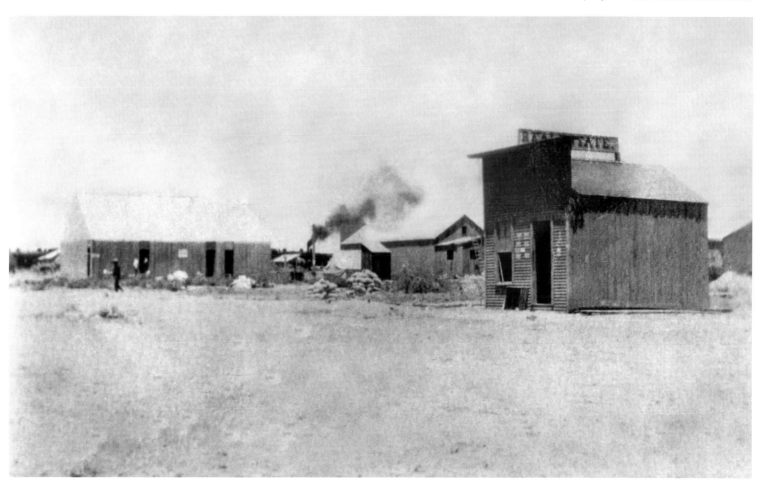

With building materials in short supply, many of the Las Vegas area's early structures, like this early post office in 1905 (which may have been in the McWilliams site), were made of wood and canvas. The first post office in the area, for a time called "Los Vegas," opened at Helen Stewart's Ranch in 1893. Around 1905, some residents of the new Las Vegas proposed calling the town "Vegas" to avoid confusion with Las Vegas, New Mexico, but the full name stuck anyway.

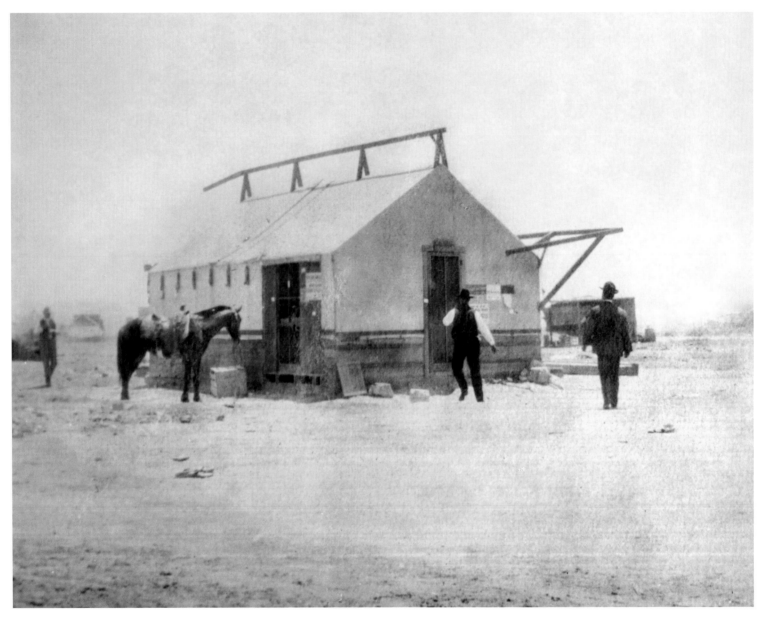

A pair of early Las Vegas residents peer at "Big Spring," a large section of an aquifer about a mile west of downtown Las Vegas, in the early 1900s. The centuries-old desert springs, created by ground water seeping through bedrock, served as a much-needed water source and oasis for Native Americans, early travelers, train operators, and residents. From increased human use, the springs would run out of water in 1962.

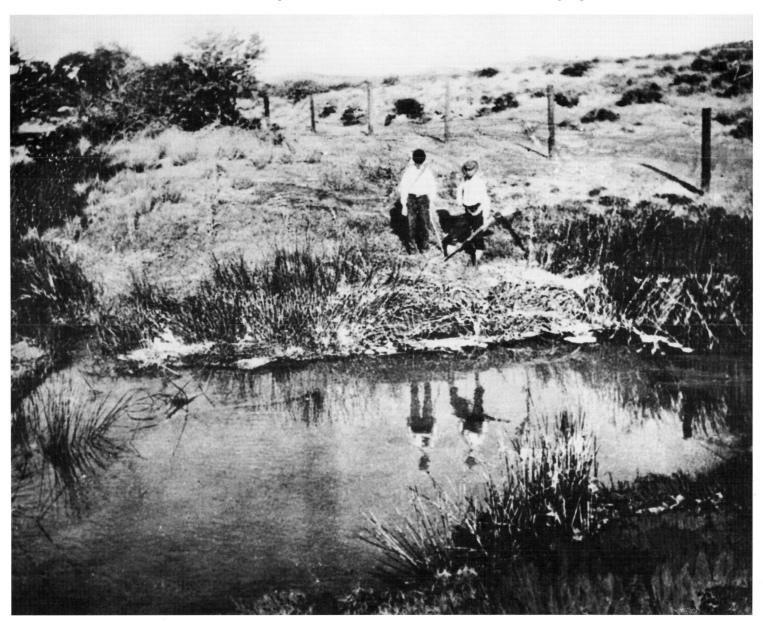

The desolate center of the McWilliams townsite, as it appeared in 1905, was Las Vegas' first settlement, started in 1904, about six months before the Clark Las Vegas townsite. Its wooden and tent structures would be devastated by fire later in 1905.

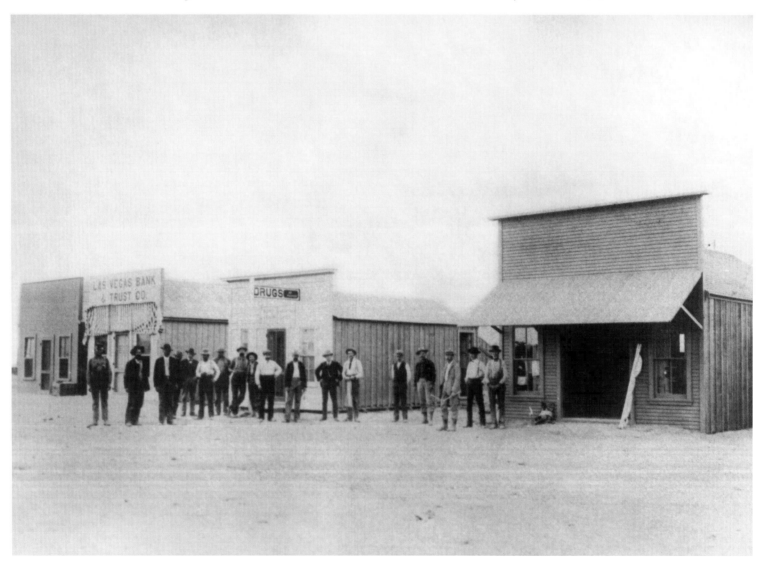

I. W. Botkin's men's clothing business was one the first stores to open on Fremont Street in the Clark Las Vegas townsite. Botkin had originally operated at the 1904 McWilliams townsite, but like many merchants, moved to Clark's in mid-1905 to be near the new railroad depot. The Palace Hotel can be seen in the background to the right and early tent houses to the left.

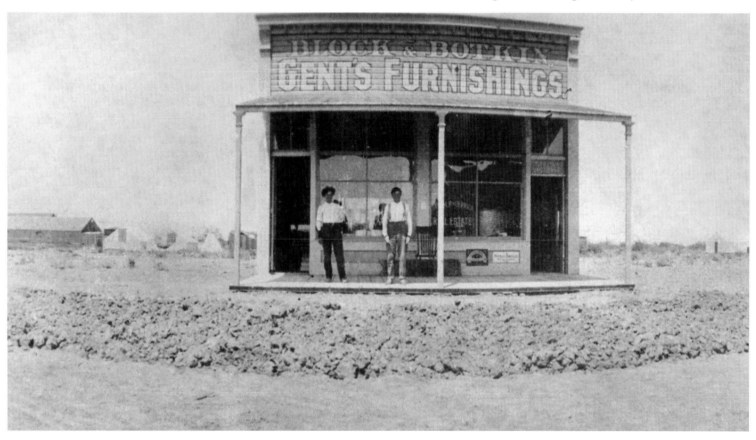

Banking and refreshments had to share space in the quickly built and hot confines of the original McWilliams townsite in early 1905. The First State Bank stood in the heart of the McWilliams site, immediately beside the post office and a small shop, Kuhn's Merchantile. In a matter of months, most of the businesses would move southeast to the nearby Clark Las Vegas townsite to be next to the new rail station.

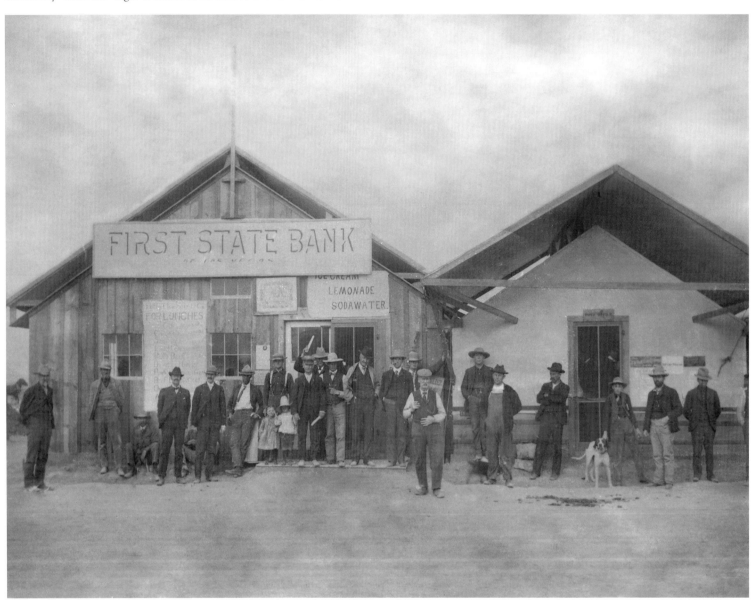

At perhaps the height of activity in the McWilliams site in early 1905, a crowd mills in the center of town outside the First State Bank and Kuhn's Merchantile. Signs selling snacks and sandwiches beside the bank reveal the boomtown atmosphere.

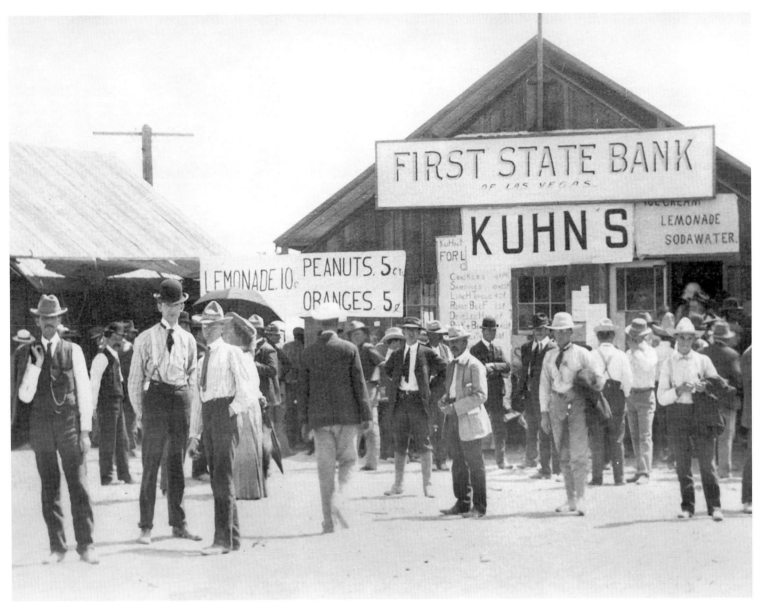

Employees of the San Pedro, Los Angeles & Salt Lake City Railroad stand beside the engine of the historic first train to arrive in Las Vegas from Salt Lake City, in May 1905, when the tracks were finally completed following years of harsh building conditions in the Southern Nevada desert. John Charles Fremont, the train's engineer, is standing second from left.

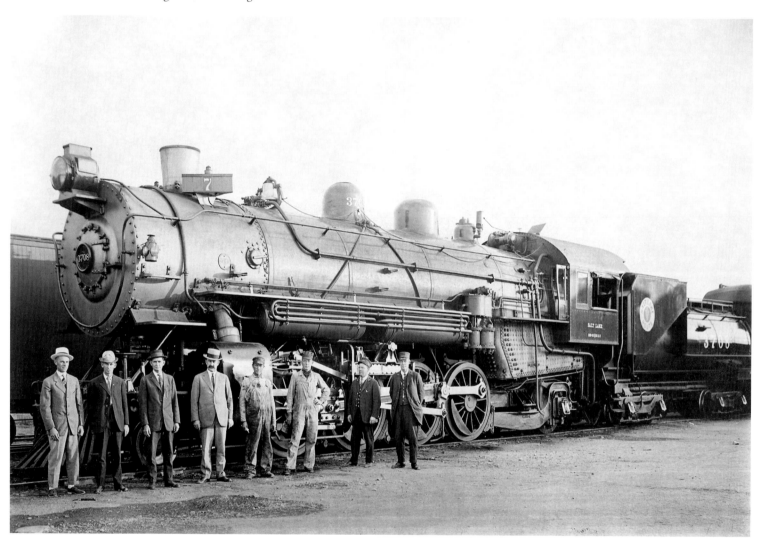

Baggage-carrying new arrivals disembark between passenger and freight cars from the first public train to arrive in Las Vegas from Los Angeles, on May 15, 1905. Among the passengers who would settle in the Clark Las Vegas townsite was Ed Von Tobel, Sr., who would start a lumber business and a local family dynasty.

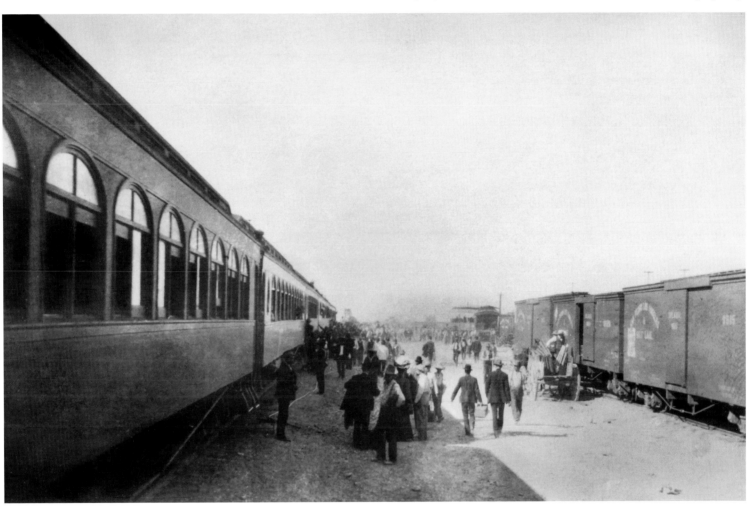

The first photograph taken of the "temporary" Las Vegas rail depot, consisting of a converted passenger car of the San Pedro, Los Angeles and Salt Lake Railroad and some makeshift stairs, in 1905.

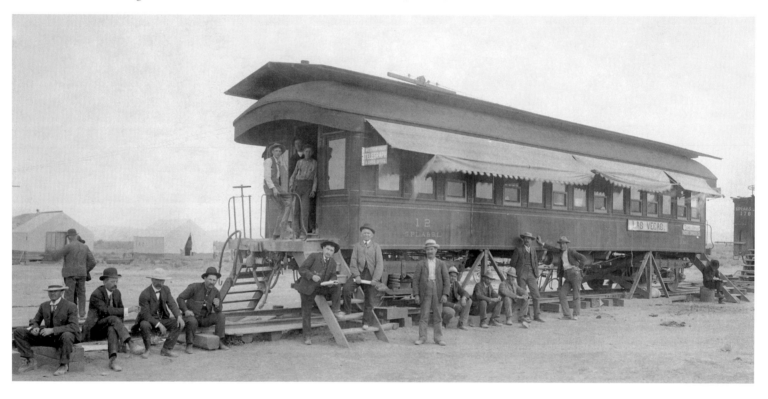

The rebuilt rail car serving as the Las Vegas depot soon took on a life of its own in 1905, with a ticket office and waiting room with shades over the windows. The building to the left housed offices of the Pacific Fruit Express Company and Western Union Telegraph (wire pole is seen above depot), where Joe Keat was the town's first telegraph operator.

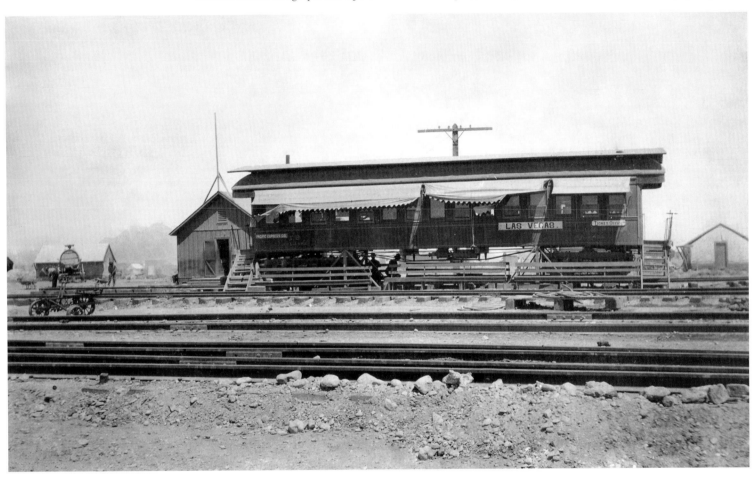

The first hospital built in Las Vegas, in 1905, made of wood and canvas.

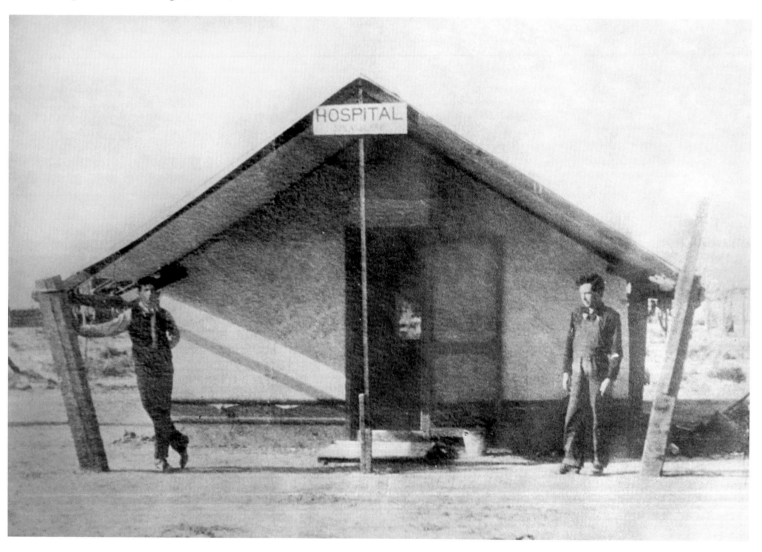

One early major business to appear in the Clark Las Vegas boomtown, Clayson & Griffith sold new and used goods within a wood and canvas structure facing the rail station, at Fremont and Main streets, 1905.

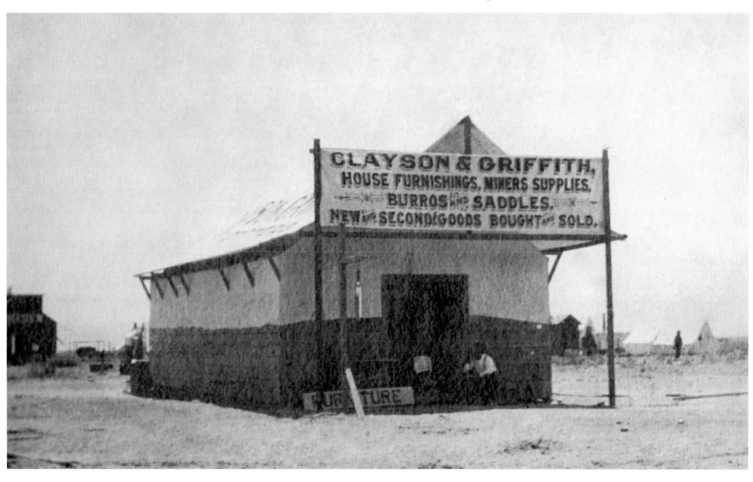

A cluster of lonely buildings remained in the deserted-looking business district of the McWilliams townsite while it struggled to compete with the Clark townsite, mid-1905. That summer, the townsite, abandoned by most of its significant businesses, was nicknamed "Ragtown," for its tattered tent structures, damaged by fire and neglect.

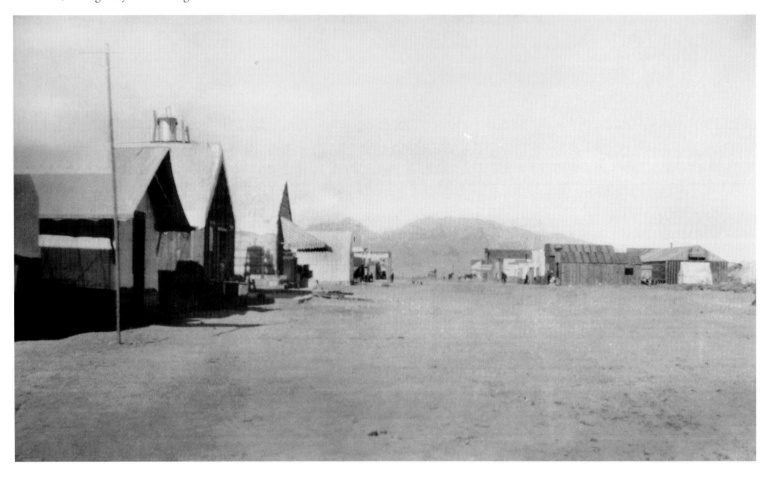

The flight of important businesses from the McWilliams site to the Clark site in 1905 included the First State Bank. The bank became the first permanent, two-floor building in Las Vegas, at First and Fremont streets.

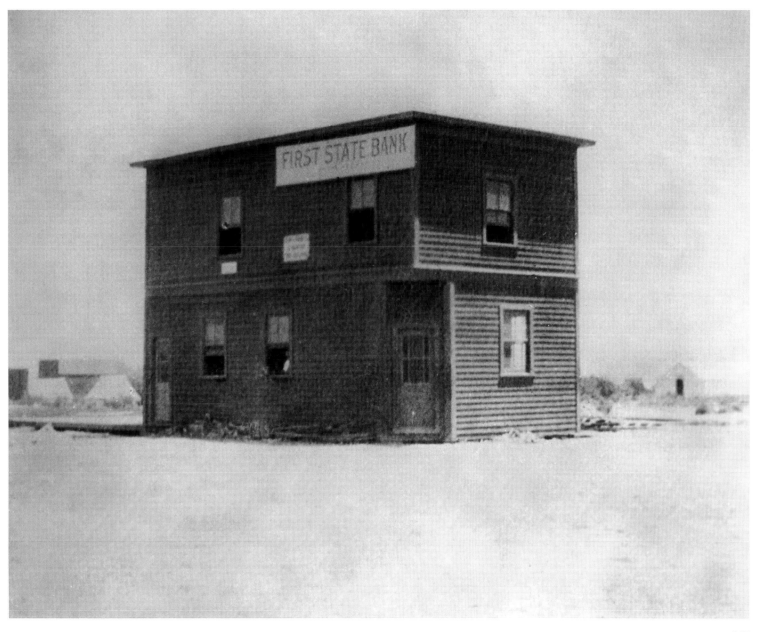

The new Clark townsite in 1905 initially permitted alcohol and prostitution on only Block 16 and 17 and soon restricted them to just Block 16, in the town's extreme northeast corner. It did not take long for Block 16 to become a bustling attraction in Las Vegas for residents and tired train passengers, with wooden saloons like The Gem, the Arizona Club, Red Onion Club and The Arcade on the east side of North First Street between Ogden and Stewart streets. The Arizona Club would establish itself for years as the finest and fanciest saloon in town.

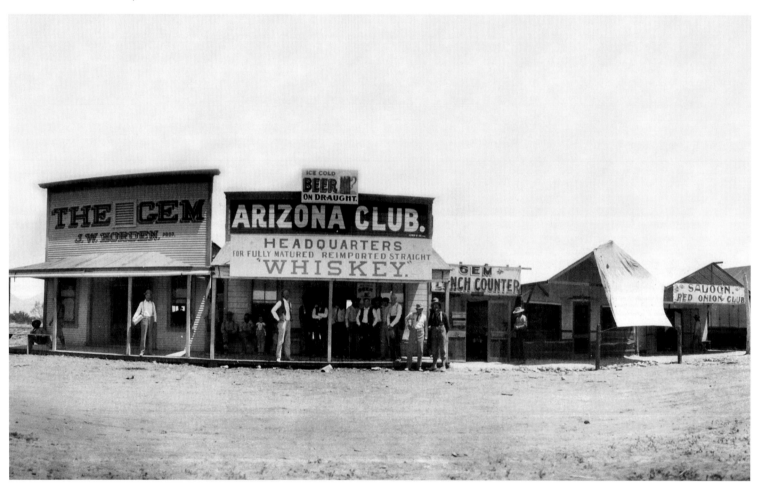

Lumber, cement, and other building materials, offered here at the Las Vegas Trading Company in 1905, were scarce in Clark's young town. Demand for wood was so high even the new railroad could not deliver enough to meet it. Lumber sellers bore the brunt of many complaints from residents. Carpenters received double the wages of day laborers. Many residents who arrived in 1904 and 1905 lived in portable tent houses (easily picked up and moved on wagons), and some placed pieces of lumber on the ground to serve as walkways.

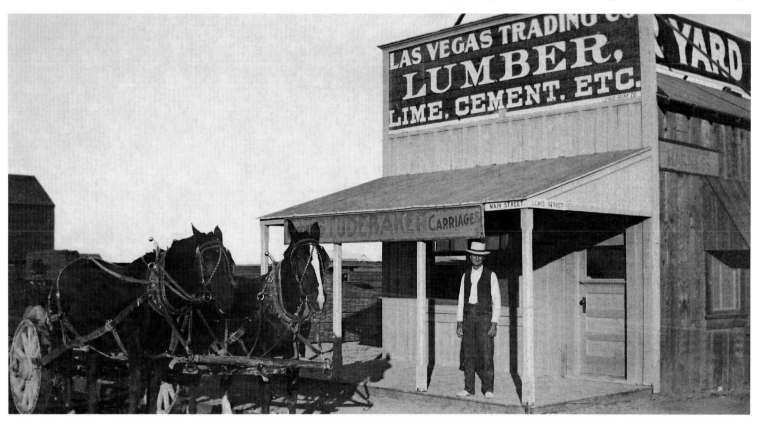

The Las Vegas townsite's first bakery, Vegas Home Bakery, was another refugee from the McWilliams town in 1905. It took longer to relocate than other merchants' shops because of its heavy ovens.

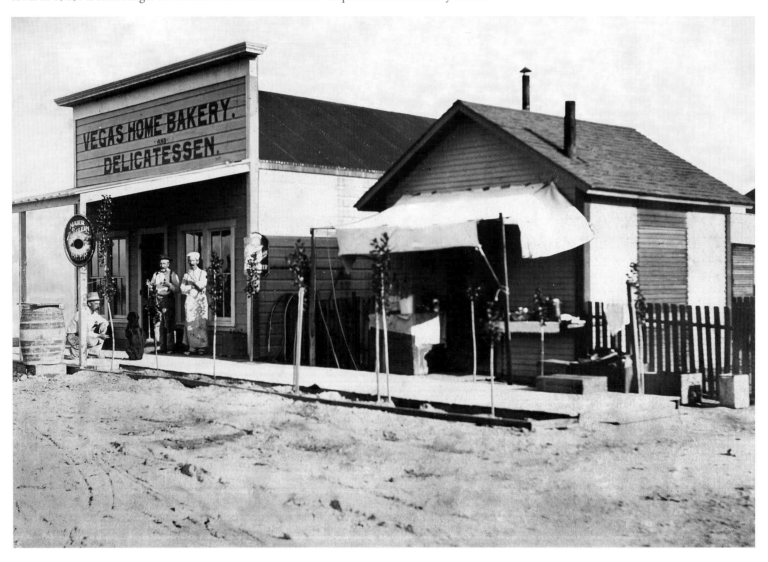

Many aspects of early life in Las Vegas were makeshift, including this "bath house" in the desert, consisting of a tent pitched over water diverted from the Las Vegas Creek. Patrons closed the canvas curtain, stepped onto a wooden board, and then down into a sunken wooden tub of creek water. When they got up from washing, they stood on a matting covering the ground. Customers could also lounge on a bed seen inside the tent at left.

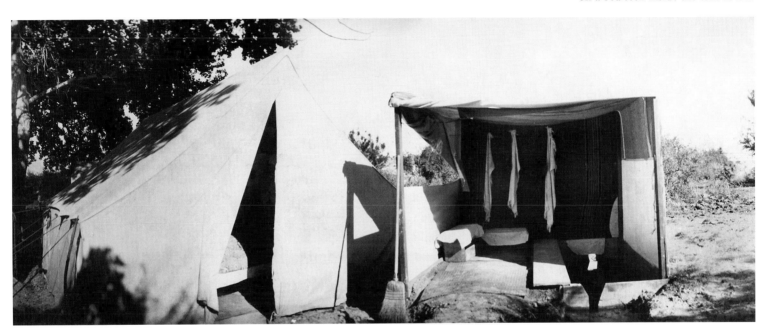

Progress—and spectacle—arrived quickly in the opening year of the Clark Las Vegas townsite. Members of a Scottish kilt band in this 1905 parade were likely among recent arrivals brought by the new San Pedro, Los Angeles & Salt Lake City Railroad. More evidence of swift advancement is seen here in the line of structures and the wooden sidewalk along Main Street, immediately east of the rail line.

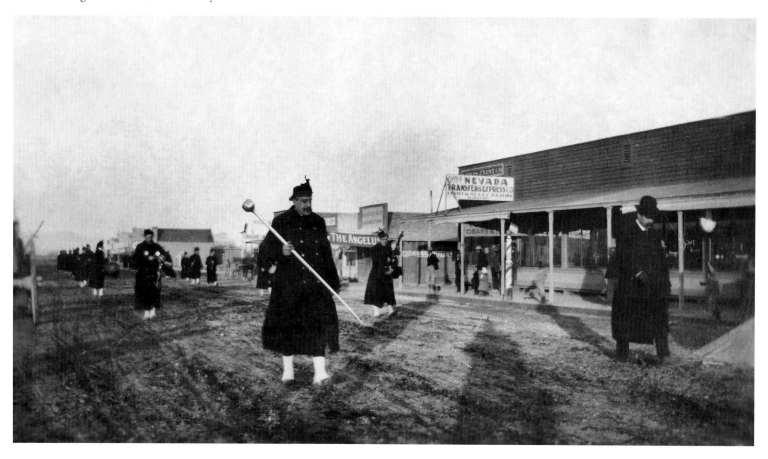

The transition from tents to more permanent buildings continued in late 1905 with this, the town's first brick building, which housed the Las Vegas Drug Store and the relocated Crowell & Abbott's General Merchandise (right). Crowell & Abbott's, formerly of the McWilliams town, installed a retractable awning. Potted palm trees decorated the outside of the building, which stood on North Main Street. One of the men outside stands next to a burro loaded with fully packed sacks.

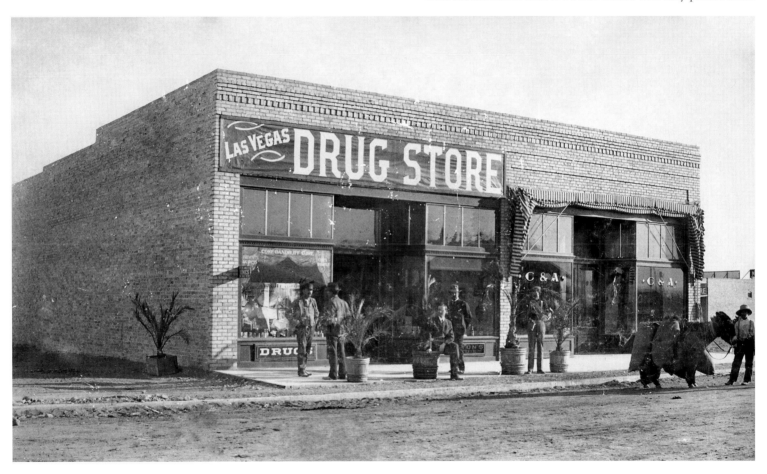

Canvas and wood, cut to size in Los Angeles, then transported, assembled and erected here, were used to create the first hotel in the town's history, the Hotel Las Vegas. Completed on North Main Street near Stewart Street, prior to the land auction in May 1905, the tent hotel was 40 feet wide and 140 feet long, offered the best accommodations around (barracks-like lines of beds), plus food and cold drinks for land buyers and new residents. Almost immediately, the hotel became the center of activity in town. The innkeeper, Charles "Pop" Squires, later became editor of the *Las Vegas Age* newspaper. A utility pole stands in the foreground. The hotel and its separate tented kitchen and dining room were torn down in March 1906 after the railroad ordered all tent structures off its property.

Drivers of four-horse and six-horse teams pose outside the Arizona Club on the saloon row that was Block 16, around 1905. The bales of hay piled high in the wagons, for delivery around the region to places like Beatty and Bullfrog, served as fuel for mules and horses that were the only forms of local transportation. The drivers, with teams of up to eighteen animals, weathered many hours traveling scores of miles on bumpy, dirt roads in the desert heat. Limited automobile transport, called "stages," was added in June 1905.

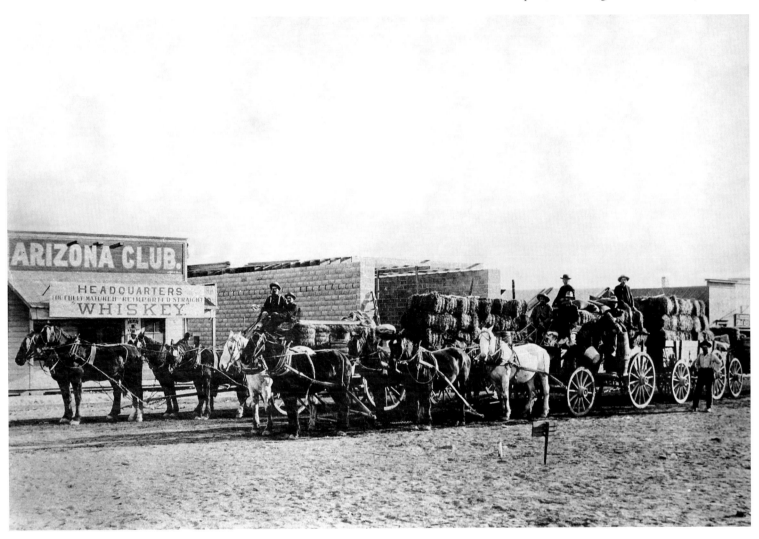

A horse-team chain is laid out on the ground in front of a wagon in the supply yard on the west side of the 500 block of Main Street, the hub of local transportation in 1905. Wagons and horses waited for supplies unloaded by the adjacent railroad. Horse-pulled wagons were the only way to deliver materials to area mining "boomtowns" such as Rhyolite, Beatty, Bullfrog, and El Dorado Canyon, but that ended with the debut of a local rail spur, the Las Vegas and Tonopah Railroad, which starting hauling freight in 1907.

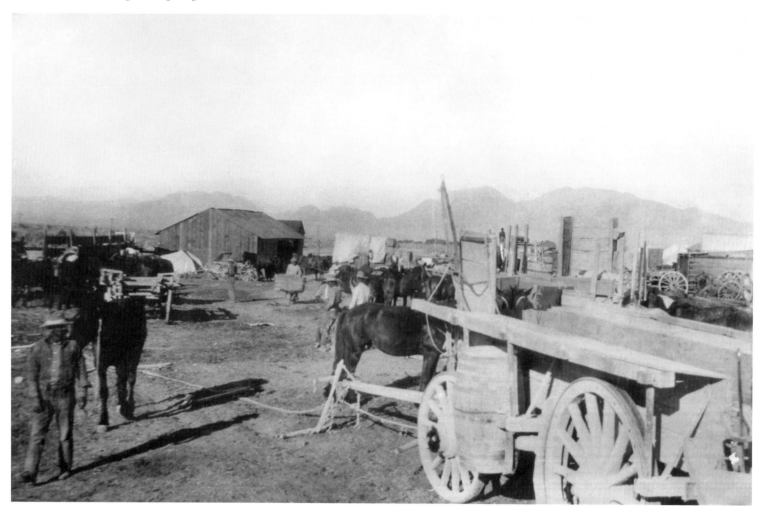

Main Street (running left to right, center), about 1906, included utility poles, canvas-and-wood buildings, and Las Vegas' first brick structure, the two-story Hotel Nevada. Crowell & Abbott's and the Las Vegas Drug Store are at the extreme left. In the foreground, a mule-drawn wagon is driven on a dirt road running parallel to Main Street and the railroad on the other side of Main.

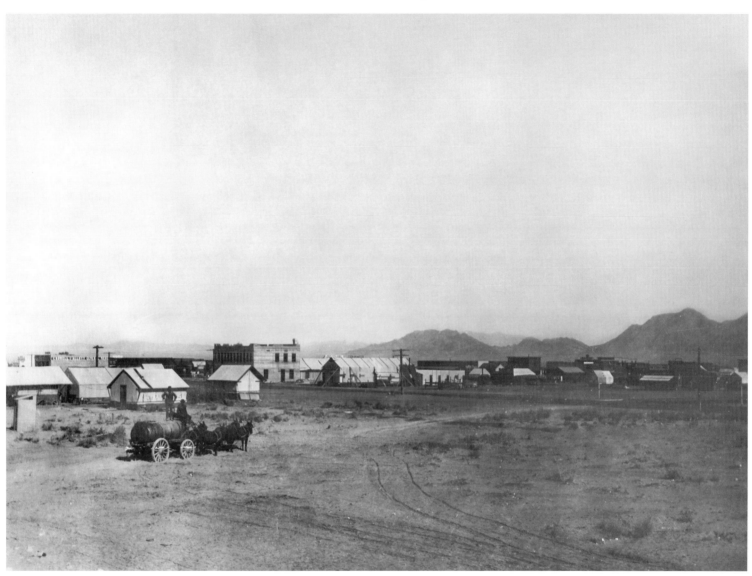

For this unique view from 1906 or 1907, the photographer climbed a utility pole to take a picture of the rail yard of the San Pedro, Salt Lake City & Los Angeles Railroad, looking east toward Las Vegas. Engines traveling north and south converged here. Thirty-five of the rail line's coal-fired engines were serviced in the yard. The town's icehouse, the two-floor, wooden structure in the center, could hold up to fifty tons of frozen water, but it burned down in July 1907.

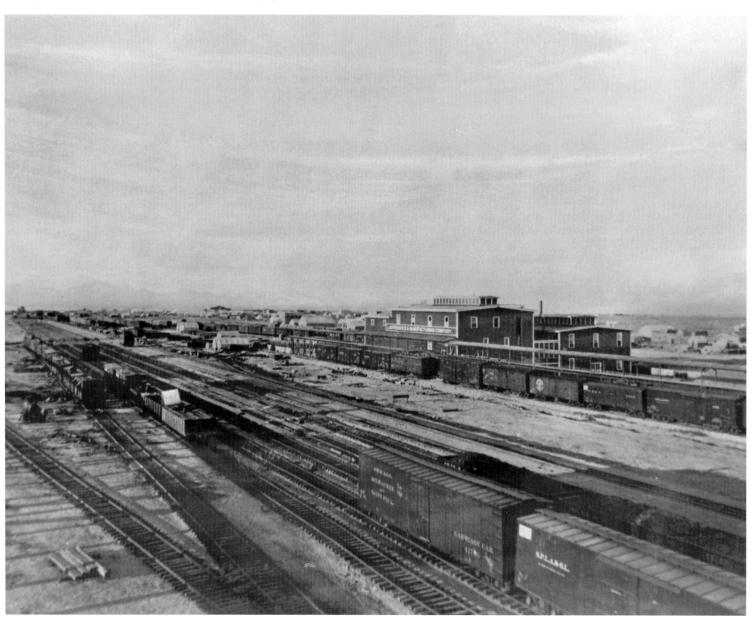

Carrying lanterns, a uniformed signalman walks along the railroad in front of the depot built in 1906 for the San Pedro, Salt Lake City & Los Angeles rail line. The mission-style depot defined Las Vegas for thousands of visitors until it was remodeled in the 1940s.

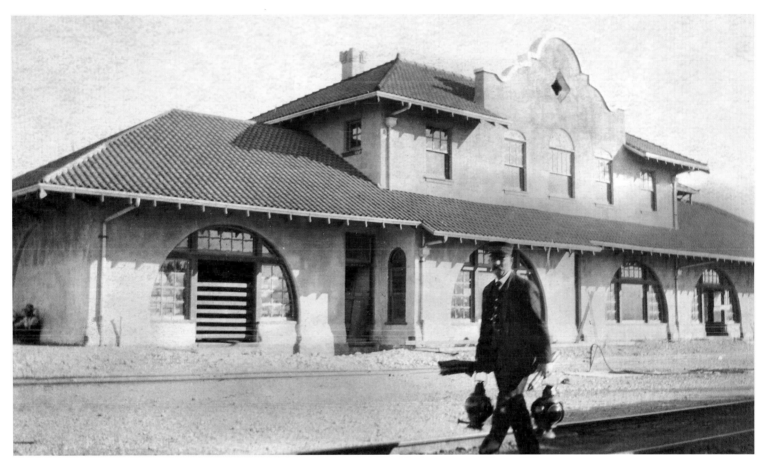

Crowds gathered beside and on the railroad to watch the Pullman passenger car carrying Montana's U.S. Senator, railroad builder William A. Clark, who stopped here briefly to tout the 1905 land auction that would create modern Las Vegas. He is the namesake of Clark County, which has Las Vegas as its seat of government.

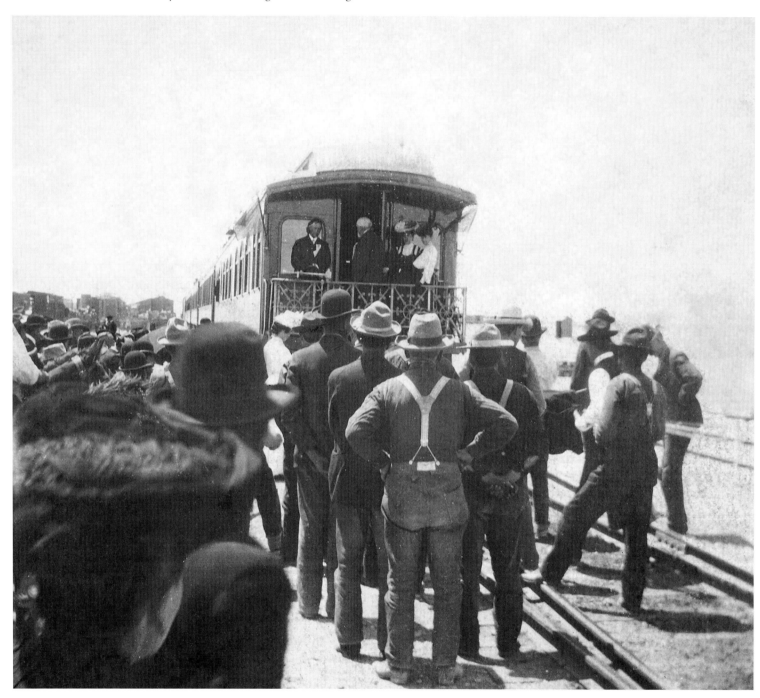

From the back of his private passenger rail car, Senator Clark addressed onlookers at the new Las Vegas townsite in 1905. Although he continued to own the railroad for years, Clark never returned to Las Vegas.

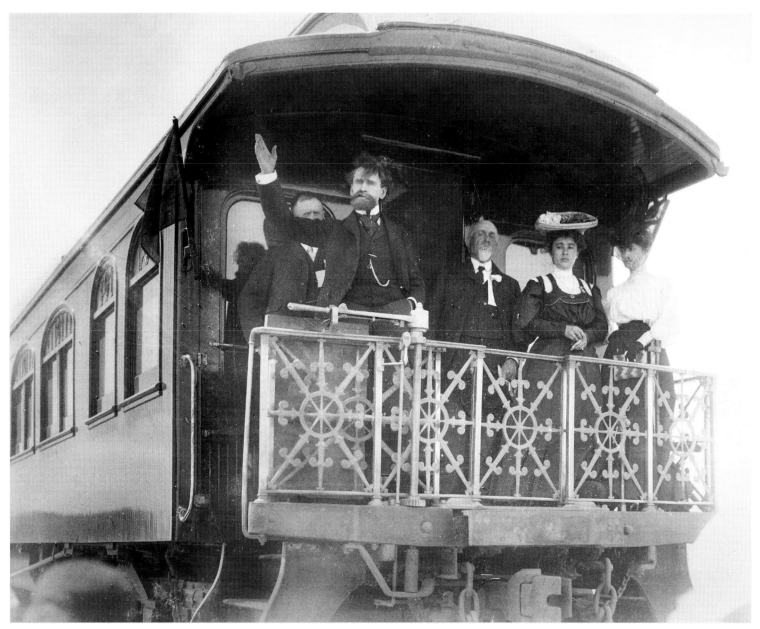

Men in a longboat approach the wharf on the Colorado River at El Dorado Canyon in 1907, when the area was thought to have potential for another boomtown similar to Las Vegas. Several million dollars in gold and other metals were extracted from an area centered around Nelson, about twenty-five miles southeast of Las Vegas, but within a few years, the mines were mostly tapped out. Some activity continued into the 1940s.

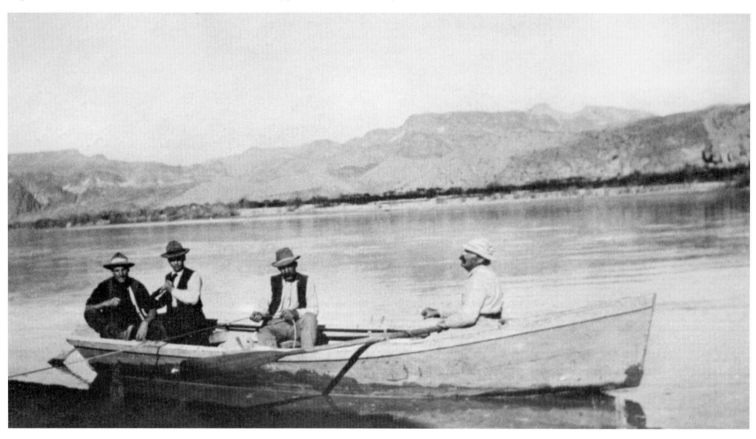

Once housed in a tent building, the Las Vegas post office moved into the First State Bank building on Fremont Street in 1907. Walter Bracken, who was Las Vegas' postmaster from 1904 to 1914, leans beside the wooden pigeonholes with sorted mail in 1908. Electric lights hang from the ceiling. A postage scale and calendars can be seen among the office equipment.

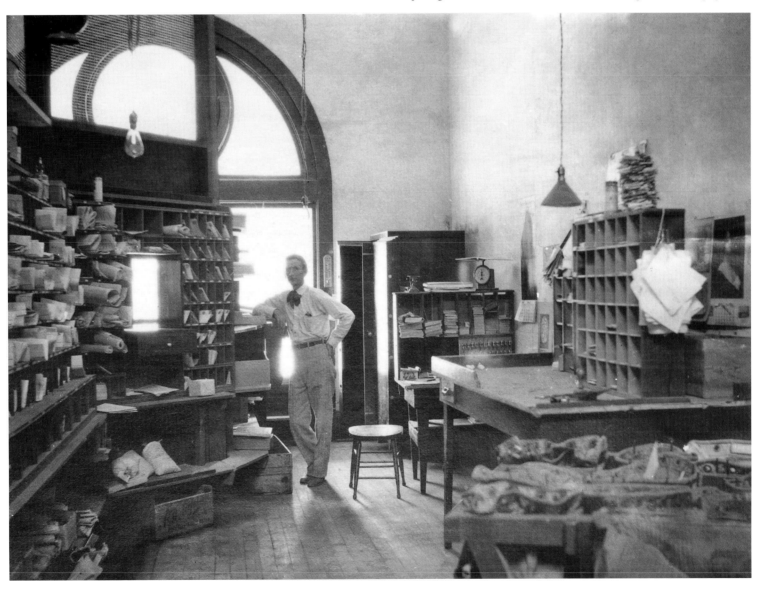

Early resident Ed Von Tobel, Sr., inspects three wagons full of heavy mining equipment and other supplies headed for the Bullfrog mining district sometime in the early 1900s. Von Tobel, formerly of Los Angeles, came to Las Vegas in 1905 and started a lumber business with partner James Beckley.

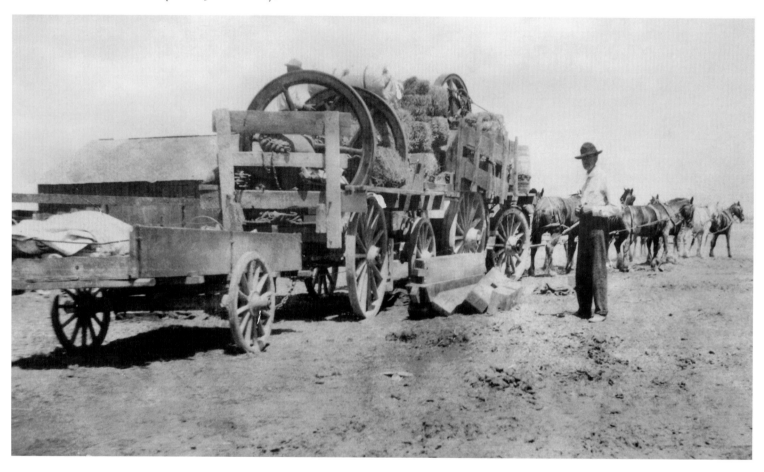

As Las Vegas began to look more like a settled town in early 1909, one of its central buildings was Thomas' Department Store, which took up an entire corner of First and Fremont streets. Its second floor housed an opera house. Like other new buildings in Las Vegas, such as the Ferron & Martin drug store across from it on Fremont, Thomas' was constructed of brick and cement blocks.

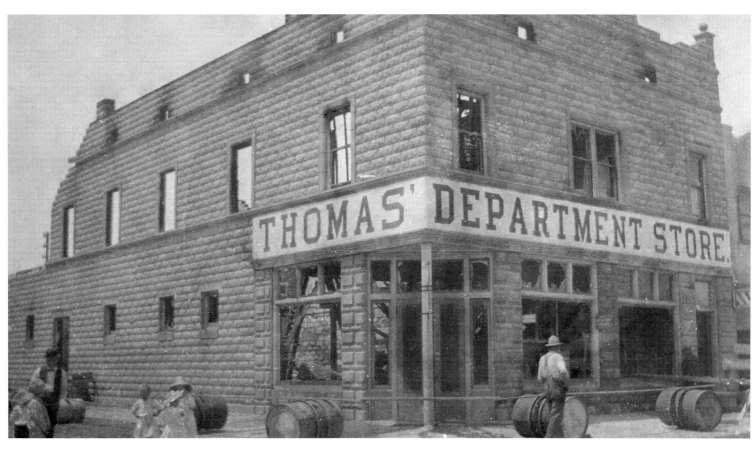

The Arizona Club, little more than a wooden shack when James O. McIntosh opened it soon after the May 1905 auction, was an immediate hit with locals. Shown here less than a year later in April 1906, following an obviously prosperous period, the two-story bar is now fashioned in a mission building style. Built of brick and masonry, it featured red mahogany columns, leaded, beveled glass windows, front doors made of oak, a thirty-foot front bar and a back bar. McIntosh sold it to Al James in 1912, who would install a brothel upstairs.

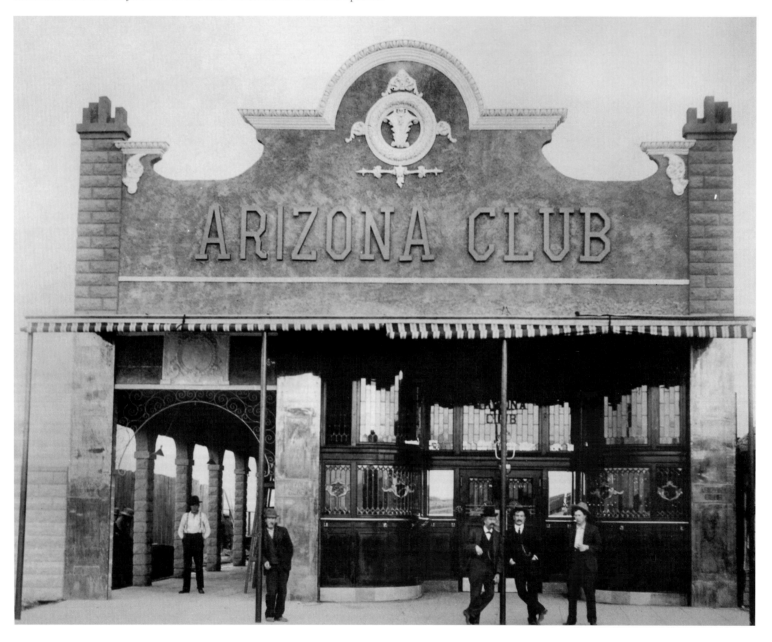

Celebrants gathered at the Las Vegas Ranch, nicknamed the "Celebration Ranch," for a Fourth of July picnic, in 1908.

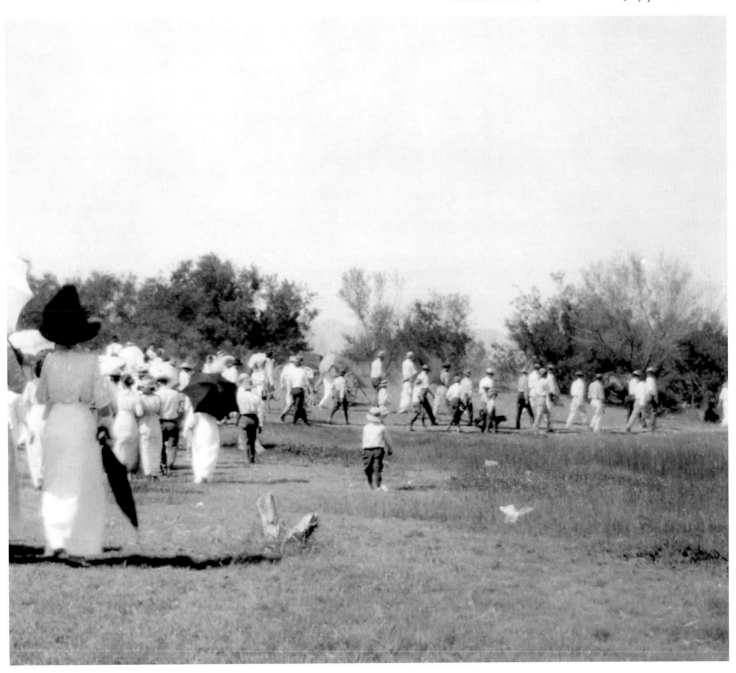

American flags fly over the freight station of the San Pedro, Los Angeles &
Salt Lake City Railroad, which set up a public area that offered shade in the
summer heat on the Fourth of July, 1908.

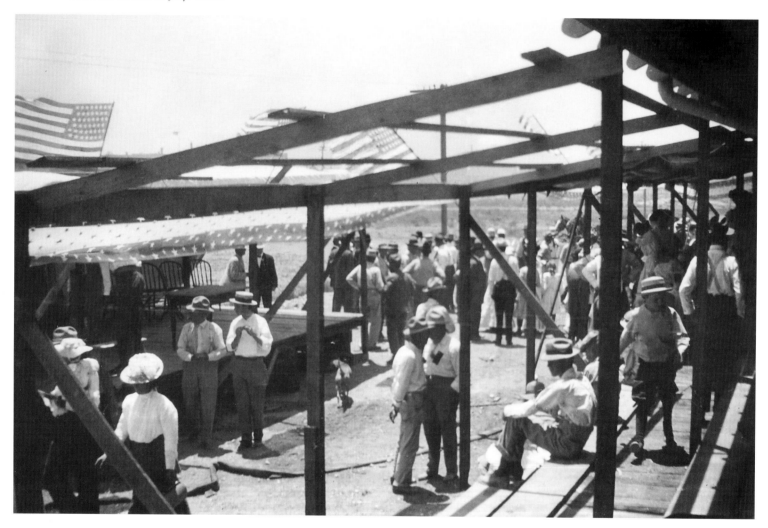

Some Paiute Indians in an encampment with animal-skin tents around 1905, beside Big Springs of the Las Vegas Springs about a mile west of the Las Vegas townsite. Note the small toy wagon, left foreground. Native Americans, starting with the Anasazi, traveled through the valley around Las Vegas for thousands of years. The Anasazi left about 1150 A.D., replaced by the modern-day Paiutes.

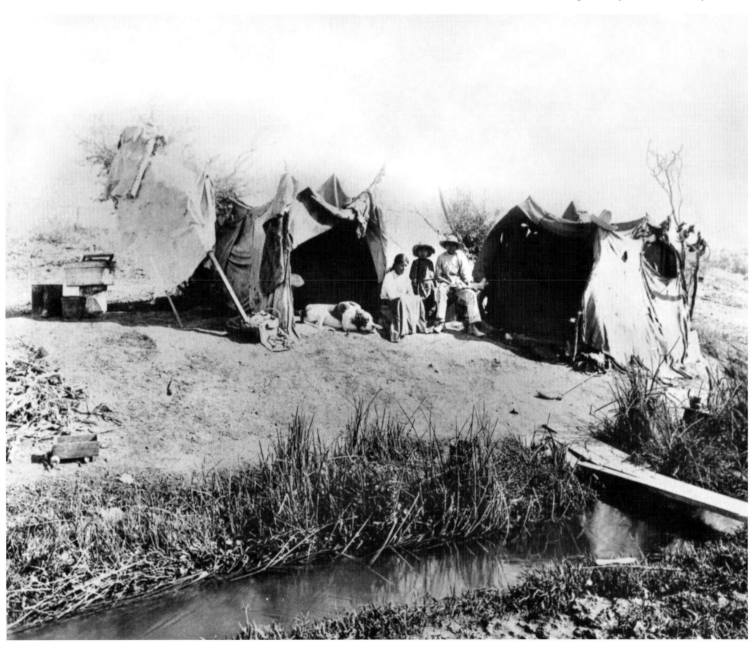

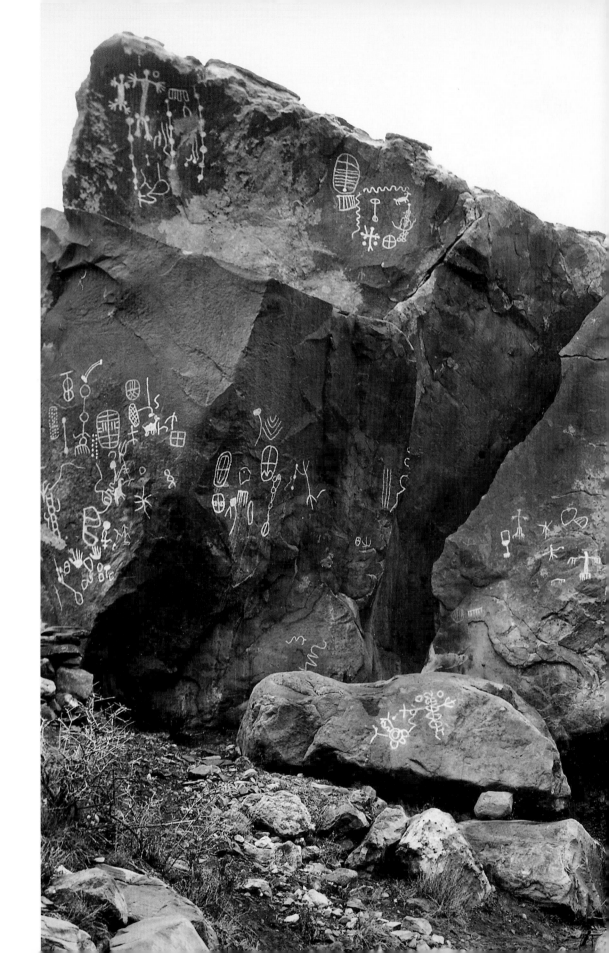

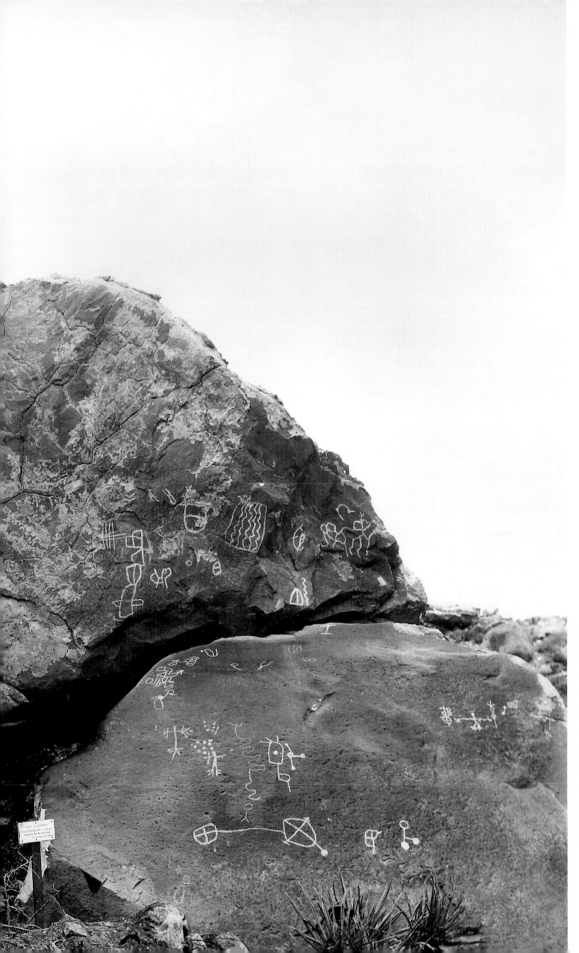

Prehistoric petroglyphs, like these discovered in the early 1900s, were carved by Native Americans, including the Anasazi and Pauites, while passing through the Valley of Fire and other remote areas northeast of the Las Vegas townsite over hundreds of years. The images, pounded into the heat-baked, brittle brown sandstone rock, were a form of communication through symbols, such as bighorn sheep and other animals the Indians hunted. Tribal members also used desert soil to paint images known as pictographs on rock.

New residences had spread widely in Las Vegas, as shown in this view down Bonneville Street from Main Street, looking east about 1909. In the distance, on Second through Fourth streets, are a series of "railroad cottages," built by the San Pedro, Los Angeles & Salt Lake City Railroad for its employees. The railroad built the homes of wood and concrete block, using the same floor plan, from 1909 to 1912.

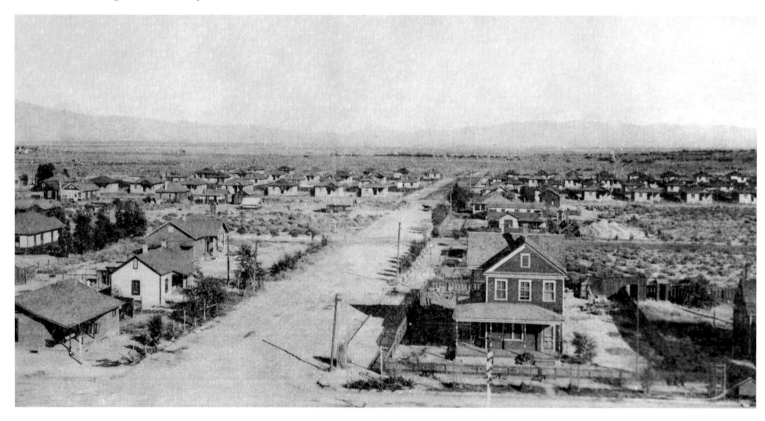

Another milestone in 1905 was the first schoolhouse in Las Vegas, located in a then-isolated area on Second and Lewis streets. The wooden schoolhouse, formerly the Salt Lake Hotel, had two rooms, a potbellied stove, and one teacher. The first class in early 1905 had only a few dozen children, but by autumn that increased to two hundred students. The school was destroyed by fire in 1910.

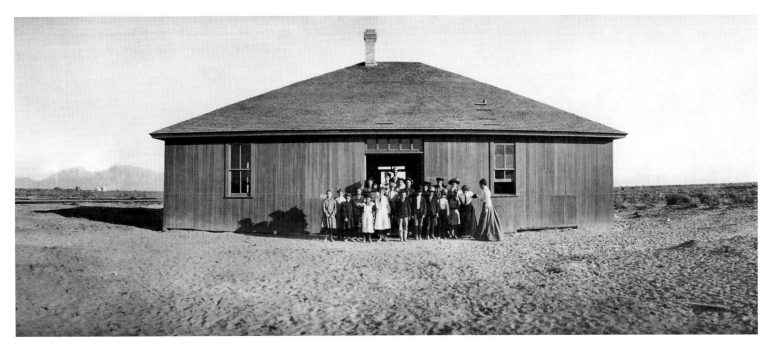

On First Street, looking south to the intersection of Fremont Street, downtown Las Vegas had progressed as a town by the spring of 1909. It boasted many large commercial buildings and ten oiled, dirt streets with curbs. In the center is Thomas' Department Store with its wraparound sign, on the northeast corner of Fremont.

Fremont Street about 1910, west from Second Street. By then, the available space along the first two blocks of Fremont had been covered by commercial buildings.

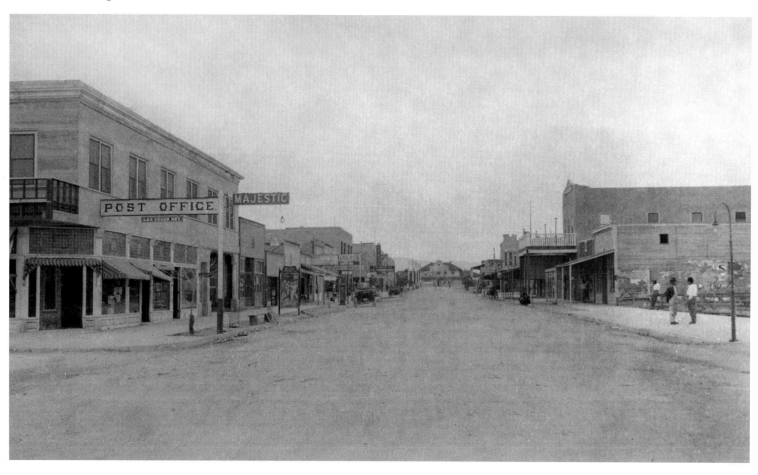

In 1909, the original First Methodist Church was completed at Third and Bridger streets, using locally made concrete blocks. The parson's house is at right. The Methodist church, with its steeple, could be seen for miles and was one of the most noticeable buildings in town. It survives today, serving as a café and nightclub.

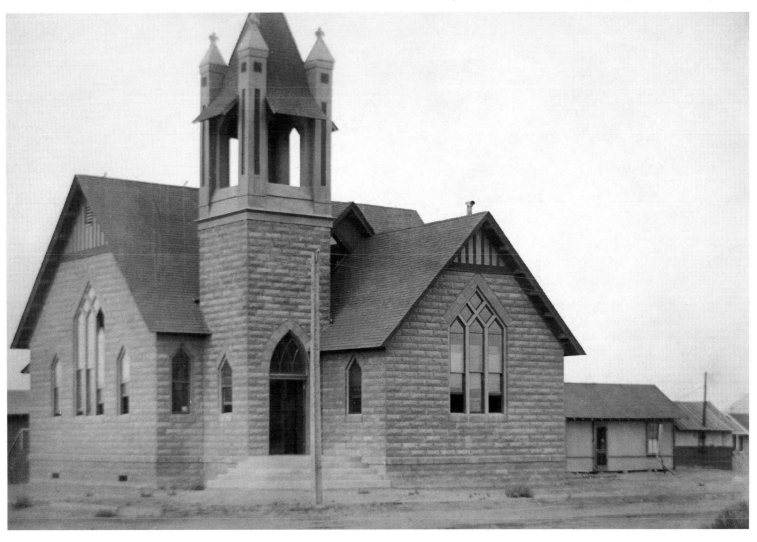

A bird's-eye view of Las Vegas taken in 1910 from the roof of the Episcopal Church, which was founded in 1907. The light-colored cement building to the right would serve as the town's county government after Clark County was created and Las Vegas was made the county seat. The building later became the town's jailhouse. The First Methodist Church is in the background to the right.

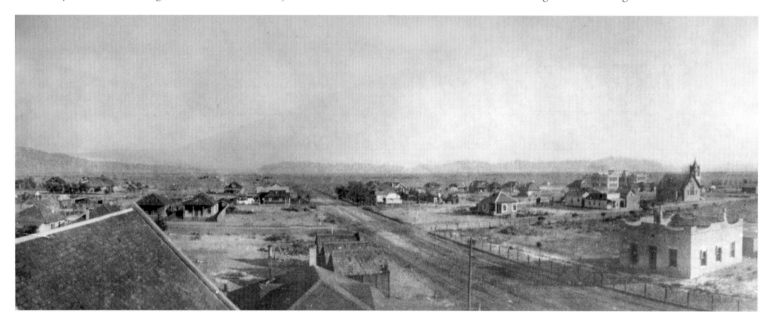

A wide-angle panorama of downtown Las Vegas, from atop the Episcopal Church, in 1910.

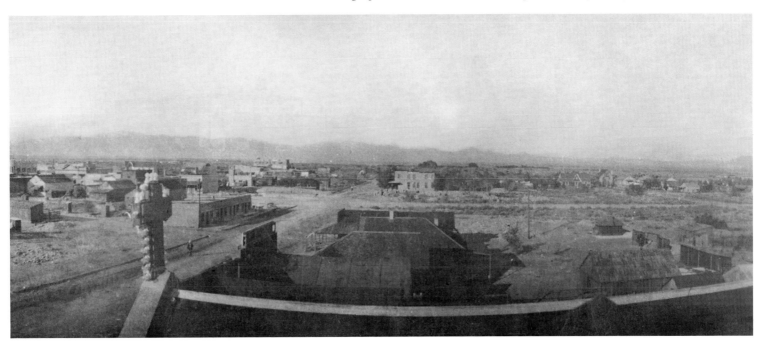

A woman relaxes with her dog on the porch of a home at the Las Vegas
Ranch in the early 1900s.

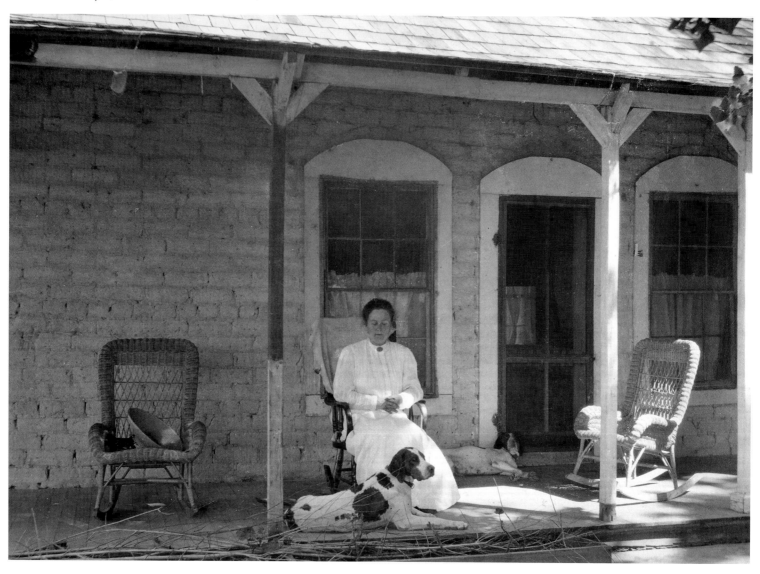

Las Vegas residents gather to celebrate Labor Day outside the First State Bank at Second and Fremont streets in 1910.

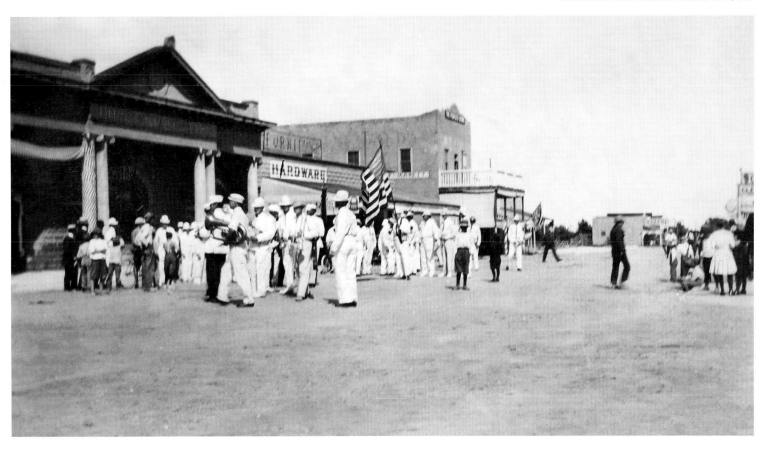

Homes mix with commercial buildings on Third Street (foreground), about 1910. Ogden Street is at right. At the time, Las Vegas ended two blocks to the east, at Fifth Street, later Las Vegas Boulevard.

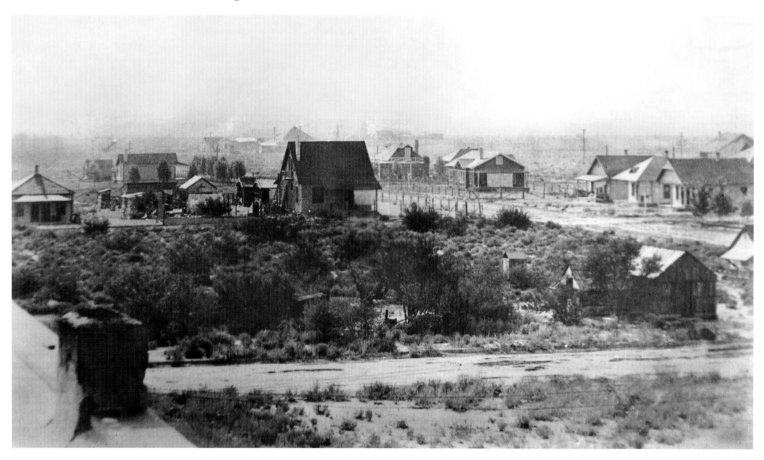

An indication that automobiles had become more common in town by 1910, a traffic sign sits in the middle of Fremont Street. This image is facing west, with the train station at the end of the street.

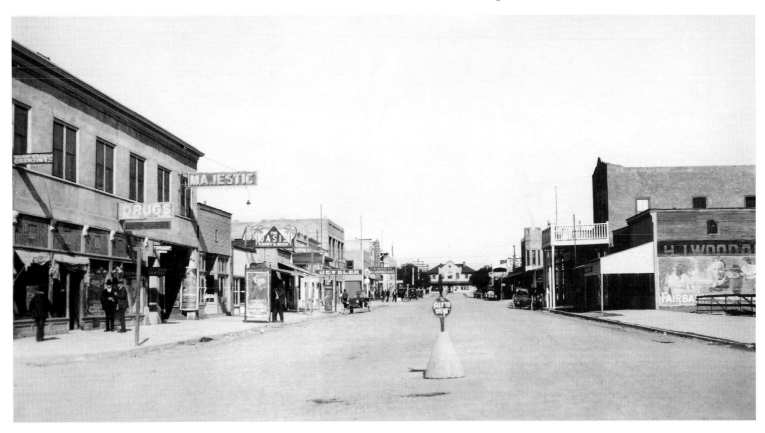

The El Dorado Valley, a mining district southeast of Las Vegas near Arizona, about 1910.

Miners stop their team of burros and covered wagon to check one of the
animals along a dirt road headed west toward Las Vegas, with Sunrise
Mountain in the background about 1910.

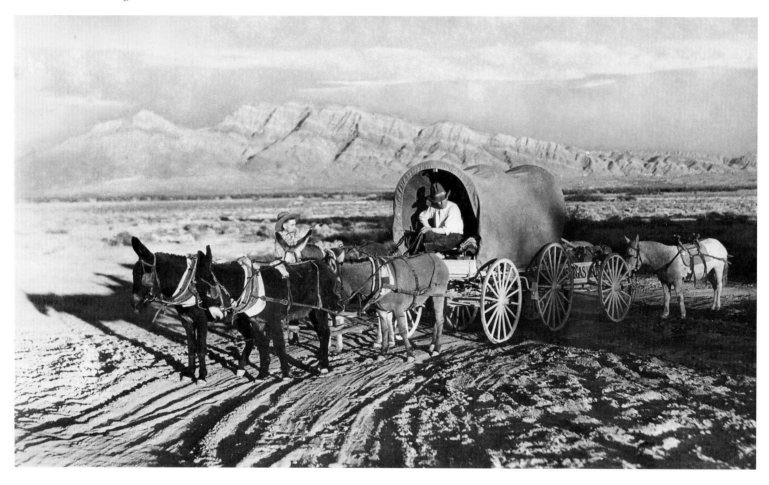

A cowboy tends to cattle and horses on the Stewart Ranch in the early 1900s. Though she sold most of her ranch in 1902 to Clark for the Las Vegas townsite, Helen J. Stewart held onto part of her tree-lined property and remained in Las Vegas until her death in 1926.

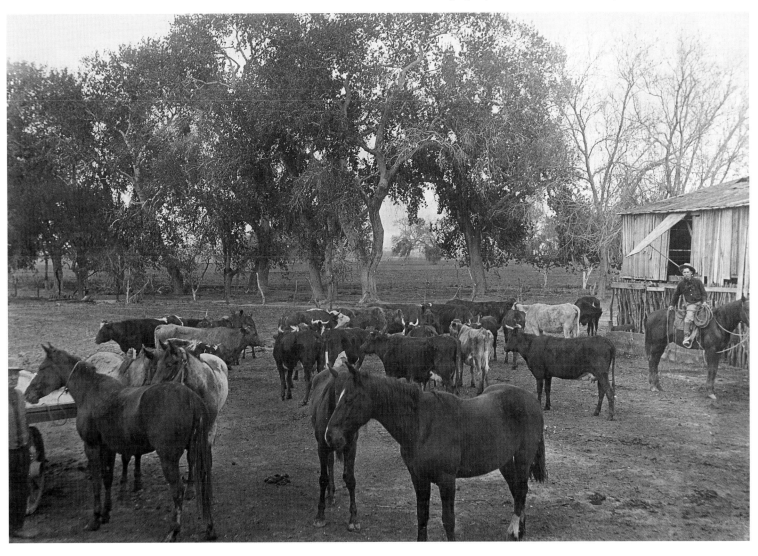

Two early Las Vegas hotels, the Union and the Shamrock, shared a building and merged into one hotel on Main Street in the early 1900s.

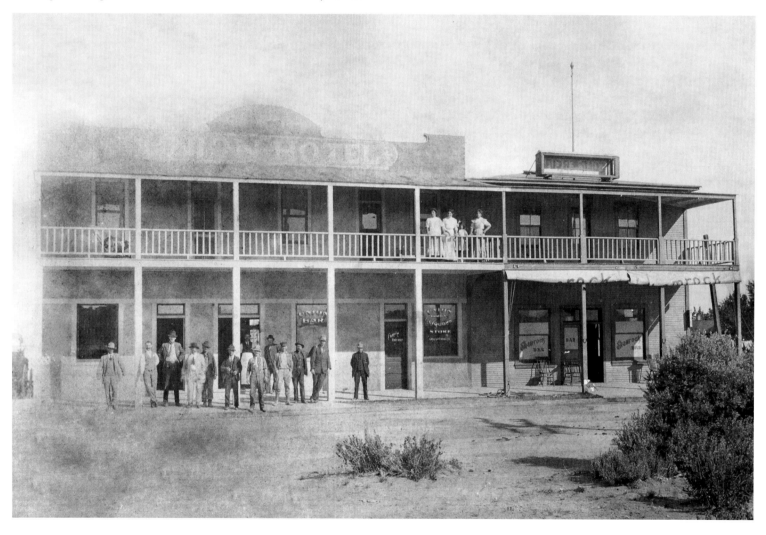

Bartender and hotel owner Joe Graglia stands behind the bar inside the Union Hotel, with a ceiling fan, hanging electric light, and a pool table in 1910. Spittoons line the floor in front of the bar.

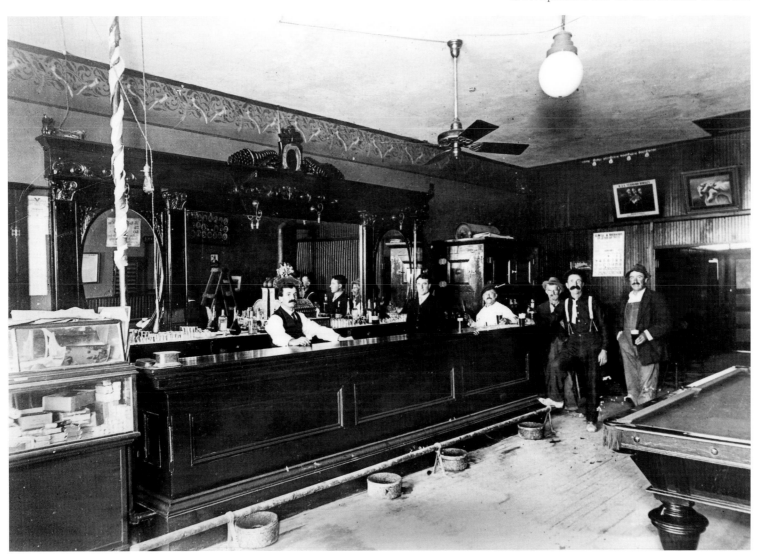

In 1906, only a year after arriving in Las Vegas, Ed Von Tobel, Sr., (standing center), with his partner, Jake Beckley (left, holding wagon reins), had built a prosperous lumber business. They opened on Main Street in 1905 but moved to this location on Fremont and First streets, which was closer to the train station. These buildings burned down in 1914, but the partners rebuilt them.

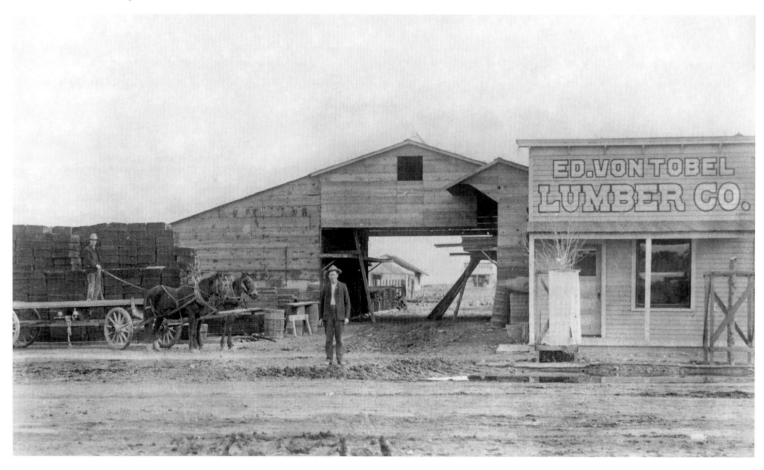

A boating crew from Las Vegas is about to make the journey to the Colorado River, about twenty-five miles to the southeast over rough, dirt roads in the early 1900s. Earl Rockwell is the driver, next to Henry Lutz; Pinky Waite is sitting on the burro; Frank Waite is on the first horse; Eddie Marshall is driving the buckboard and Spud Lake is on the rear horse.

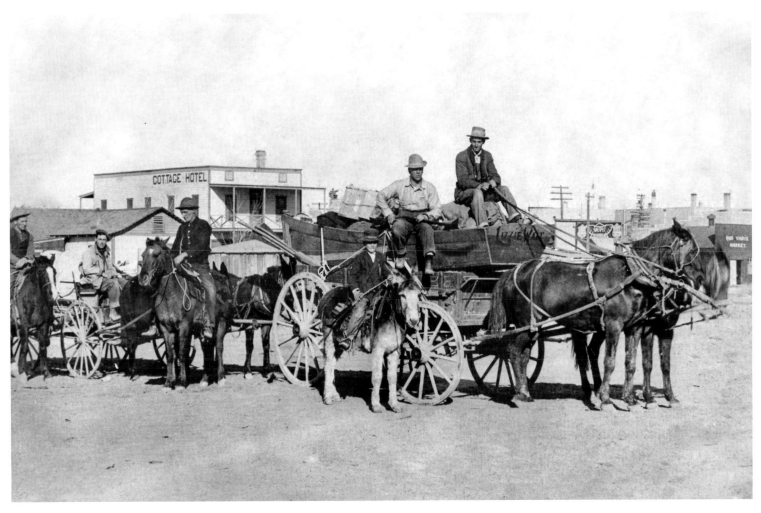

A rear view of the Las Vegas depot of the San Pedro, Los Angeles & Salt Lake City Railroad, as
engineers work on switching an engine and caboose about 1908. The train station, at the far end of
Fremont Street, was fronted by a dirt road and fenced open space (later a park).

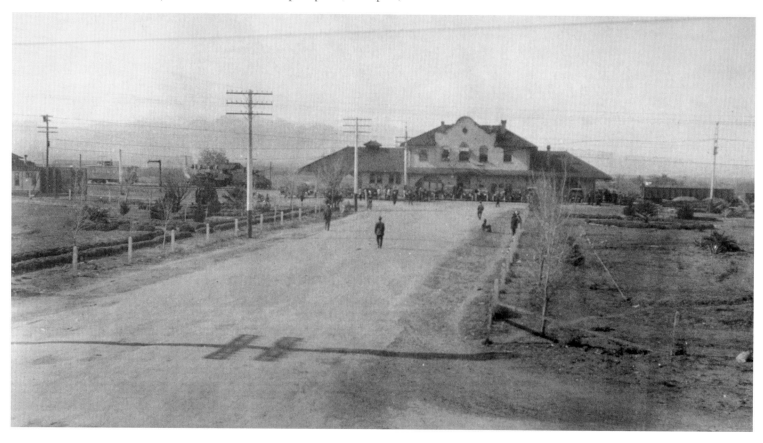

The mission-style rail station, center, stands at the end of Fremont Street, 1909. To the left, a series of steel columns make up the partially completed machine shops of the SP, LA & SL Railroad, which served as the economic center of Las Vegas into the 1930s.

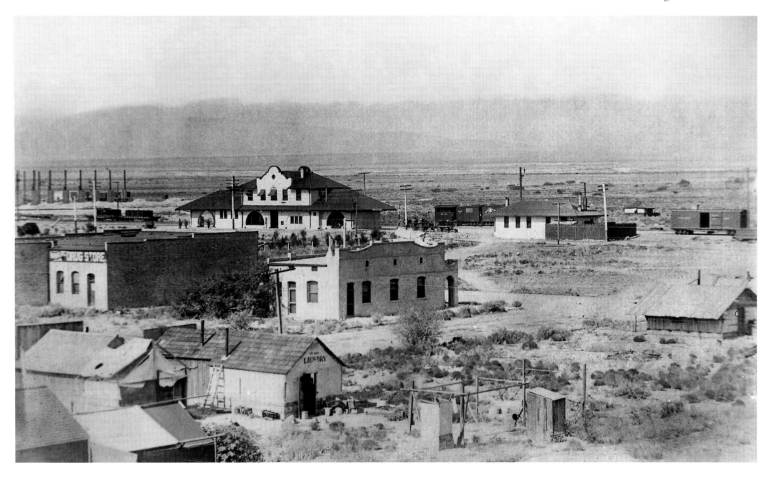

A sixteen-horse team pulls wagons heaped with feed hay and other provisions down Fremont Street, likely on the first leg of the slow, arduous drive northwest to the Beatty and Bullfrog mining districts in the early 1900s.

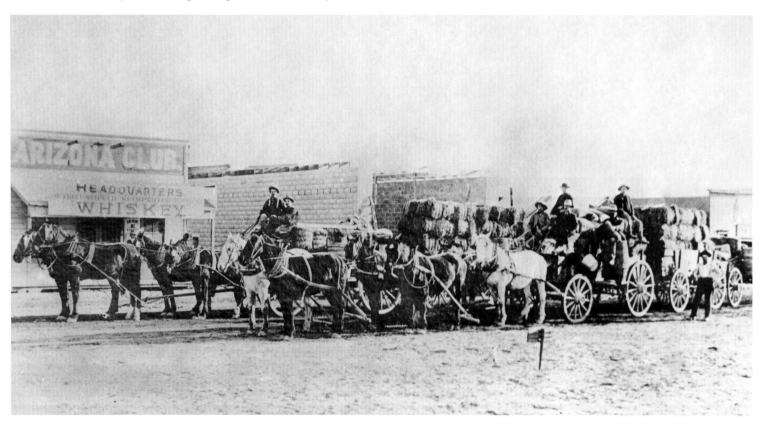

The steeple of the First Methodist Church, far right, is recognizable among structures downtown in this view facing east in 1910.

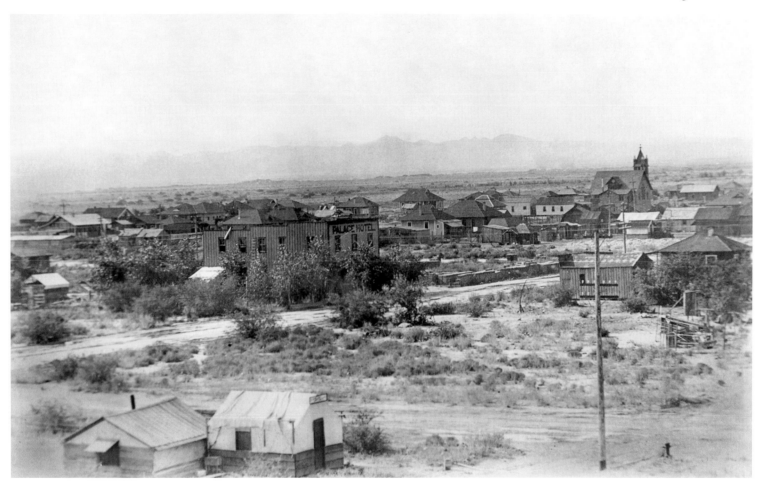

A boy stands between a rail car and the front of the American Railway Express office
at the Las Vegas train station about 1908.

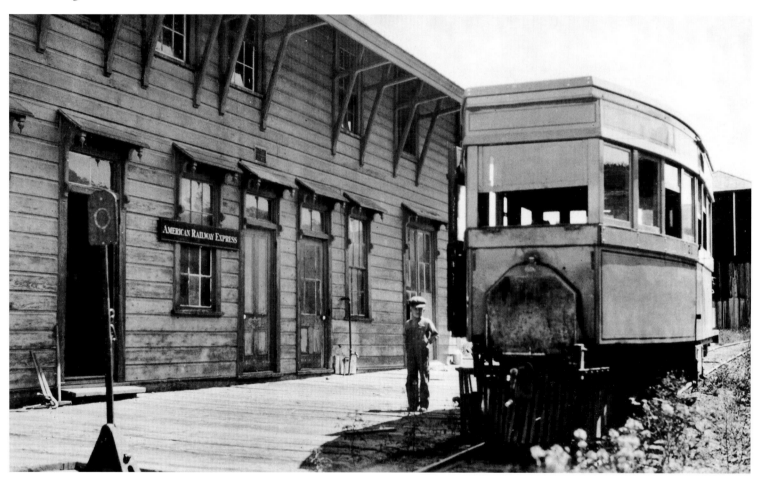

Stores selling furniture, baked goods, and groceries line Fremont Street in this west-facing image from around 1908–1910. The mission-style train depot stands at the end of the street.

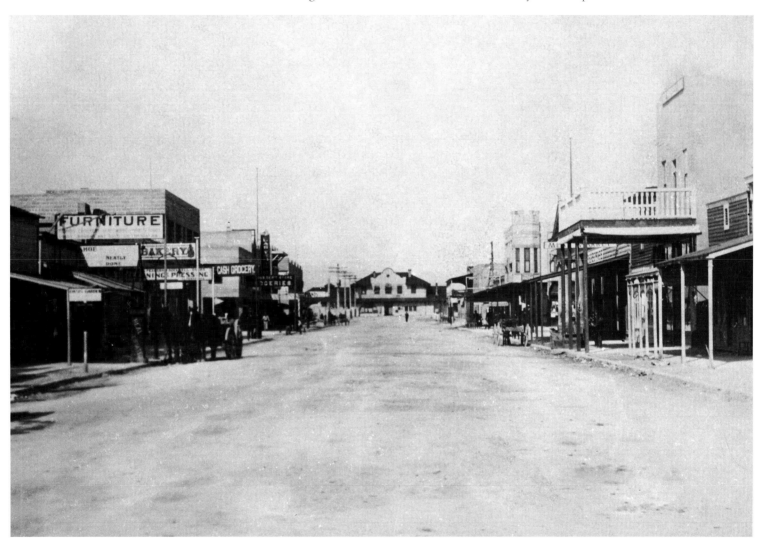

Packed burros are allowed to graze at the Las Vegas Ranch during a break
in a business trip in the early 1900s.

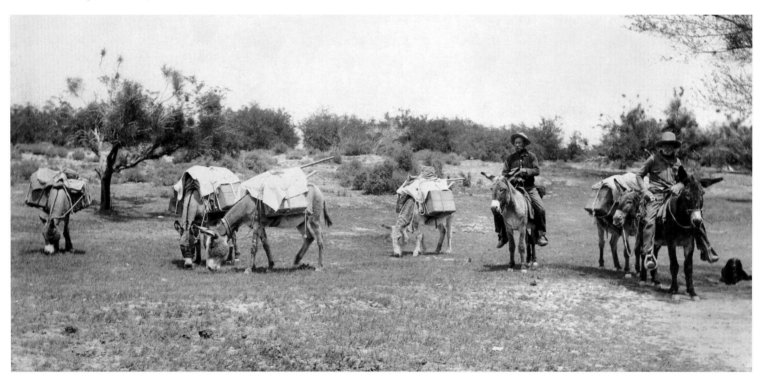

BEFORE HOOVER DAM: MOLDING A DESERT COMMUNITY

(1911–1929)

By the start of 1911, Las Vegas had barely recovered from the effects of a massive flood the year before that swept away about one hundred miles of railroad tracks between Las Vegas and Salt Lake City and took five months to repair. The flood brought the railroad to a halt, and the town's population fell to only 945. Later that year, to foster growth, town fathers convinced the state to allow Las Vegas to incorporate as a city. On June 1, 1911, the city elected Peter Buol, a well digger, as its first mayor, with four commissioners. Buol raised bond money to build a sanitation system. The Fifth Street Schoolhouse opened at a cost of $30,000. The city had bounced back. The railroad built houses for employees, operated a 380-foot, concrete machine shop and a 900-foot platform to unload twenty refrigerator cars at once. By mid-1911, the city had 1,500 residents.

Buol and city officials in 1913 tried to turn Las Vegas into a farming community. In fact, the Keil Ranch, located just north of town, was known for years for the quality of its grape crops, but the generally poor quality, hard alkaline soil of the valley put an end to Buol's plans. The city's economic growth stalled during World War I, when Clark's Las Vegas and Tonopah Railroad to nearby mining districts ended in 1918, along with its workers' paychecks. Meanwhile, to accommodate the growth of motorcars, Las Vegas in 1914 paid to improve its road to Jean, Nevada, and sold bonds in 1918 to expand its roads toward Los Angeles and Salt Lake City.

The city still enjoyed steady, if modest growth. By 1920, there were 2,304 residents, but an unfortunate transition took place in 1921 when William Clark, the railroad's co-owner living in New York, sold his share to his longtime partner, the Union Pacific Railroad. Union Pacific immediately laid off sixty Las Vegas workers. The local railroad workers' union went on strike in protest, returned to work, then joined a national strike. In response, Union Pacific in 1922 moved its rail maintenance works out of Las Vegas north to Caliente, eliminating three hundred local jobs. Many people left to seek work.

Regardless, Las Vegas did experience progress in the 1920s. A local airport built in 1921 started receiving aircraft, and in 1926, the first plane bearing airmail arrived, creating a regular delivery service from Los Angeles. The air carrier, Western Air Express, also began offering passenger service to Las Vegas, which became a refueling hub for planes headed elsewhere.

But the 1920s would produce an even more profound change in the fortunes of Las Vegas. The U.S. Government was seeking a location for a dam project to prevent flooding in California, divert water for drinking and agriculture, and generate electricity. After considering seventy sites, the choice was narrowed down to two locations near Las Vegas, and Black Canyon, thirty-five miles to the southeast, was ultimately chosen. Las Vegas was the closest city, and residents rejoiced. In 1928, Congress approved the site for what would be a $49 million dam, bringing hundreds of nearby jobs, new businesses, and development. Thanks to this coming prosperity, Las Vegas would no longer be dependent on its railroad.

Residents inspect the burnt remnants of the Overland Hotel, destroyed by fire in 1911, at the northeast corner of Main and Fremont streets, across from the Hotel Nevada. The Overland was later rebuilt and became one of the town's best hotels. The site is now home to the Las Vegas Club hotel-casino.

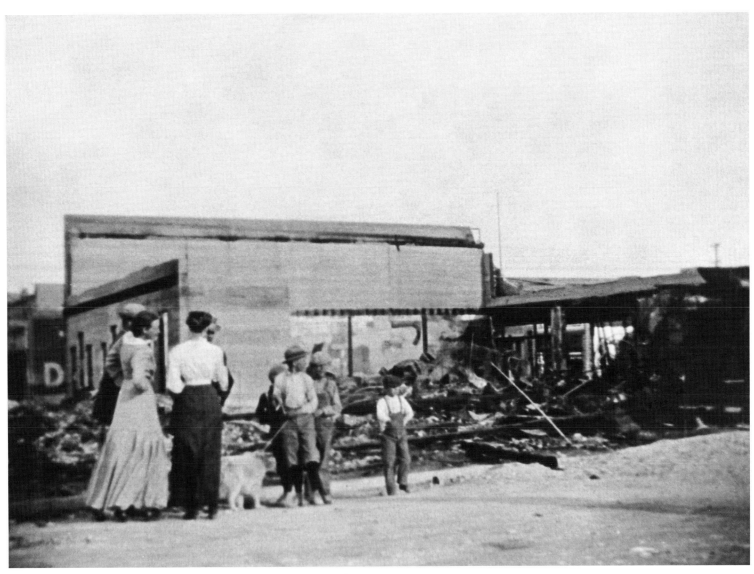

Early automobiles, like this one photographed around 1912, became a more common sight after 1910, but the long trip on poor roads from anywhere to Las Vegas—almost isolated except for its railroad—was only for the sturdiest motorists and automobiles.

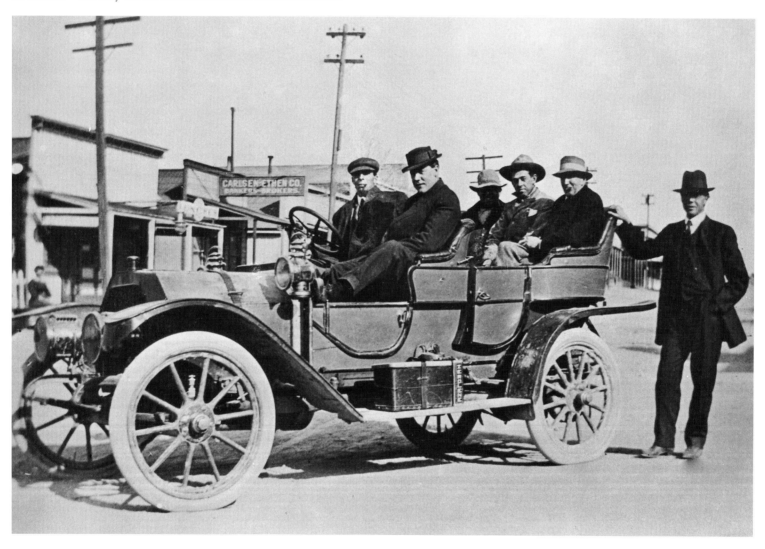

White-uniformed members of a parade band stand beside a group of curious children in the center of Fremont Street at First Street on Labor Day in 1914. A decorated column of the First State Bank is at left.

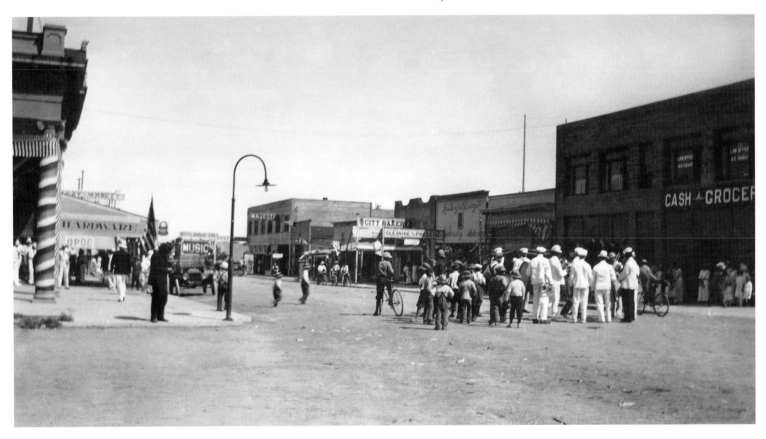

Using new technology to emphasize speed, a laundry business offered one of the first motorized delivery services in Las Vegas in 1914. The smiling driver is Joe Dunlap, brother of Mrs. Dave Farnsworth, whose husband, Dave Farnsworth, owned Troy Steam Laundry.

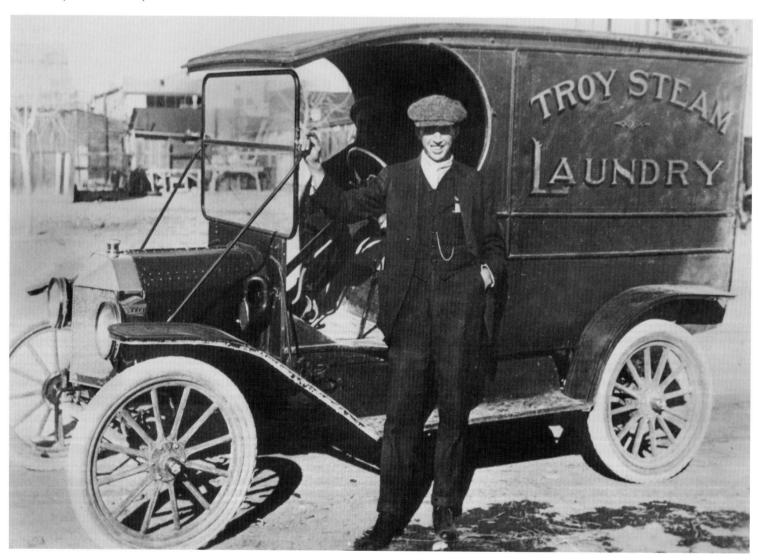

Moving pictures arrived in Las Vegas in the early 1910s. A well-dressed woman walks by the Majestic Theater in 1913 or 1914. The sign on the sidewalk advertises what was showing at the time: the Western movie *Bar-K Foreman*, which was released in late 1912.

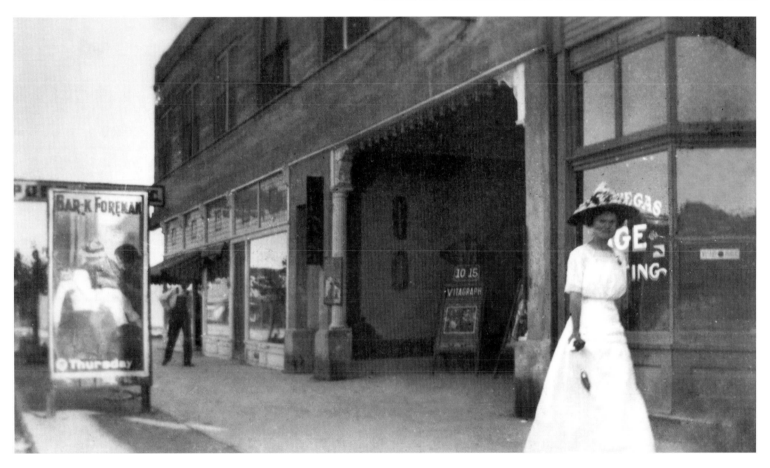

A rare Las Vegas snowstorm that covered downtown streets in 1915 didn't seem to discourage these motorists, who drove and parked on Fremont between First and Main streets.

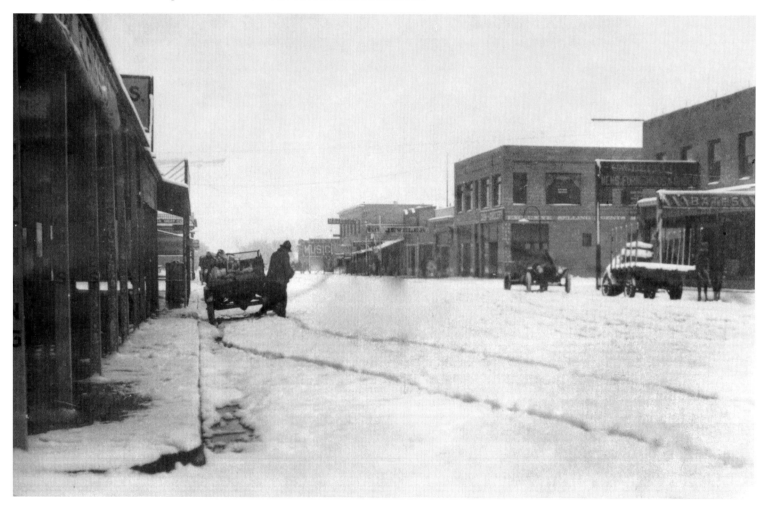

Students of the Fifth Street Grammar School, some bearing American flags, walk in a circular line on their way to morning classes as one ties a rope to a long flag pole about 1915. The school had both high school and grammar level students until 1930. A block to the west (center) is the tower of the First Methodist Church.

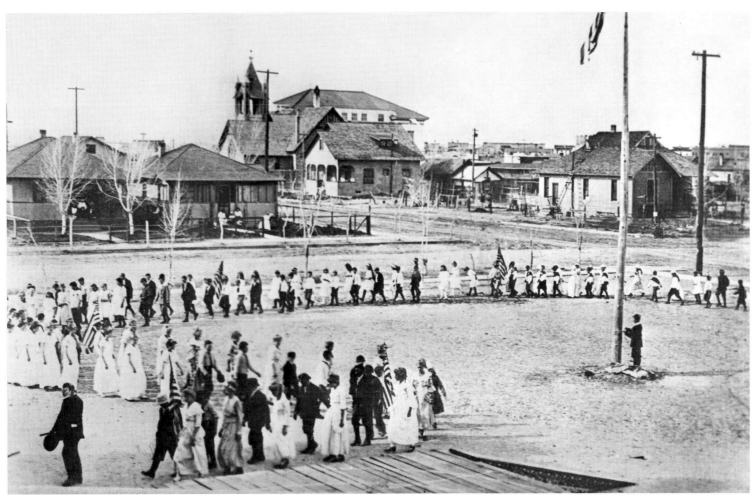

On Fremont Street between First and Second streets, looking west about 1915. Automobiles had become the dominant form of transportation and servicing them at places such as the Las Vegas Garage machine shop was a big new business. With no air conditioning, driving in the open-air cars was a miserable experience in the desert summer months.

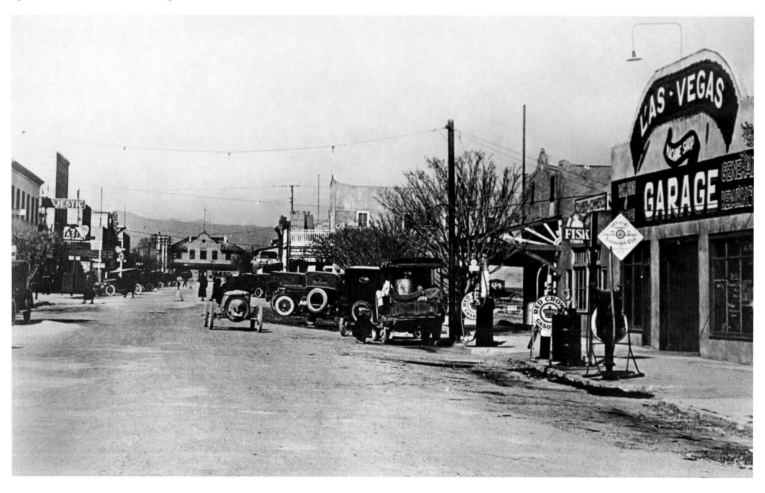

Las Vegas' first solid-built hotel, the Hotel Las Vegas, at the southeast corner of Main and Fremont, also housed this barbershop run by William J. Reid, standing, center, in 1916. This photograph was taken with the aid of a flashlight, which startled Reid's daughter, Mary (center right), who closed her eyes. In the rear is Reid's partner, George Sanderson.

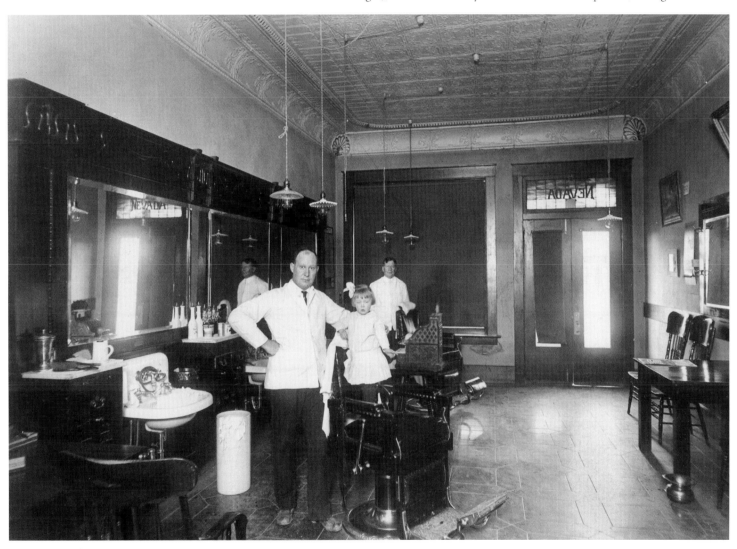

People along Fremont at First Street watch as the Colossal Shows circus parades east to advertise its upcoming show, about 1916. Thomas' Department Store is at right.

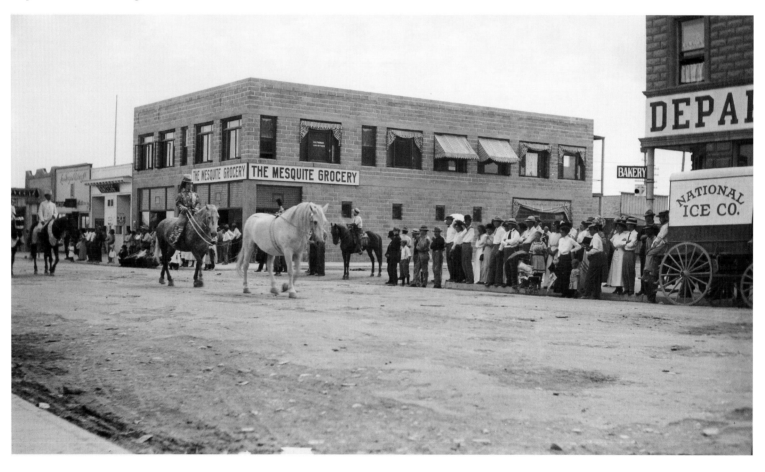

Elephants double as billboards advertising local business during the parade for the Colossal Shows circus on Fremont Street, about 1916.

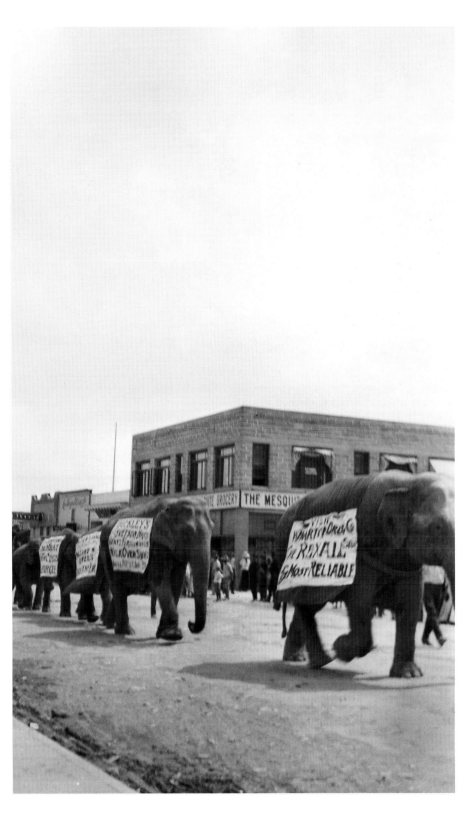

Smoke billows from the railroad station at the end of this westerly view of Fremont Street about 1917. At left in the distance is Berkley's Mens Store, and then the Hotel Las Vegas. The First State Bank is at far right, and across First Street is the Las Vegas Pharmacy, where Dr. Roy Martin oversaw a small hospital on the second floor.

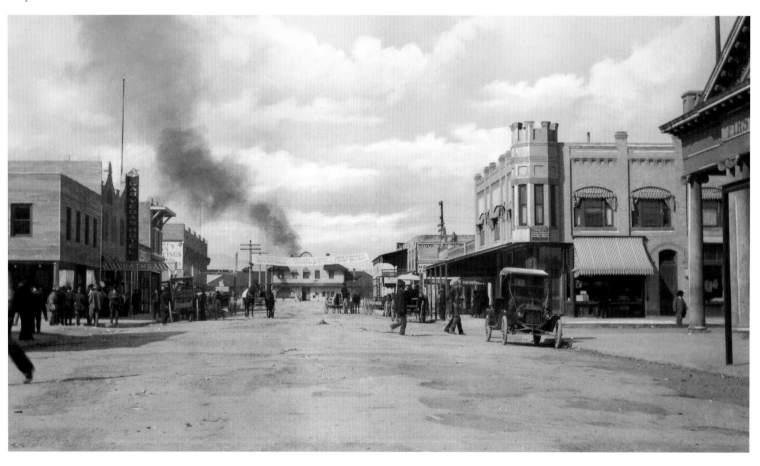

Nurses in apron-like uniforms stand outside the San Pedro, Los Angeles & Salt Lake City railroad station in the early 1910s.

A regiment of U.S. Army troops during World War I parade past the post
office on Fremont Street in 1917.

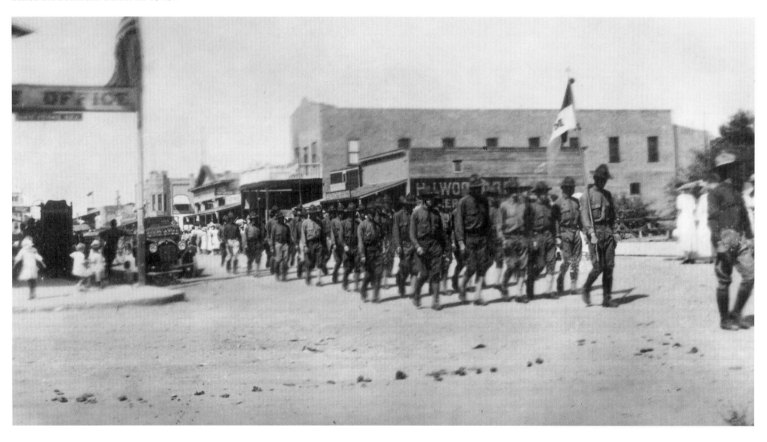

Local families felt the impact of World War I, as some of the town's young men were drafted into the military. Here, in 1918, family members and friends stand at the Las Vegas train station to say farewell to draftees, headed for service during the European war.

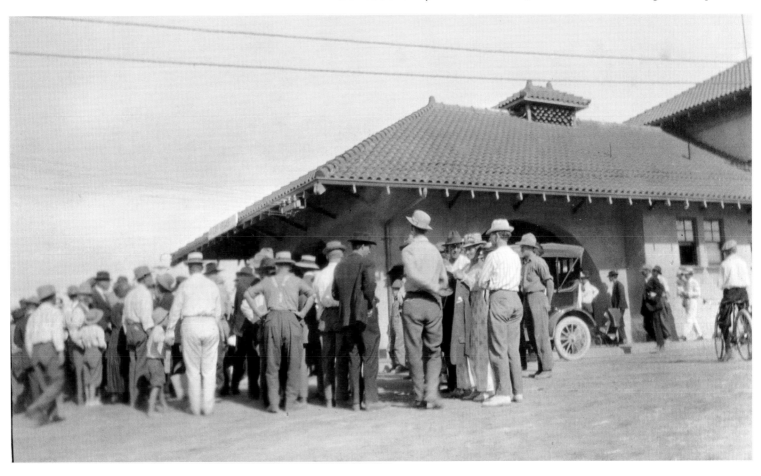

The first load of manganese ore from the Three Kids Mine several miles east of town passes the W. R. Thomas building and the Las Vegas Pharmacy on Fremont at First Street in 1917. Manganese metal was used to make bullets in both world wars. The mine operated until 1961 near what today is the Las Vegas Wash, a wetlands preserve.

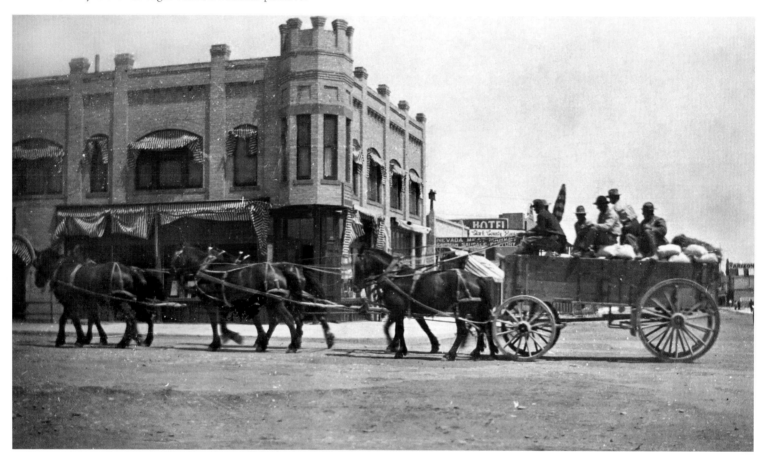

This motor vehicle was used around 1918 to haul wagons loaded with heavy manganese ore from the Three Kids Mine. Miners extracted as much as three hundred tons of ore a day from the operation, a Las Vegas-area contribution to war production during World War I.

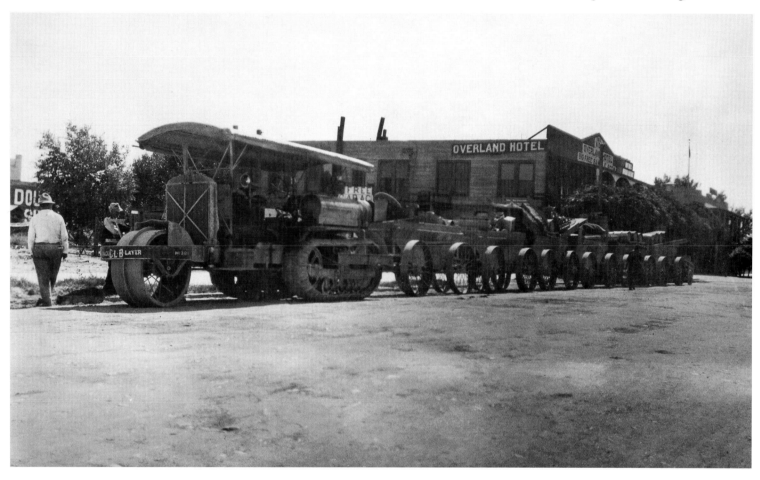

Facing a large—but reversed—American flag, Las Vegas residents listen to
a speech during a Fourth of July celebration in 1918 or 1919.

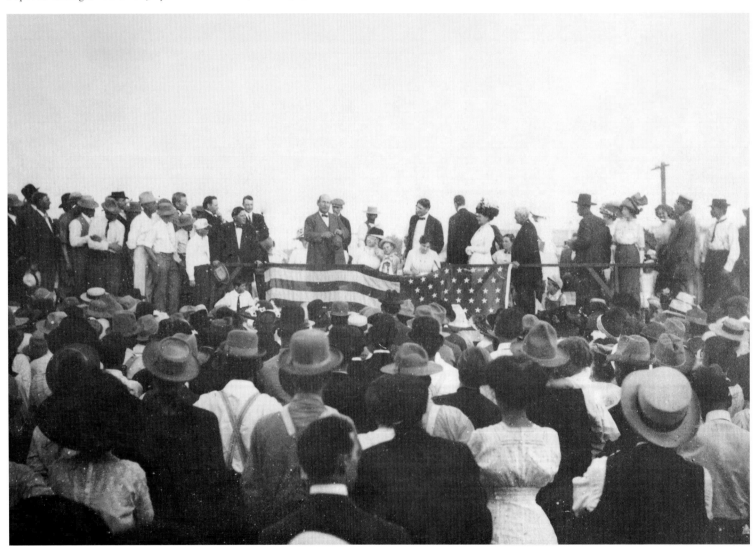

The first airplane to land in Las Vegas, a biplane, touched the ground on May 7, 1920. Regular air service, delivering mail from Los Angeles, started in 1926 at the Rockwell Airport two miles south of downtown, at a site next to the present-day Sahara Hotel.

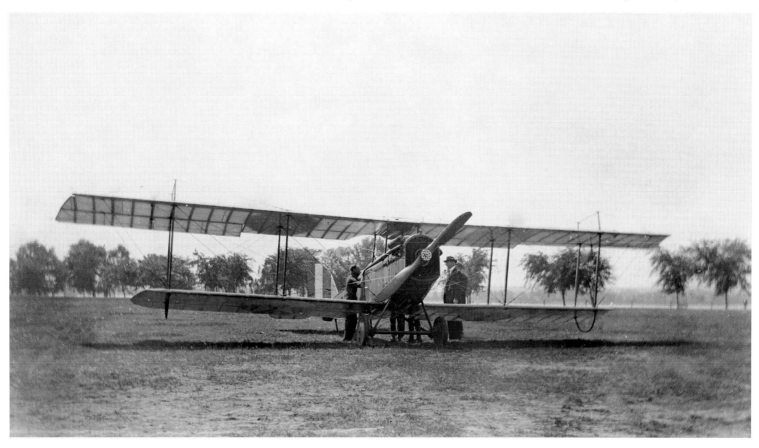

Snowfall in 1921 covered trees, cars, and ornate, electric street lamps along Fremont Street. The Golden Hotel is at left, with the El Portal Theater across the street.

Autos park at angles on Fremont Street in the early 1920s.

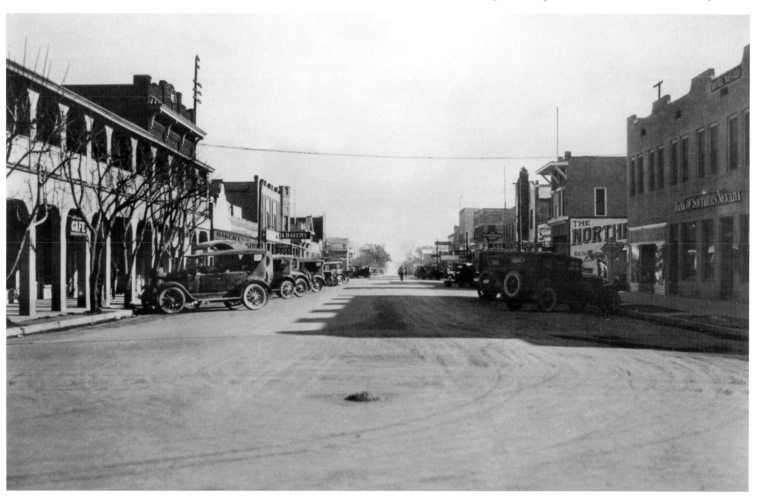

Motorized tourists, with their dog performing atop a packed running board, pose around 1920 outside the front office of the Downtown Campground, owned by Warren Woodward, which offered budget accommodations for campers.

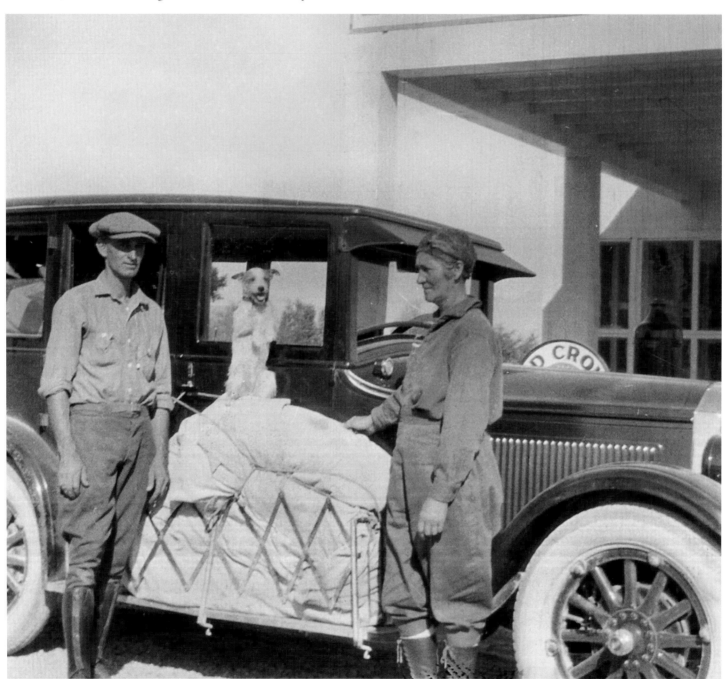

The First State Bank at First and Fremont streets, which would provide loans to home owners and businesses for decades, as it looked in the early 1920s.

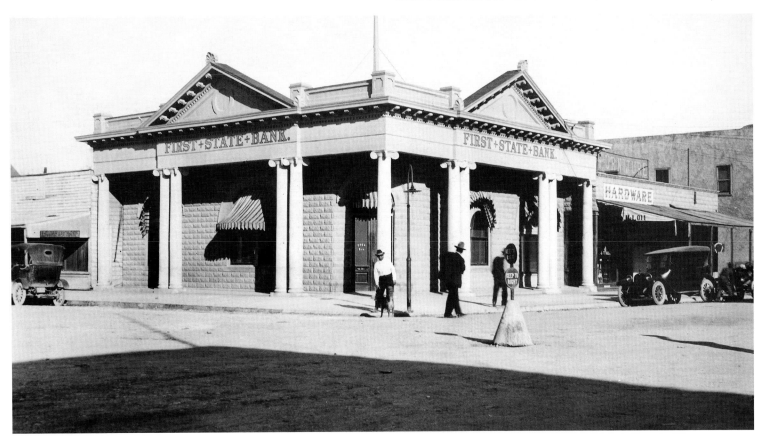

By the 1920s, Las Vegas, with its multiple store fronts and electric street lighting, was maturing as a city, as this westerly view of the first few blocks of Fremont Street shows.

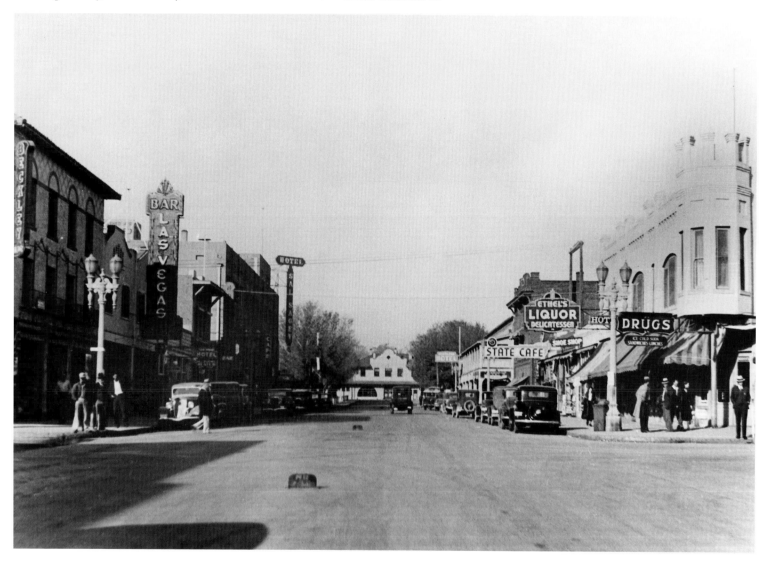

One of the first modern hotels outside the center of town, the Hotel National at 331 Carson Street was established in this two-story building and completed in 1922 by hotelier Joe Graglia.

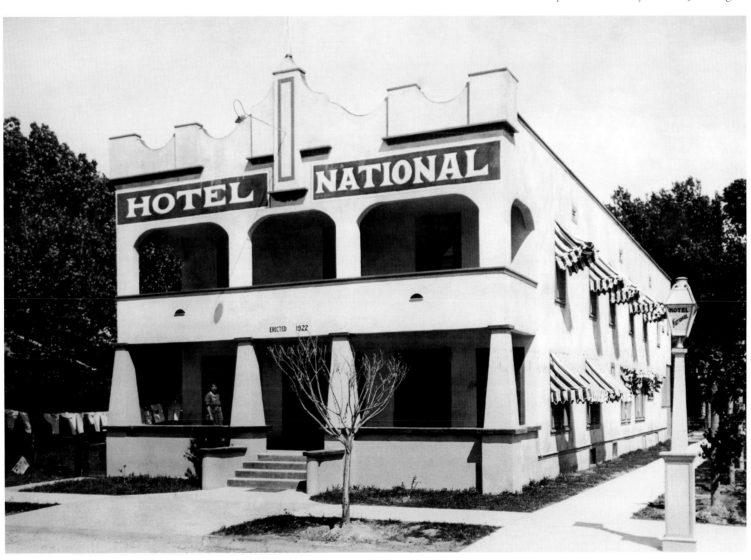

Walking along the tracks after arriving for a visit to Las Vegas, Arizona Governor Thomas E. Campbell attracts a crowd at the train station in the early 1920s. Thomas served from 1919 to 1923.

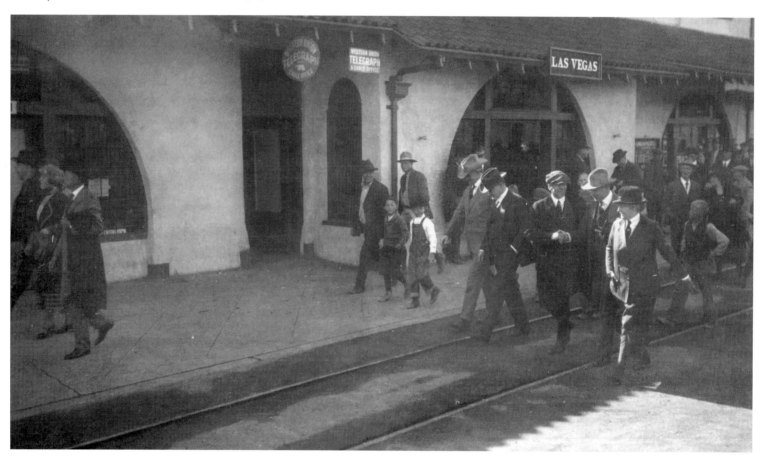

Las Vegas auto seller James Cashman, who moved to town from Searchlight, Nevada, in 1920, set up this car dealership at the Overland Hotel, with some of his models shown here facing Main Street. Cashman's indoor showroom was around the corner, inside the Overland.

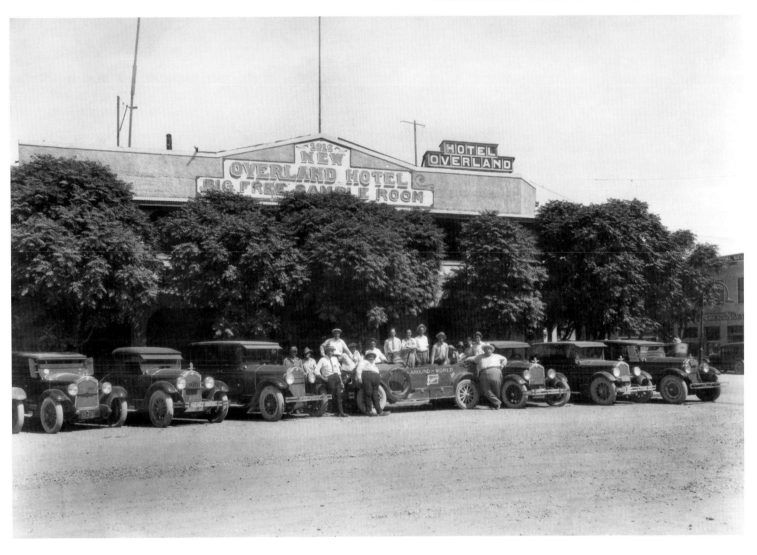

The Conklin Brothers' auto repair garage at 213 Fremont Street, advertising its fireproof, concrete block building, set up shop in the late 1910s. It specialized in servicing cars made by Ford—the largest automobile manufacturer of the time—and by Studebaker.

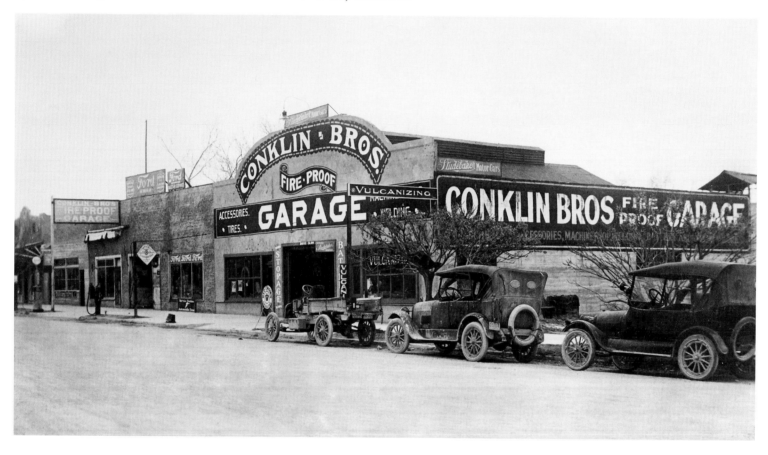

Dressed in a white uniform, an attendant checks a car at James Down's Texaco gas station on Fremont Street in the early 1920s.

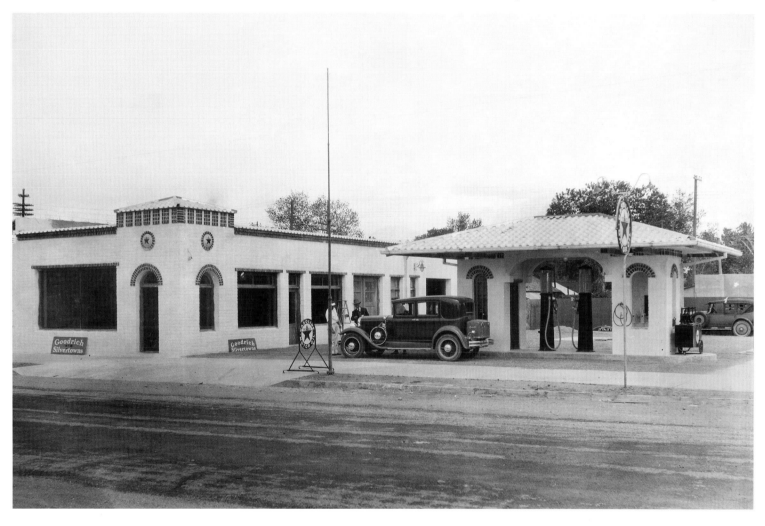

Neon signs glitter beside street lamps at dusk as a pair of pedestrians stroll across Fremont Street in the 1920s. Prominent is the three-story Hotel Apache, the newest hotel in town. The Apache would become the site of Binion's Horseshoe three decades later.

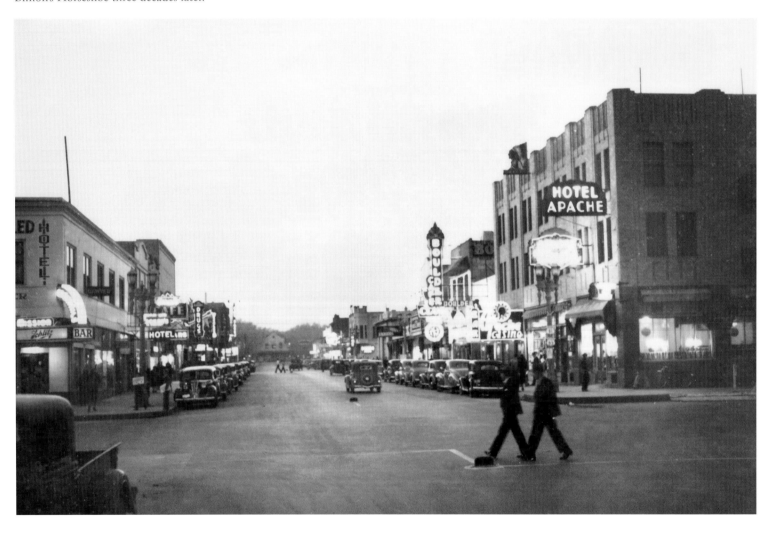

Despite Prohibition, the nationwide ban on liquor sales from the 1920s to the early 1930s, Las Vegas was seldom short of alcoholic drinks, in part due to its remoteness from federal law enforcement. The man seen here in the early 1920s leaning against a car at a gas station at Apex, Nevada, about ten miles northeast of Las Vegas, was reportedly a local bootlegger.

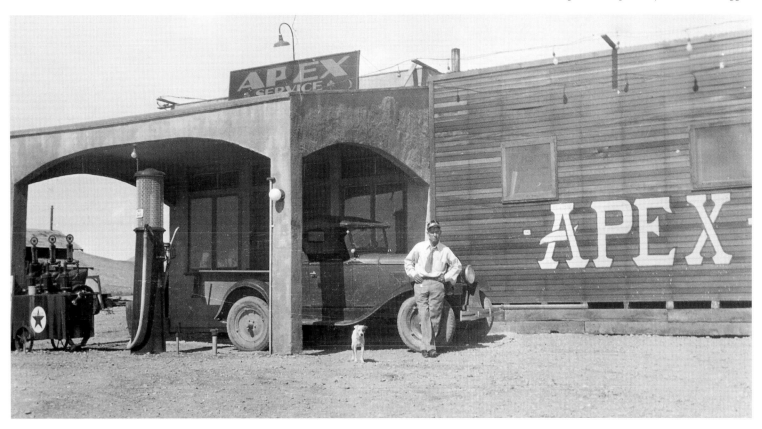

Children in the late 1920s play outside the Fifth Street Grammar School, Las Vegas'
mission-style school built in 1911. Grammar and high school students used the same
building until Las Vegas High School opened in 1930.

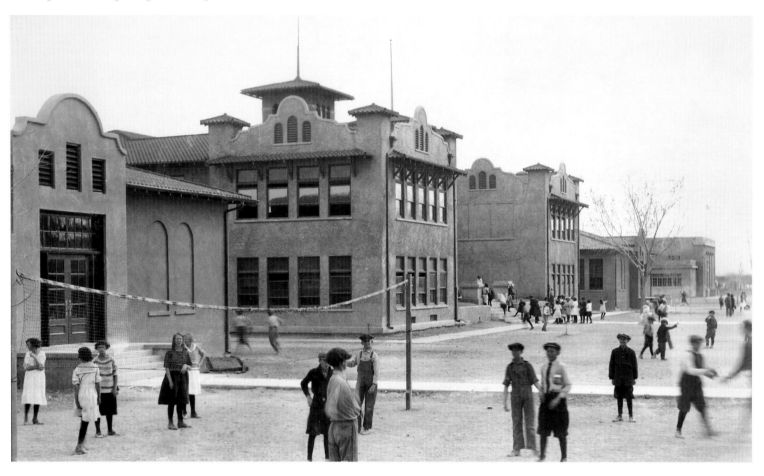

Teachers direct their grammar-school student to join hands in front of the Fifth Street Grammar School in the late 1920s. The classrooms were in the tall building in the center.

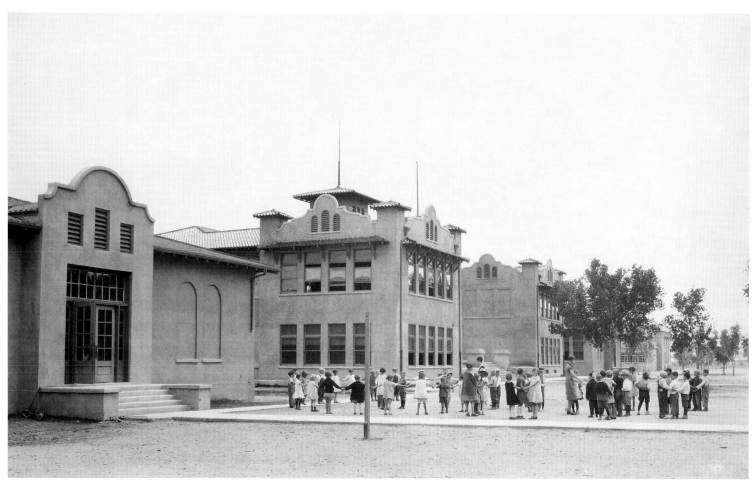

Among the autos showcased outside Woodard's Fireproof Garage, made of masonry on Fremont Street, is one (at left, with number 2) that may have been an early racecar.

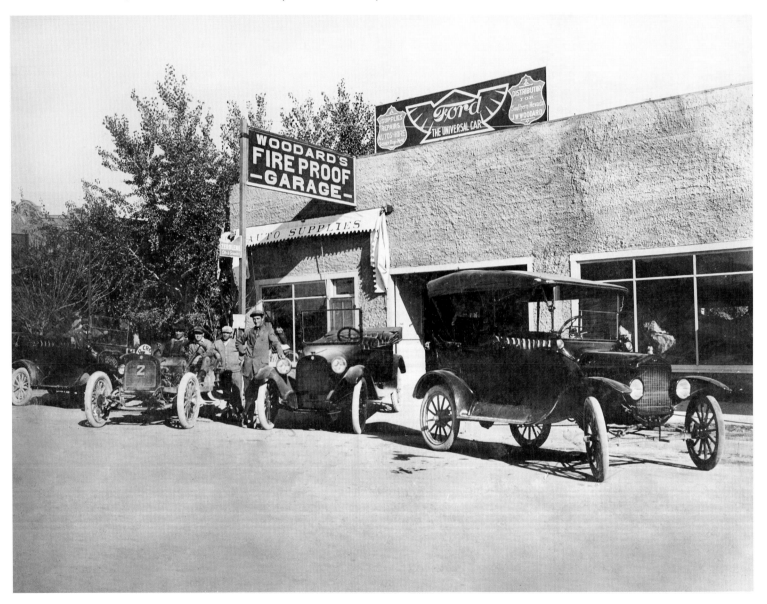

An open-air car speeds past a crowd gathered along Fremont Street in the 1920s.

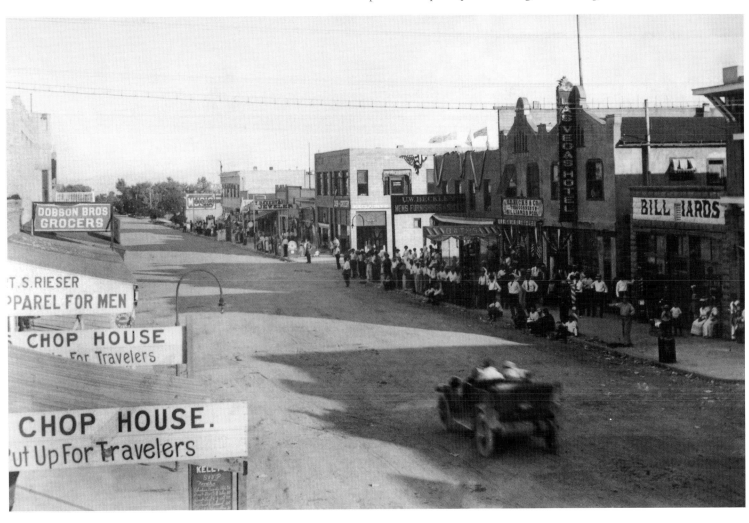

Many trees that used to grow on Fifth Street, at the far eastern edge of town, are seen in the distance at the end of Fremont in the 1920s. The White Cross Drug store operated at Third and Fremont (right).

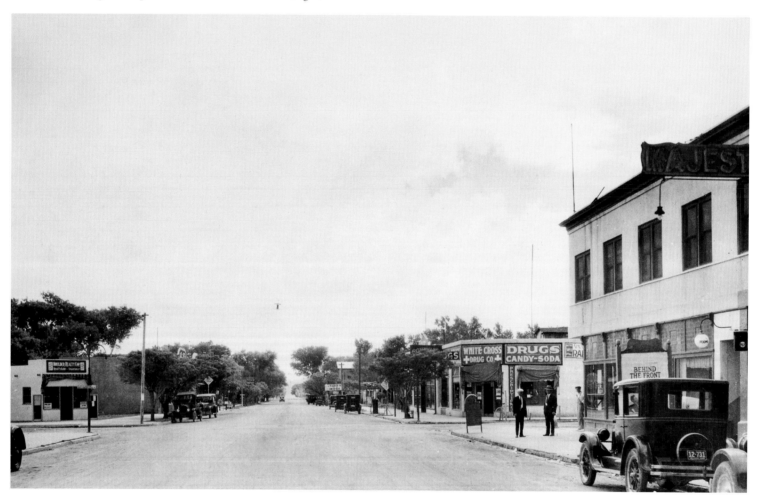

The driver of a truck, parked in front of a business next to the First State Bank in 1926, jokingly asks his five passengers to get off. The man at far right with a necktie is Harley Harmon, an early Las Vegas government official.

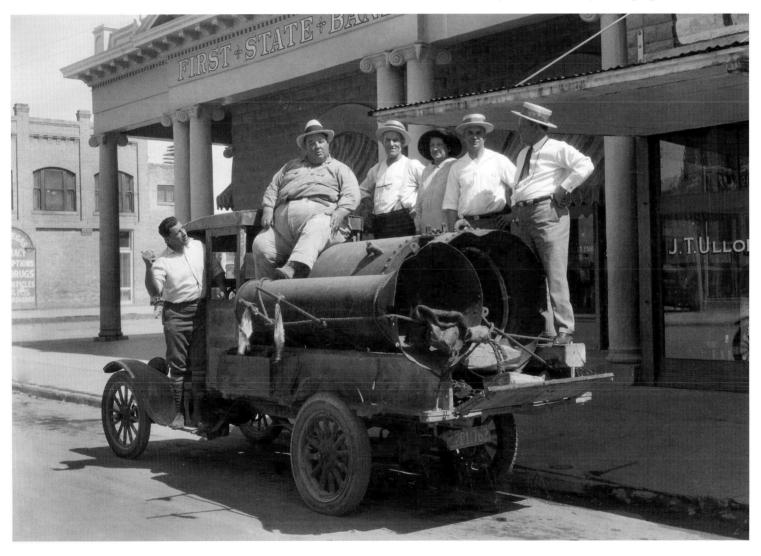

A woman (left) walks toward the lobby of the Overland Hotel in this wide view of Fremont Street, facing east at Main Street, in the mid-1920s. The Hotel Nevada and the Northern Club are on the other side of the street.

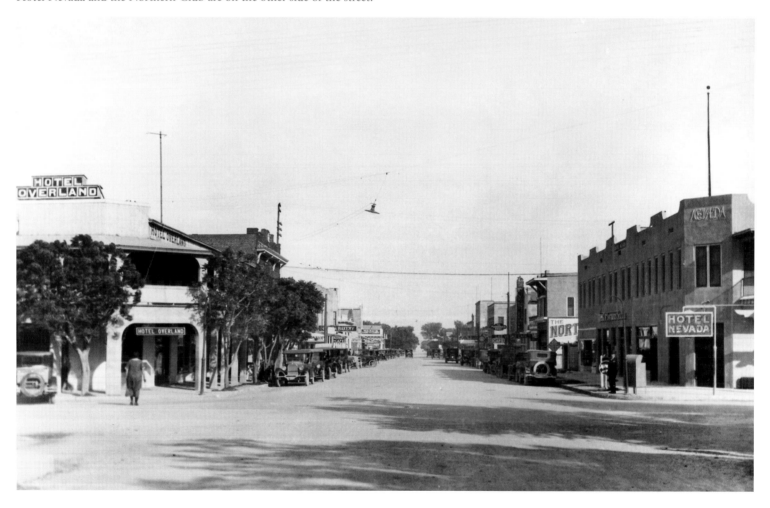

Lines of shade trees cool the Overland Hotel (also billed as the Hotel Overland) at the corner of Main and Fremont streets in the 1920s. The hotel provided space for sales people to leave free samples of their wares for the public.

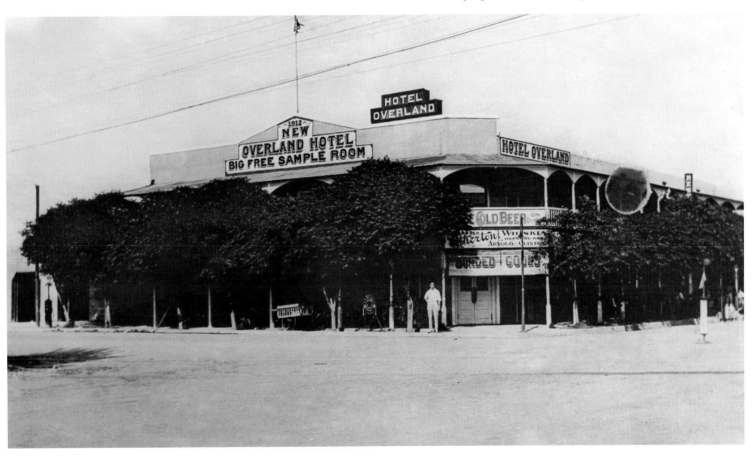

A bountiful crowd of people, some wearing sombreros in the bright spring sun, greet the pilot of a Western Air Express biplane—the first airmail plane to land in Las Vegas, on April 17, 1926, at the Rockwell Airport two miles south of downtown.

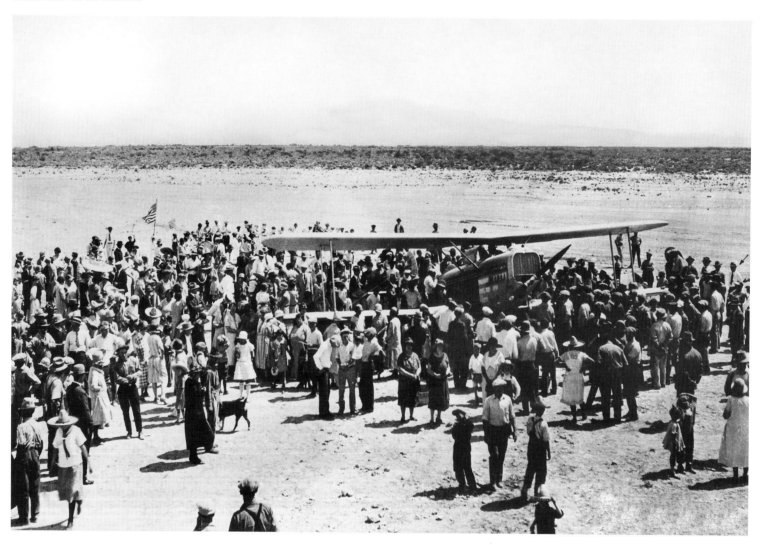

The Western Air Express plane service for the post office, originating in Los Angeles, started making regular deliveries to Las Vegas in 1926. It would land in Las Vegas, drop off the mail, and refuel on its way to Salt Lake City.

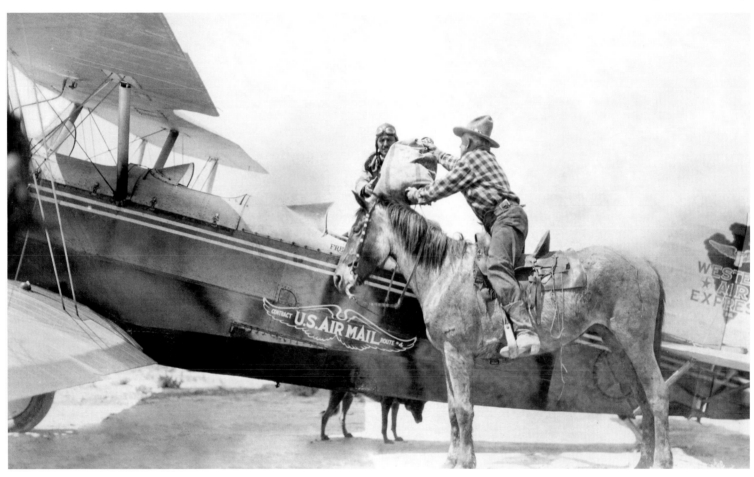

In Nevada to scout out the building site of the future Hoover Dam in the late 1920s, a delegation from the U.S. Bureau of Reclamation arrives in Las Vegas to prepare for a trip south to the site. In an important step for the future of Las Vegas, the bureau would choose Black Canyon, about thiry-five miles to the southeast, and designate public land for Hoover Dam.

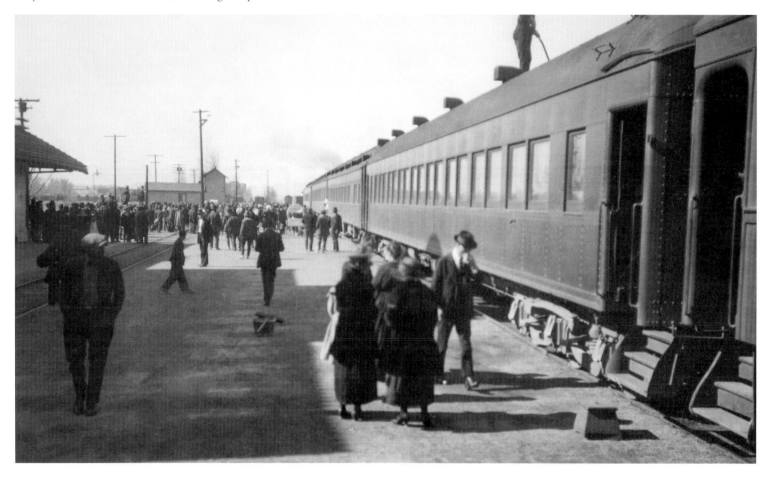

A woman pushing an open baby carriage prepares to cross Fremont at First Street, in this photo dated January 5, 1926. The sign on the building to the right advertises dental services.

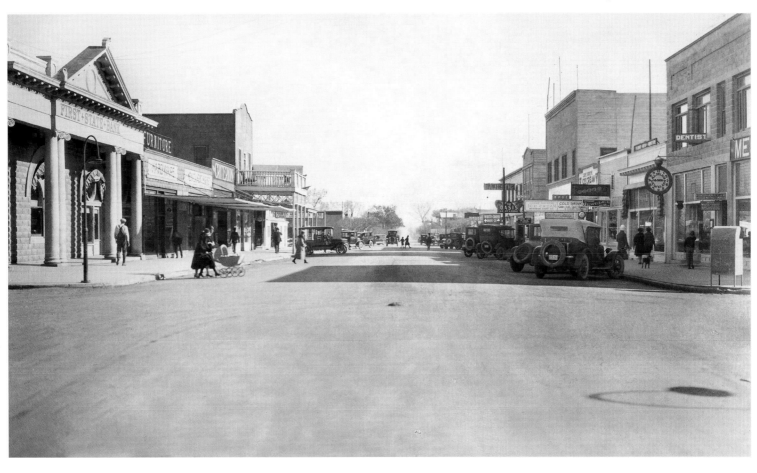

To go with his repair shop on Fremont, the Las Vegas Garage, James
Down also sold Studebaker cars.

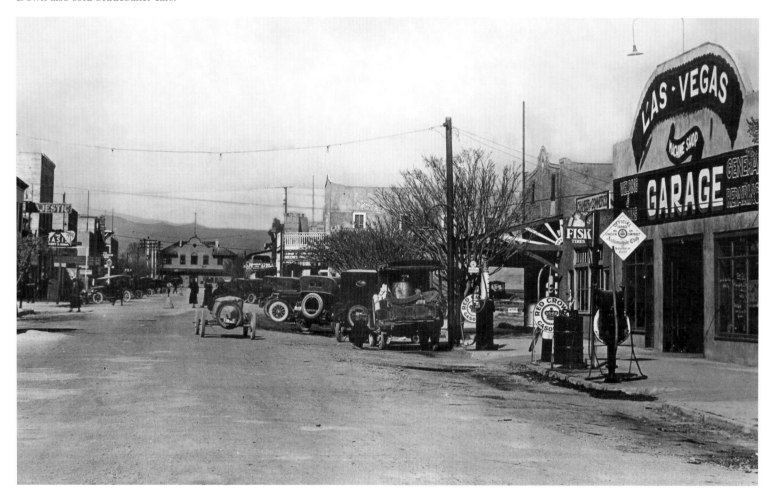

The Hotel Nevada, where the town's first phone was installed in 1906, shared its first floor for a time with the Bank of Southern Nevada in the 1920s. New owners changed the hotel's name to "Sal Sagev"—Las Vegas spelled backwards—in 1928. The business has always had a good location at Main and Fremont. Renovated and renamed the Golden Gate in the 1960s, it is the city's longest continuously operating hotel.

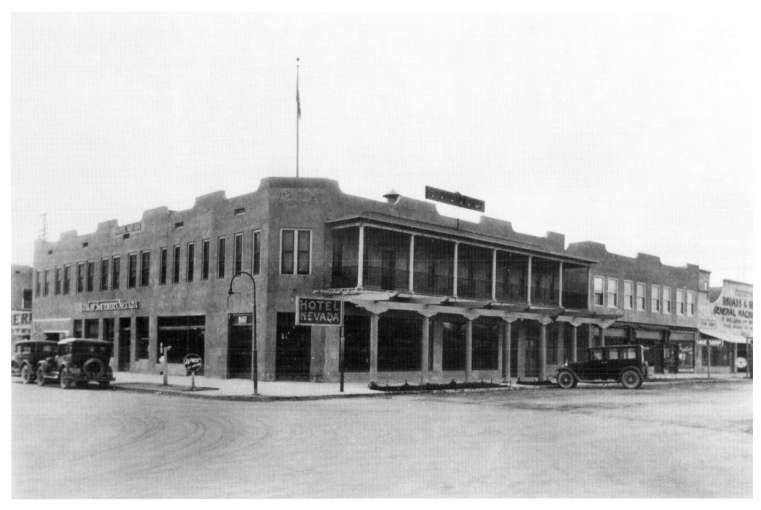

In 1929, American flags and patriotic bunting decorated the Las Vegas depot of the Union Pacific Railroad, which by then had bought out Clark's shares in the San Pedro, Los Angeles & Salt Lake City Railroad. A direction sign shows the miles required to travel to cities to the east, starting on Main Street.

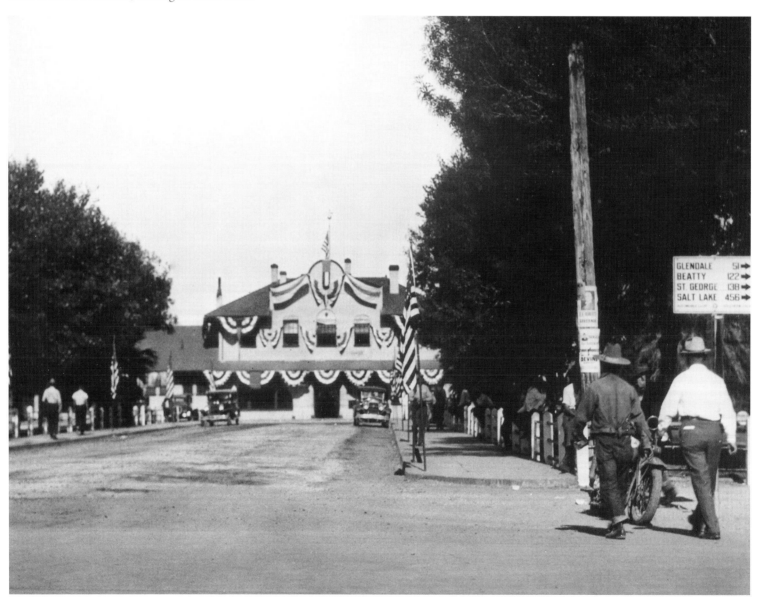

An officer gets the attention of an airport worker between lines of Army Air Corps planes at Rockwell Field outside Las Vegas in 1929. Sunrise Mountain, directly to the east, is framed between the planes in the background.

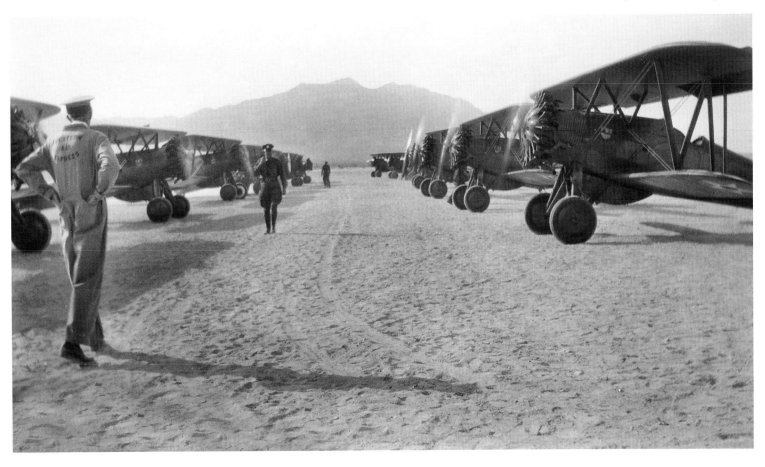

Las Vegas resident Maurine Wilson (right) stands beside planes parked at Rockwell Field. Area pilots were called to help with the search for pilot Maury Graham, whose biplane had crashed on January 10, 1930. His body was found six months later. He had flown the first airmail delivery plane from Las Vegas, in 1926.

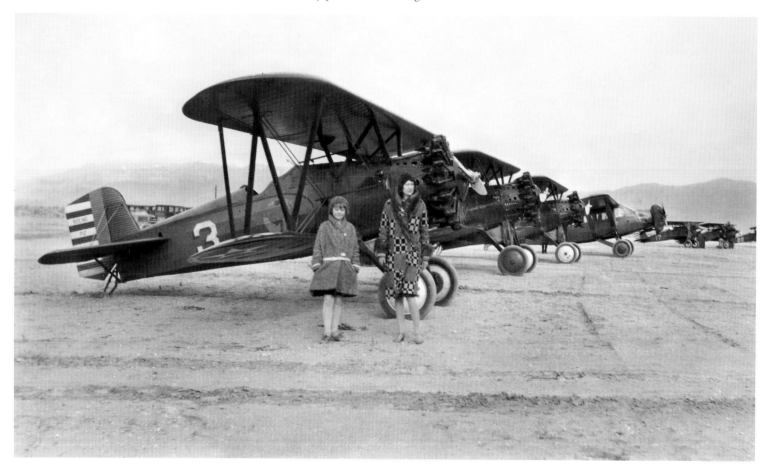

HOOVER DAM, GAMING, AND THE EARLY LAS VEGAS STRIP

(1930–1949)

The 1930s would be a standout decade in Las Vegas history. In anticipation of the growth that would take place from construction of Hoover Dam, the city of Las Vegas planned many local improvement projects, often borrowing money by selling bonds. In 1930, local developers built an estimated thirty new buildings. The city in 1931 issued $165,000 in bonds to repair streets and $115,000 to expand its sewer system to more neighborhoods. Also that year, three partners raised $100,000 to construct the city's first modern hospital, on Eighth and Ogden streets.

But other opportunities soon appeared for the taking. Despite Prohibition, establishments that served liquor illegally were common throughout the country, and by 1930 Las Vegas was well known for its bars and speakeasies—and for gambling, both legal and illegal. The town also tolerated the brothels on Block 16. In 1931, federal agents raided some of the speakeasies, but major changes occurred within two years. First, Nevada legalized casino gambling to stimulate business in 1931. Within days, the city issued rules and licenses for six, then ten, small casinos on Fremont Street. One, The Meadows, became the area's first top-class hotel-casino. To foster more visitor spending, the state also reduced the minimum residency for a Nevada divorce to six weeks. The next boon to the city was the national repeal of prohibition in 1933. Soon, Las Vegas started its popular culture of twenty-four-hour drinking and gambling.

With so many new entertainment options, and the building of the remarkable Hoover Dam, Las Vegas realized a surge in tourism, which reached three hundred thousand people in the mid-1930s. The dam, 1,244 feet long at its crest, 660 feet thick at its base, and 45 feet thick at its crest, was the biggest local attraction, and tourism continued to swell after President Franklin Roosevelt spoke at its dedication in 1935. The city's reputation as an alternative to Reno for divorces grew in the late 1930s after film actor Clark Gable's wife got hers in Las Vegas. Casinos were permitted to operate in nightclubs on Highway 91, or what casino owner Guy McAfee nicknamed "the Strip," after the Sunset Strip in Los Angeles.

In 1940, just before World War II, the federal government decided to build a military airport for the Army Air Corps. Local governments and private individuals negotiated and bought the airport (today's McCarran Field) used by the Western

Air Service and leased it to the Army for $1 a year in 1941. The military used it to train pilots and air-to-air machine gunners on bombers and called it the Las Vegas Gunnery School. Within a year after World War II started, the school was training an average of four thousand pilots and crew every six weeks. The Army spent $25 million on housing and other support structures. The impact on the city's fortunes was huge. By 1945, the training facilities in and around Las Vegas employed thirteen thousand people.

One important business during the war was the Basic Magnesium, Inc. plant, about 15 miles south in Henderson, Nevada, where ingots of magnesium were extracted from ore taken from nearby Nevada mines to make bombs, airplane parts and machine-gun tracer bullets. The BMI plant employed thousands and was the largest supplier of the metal in the United States. However, the local population dipped noticeably after the plant closed in 1944.

Meanwhile, the first casino resort on the Las Vegas Strip (which was outside the city limits) was the El Rancho Vegas, opened by Thomas Hull in 1941, followed by the Last Frontier hotel in 1942, owned by William J. Moore. Both Western-style resorts had inviting outdoor pools, plus restaurants, shows, and casinos. In late 1946, organized crime figures, led by Ben "Bugsy" Siegel, entered the Strip scene by opening the Flamingo hotel-casino, considered the first resort to offer over-the-top luxury accommodations that the Strip would become famous for. Other organized crime members would figure prominently in future Las Vegas-area casinos into the 1970s. In 1948, the Thunderbird, with mob leader Meyer Lansky as a hidden investor, became the fourth Strip hotel-casino. The Strip, with its new resorts, big-name performers, fancy stage shows, and its exploding visitor volume, had begun to overshadow downtown Las Vegas and would expand dramatically in the 1950s.

Local public school students, including a couple of Boy Scouts, hold flags and signs during a ceremony for the laying of the cornerstone of Las Vegas High School, the area's first high school not connected to its grammar school, on February 22, 1930.

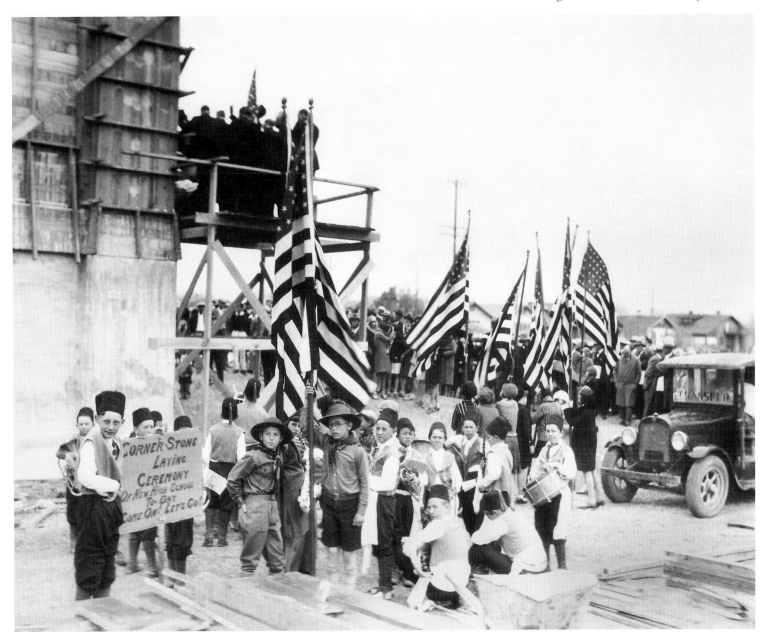

In a shade of Las Vegas' not-too-distant past, a horse-drawn covered wagon, with people dressed in turn-of-the-century period clothing, rolls past spectators and automobiles on Fremont Street during a Labor Day parade around 1930.

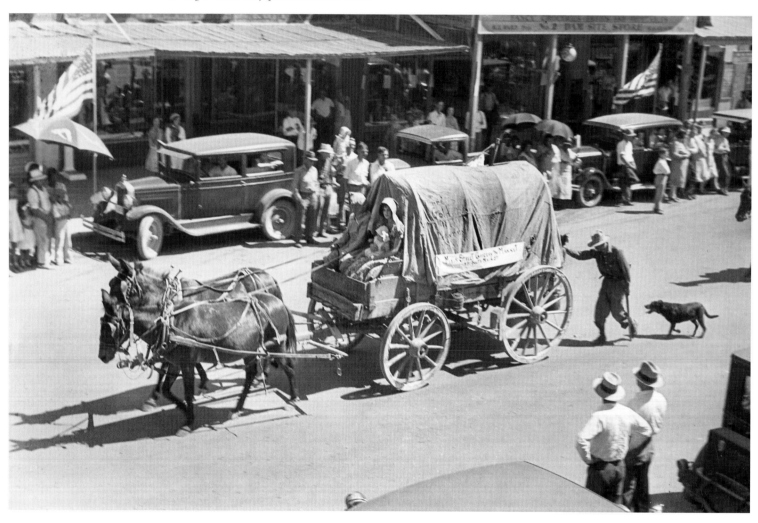

Proud members of the Las Vegas Volunteer Fire Department relax against their motorized fire engine and hose system under shade trees in 1930. The well-respected department remained all volunteer until 1940.

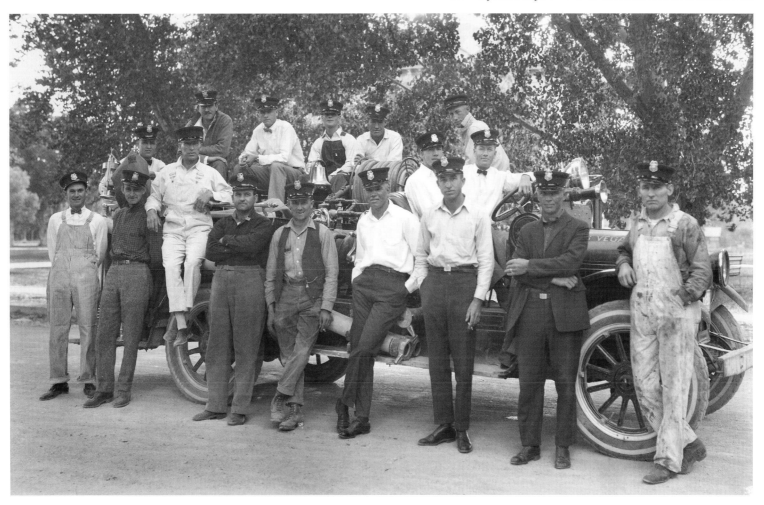

Following Spread: Hundreds of Las Vegas citizens and others, many coming by car (background) and some by bus (far right) cram together in Bracken, Nevada, to hail the dedication of the first laying of railroad track to Hoover Dam, on September 17, 1930. City residents were excited about the major growth that would come from the dam's construction. The trains started running to Boulder City in April 1931. Las Vegas would serve as the main hub for supplies for the immense dam project.

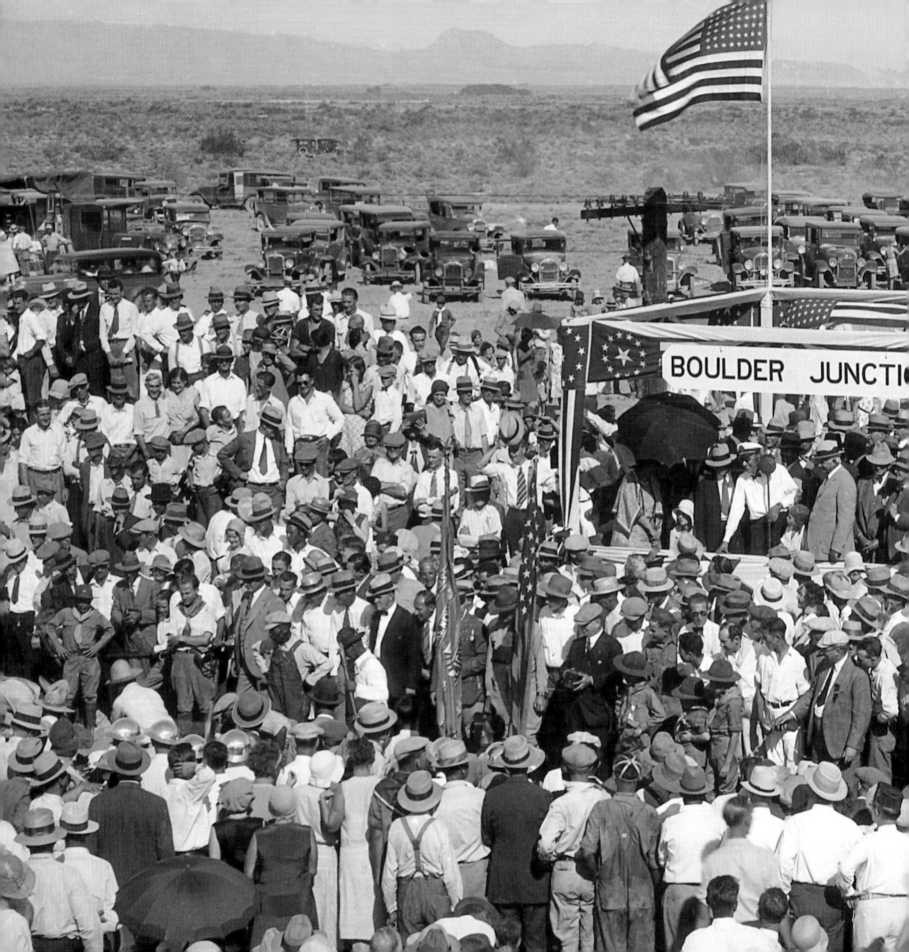

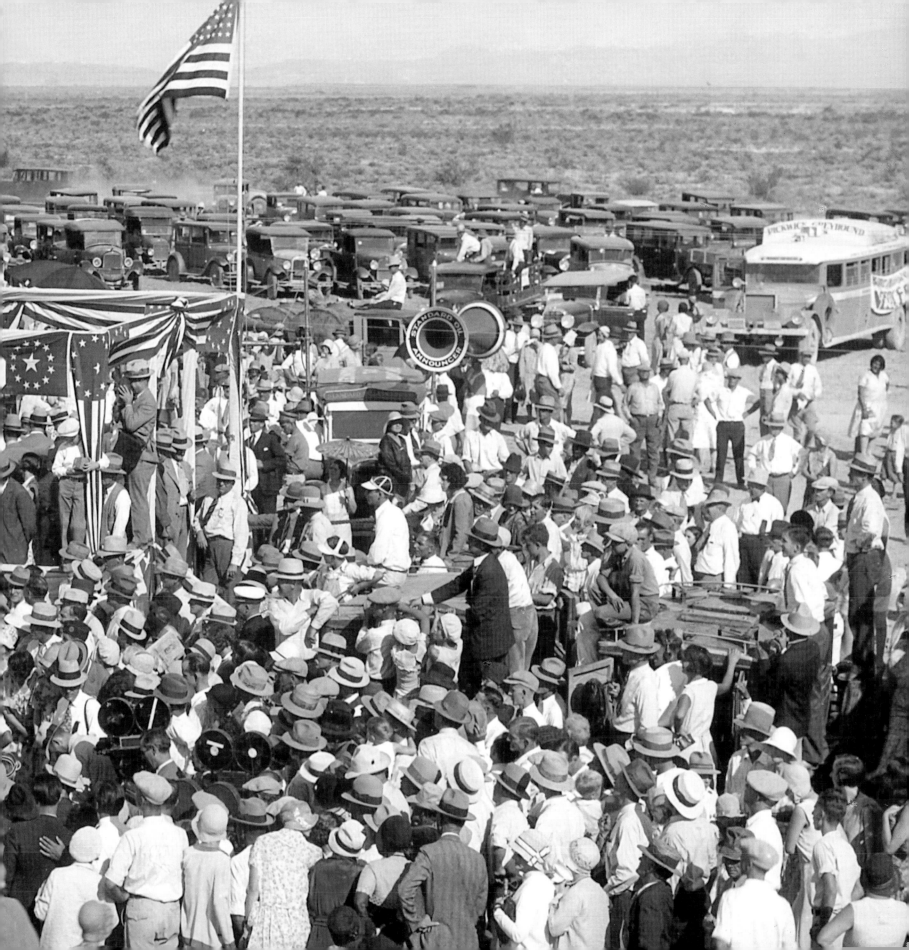

Bunting hangs on the Union Pacific railroad station in Las Vegas to celebrate the start of railroad construction, connecting Las Vegas to Boulder City and the dam site in 1930. Union Pacific would build twenty-three miles of track to Boulder City, and the U.S. government would build ten miles to the dam site. Later that year, Congress approved funding for the dam, and construction bids were opened on March 4, 1931.

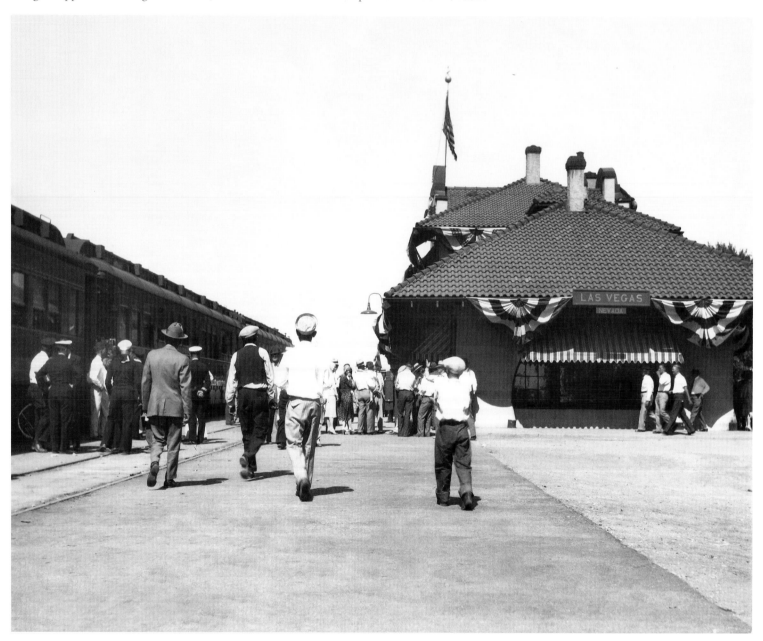

Commemorative decorations adorned the renovated Berkley's Mens store downtown on September 15, 1930, two days before the dedication of the new railroad from Las Vegas to Hoover Dam.

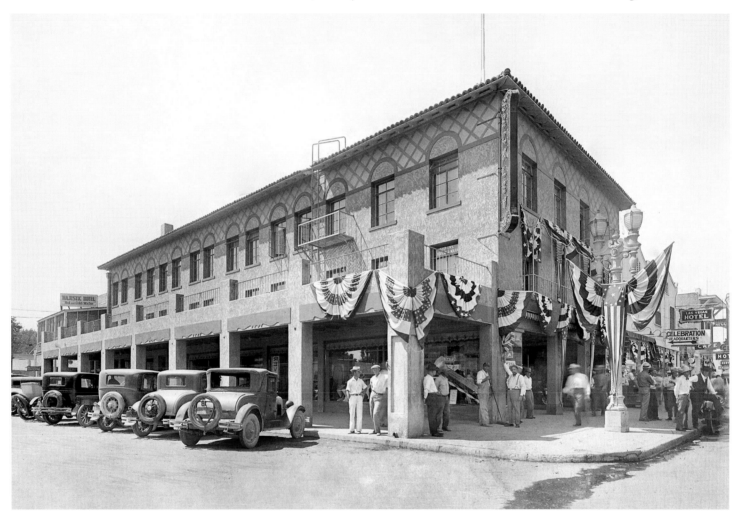

Blocks of Fremont Street are awash in American and other flags draped in celebration of the railroad to Boulder City, 1930.

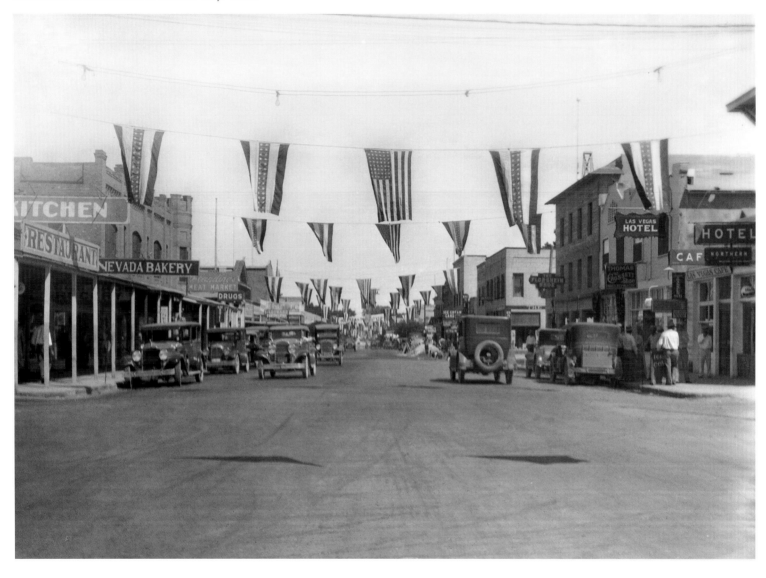

Manning a lightened, bare-bones automobile and trailer, these young
local men took a road trip to the Colorado River in 1931.

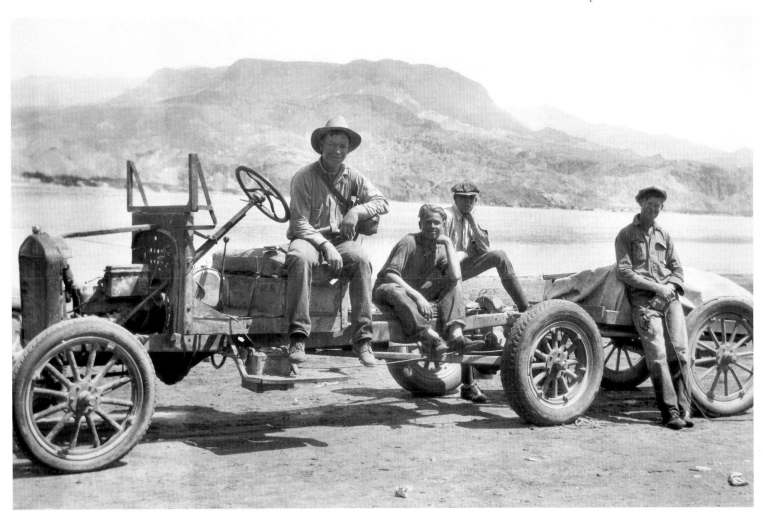

The float made for Sam Gelber's Electric Shop, on top of a car, heads down
Fremont Street, about 1930.

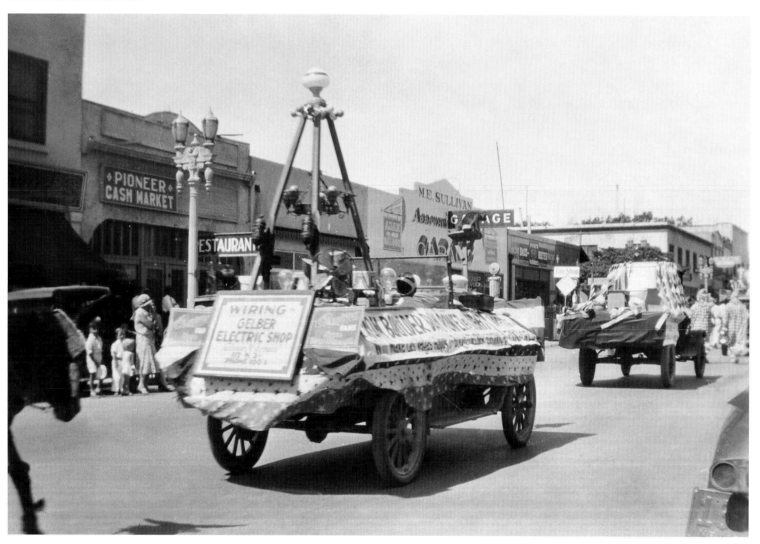

Local character Frank Waite ran for sheriff in 1930 and 1934, campaigning in a burro-pulled, small covered wagon that he drove throughout town with his dog. He was unsuccessful in both races.

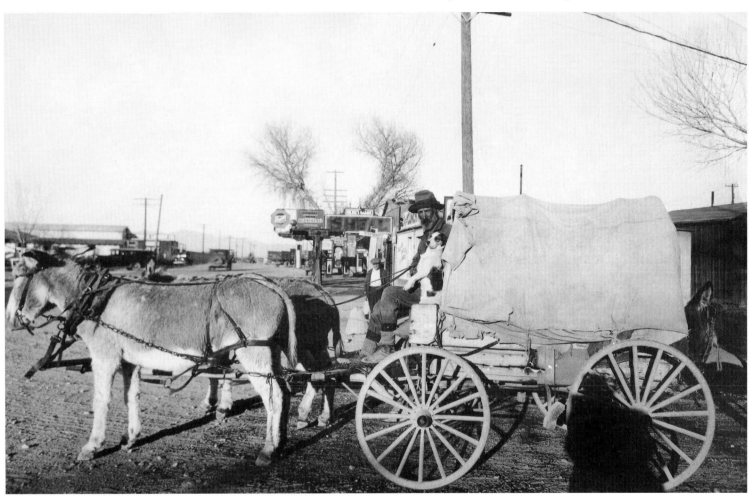

Snow covered Fremont Street in 1932, outside two establishments that show how much
Las Vegas had changed during the previous year. The Northern Club (center) and the
Bank Club now offered casino gambling. The Northern received the first license in Las
Vegas after Nevada legalized licensed casinos in 1931.

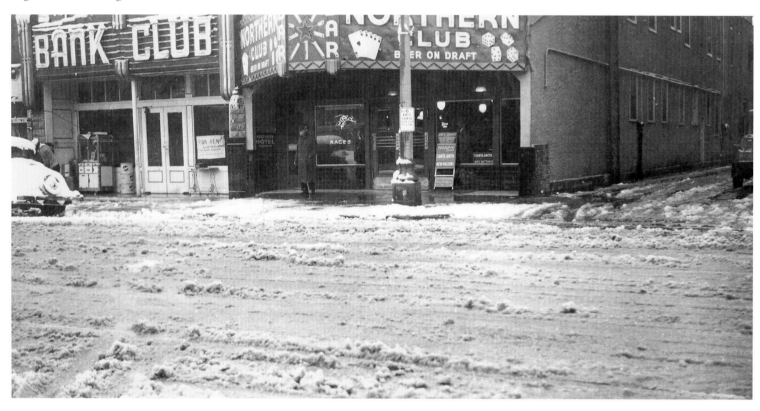

With gambling available (as well as illegal liquor), the nightclub business started to take off in Las Vegas in the early 1930s. Two new clubs, the Red Mill (with windmill, left) and the Black Cat opened in 1932 on East Charleston Boulevard and Fremont Street, about a mile east of downtown.

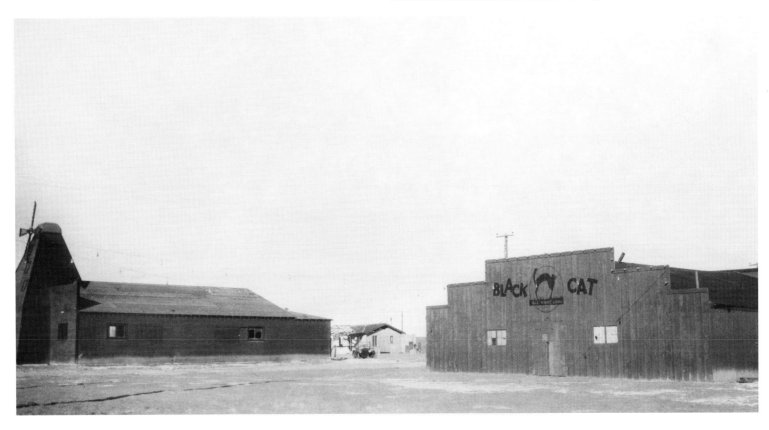

Rapid progress continued in Las Vegas, now with passenger aircraft service in the early 1930s. A Western Air Express plane from Los Angeles has just landed.

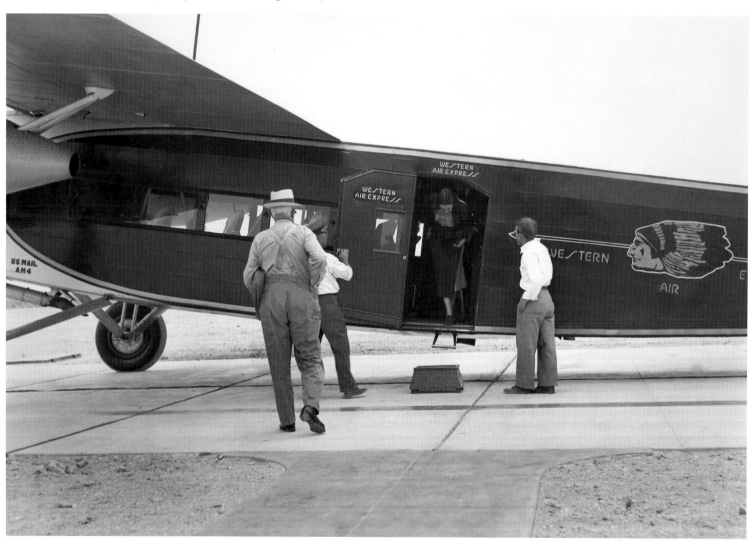

The Boulder Club bar and casino figures prominently in this 1930s view of Fremont Street. The club's second floor housed the Union Labor Temple. A store sign (right) announces watermelon for sale.

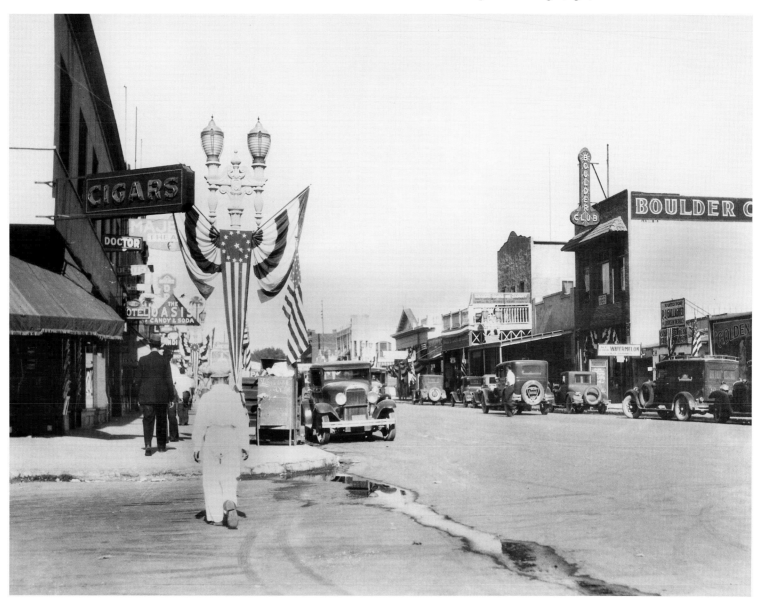

Before its new incarnation as a "club" casino in spring 1931, the Northern,
shown in this photo taken in 1930 or 1931, served as a hotel at 13
Fremont Street.

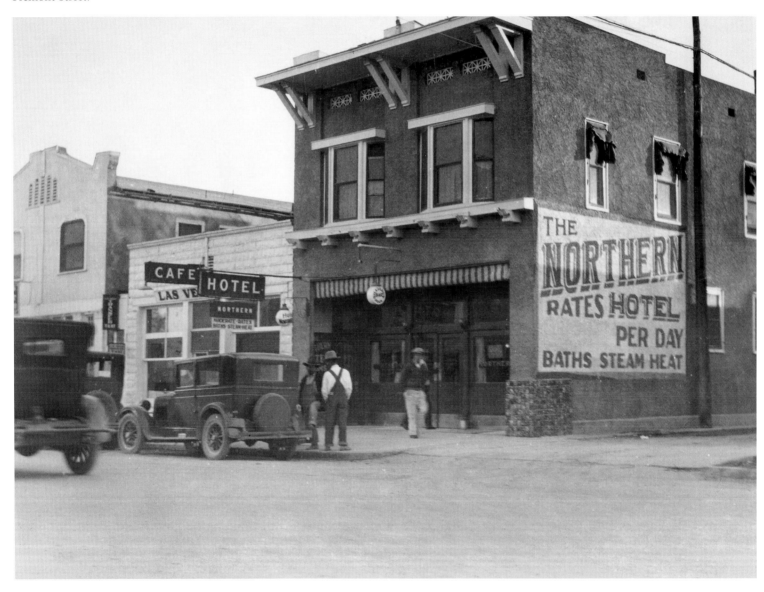

With the Hoover Dam (then known as Boulder Dam) project under way, Las Vegas city officials decided to build an archway touting its new, national distinction as the "gateway" to Boulder Dam, which began construction in 1931. Marchers walk under the arch during a Labor Day parade in the early 1930s.

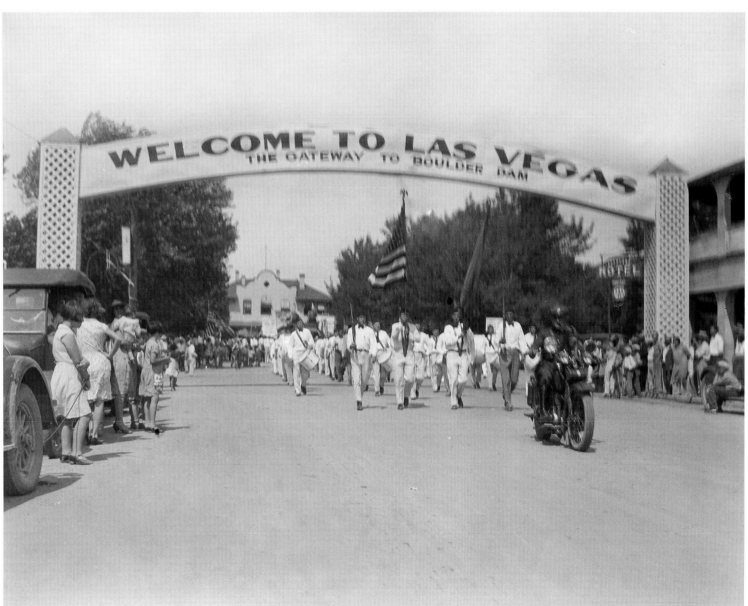

Participants in an early 1930s Labor Day parade, which for years was an
important annual celebration in Las Vegas, largely due to the many union
railroad workers living here.

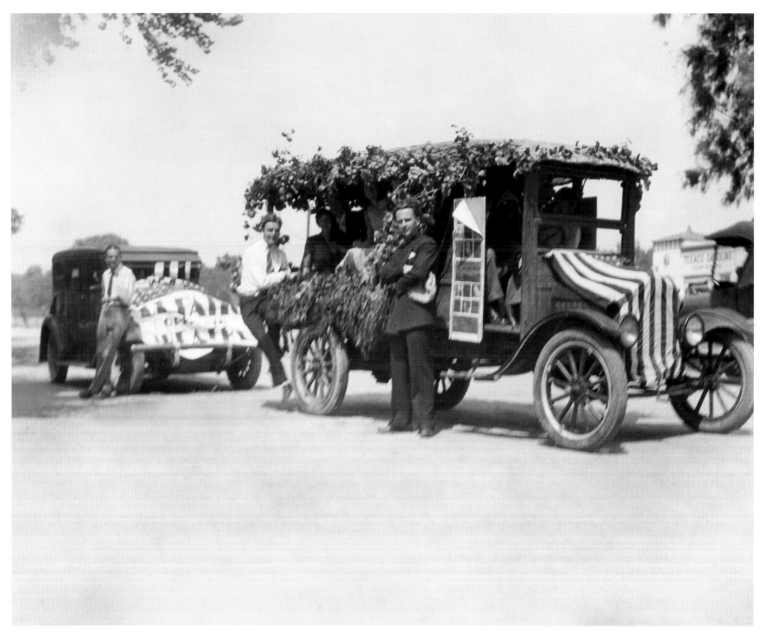

Labor union members and friends pose with their float for the Labor Day parade down Fremont Street in the early 1930s.

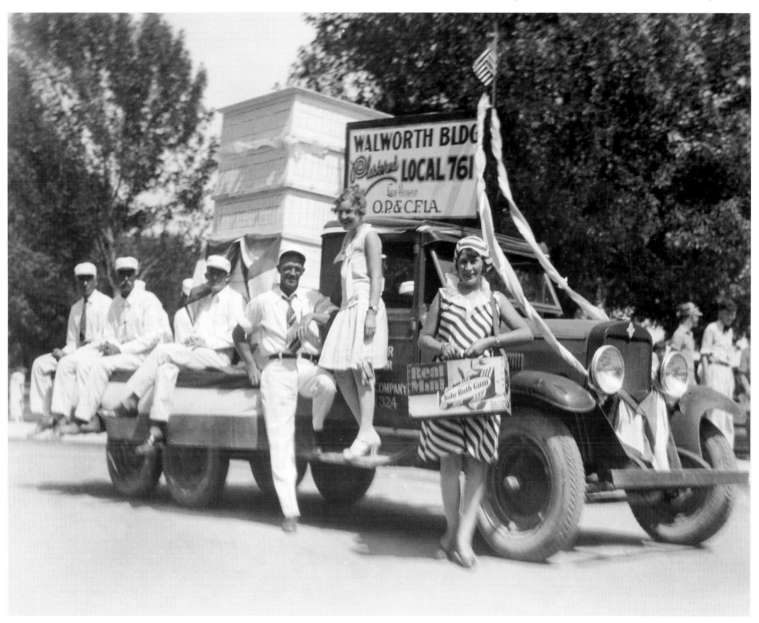

Advertisements of various shapes and sizes, homemade or otherwise, are towed by a burro-drawn wagon along a residential street in 1933.

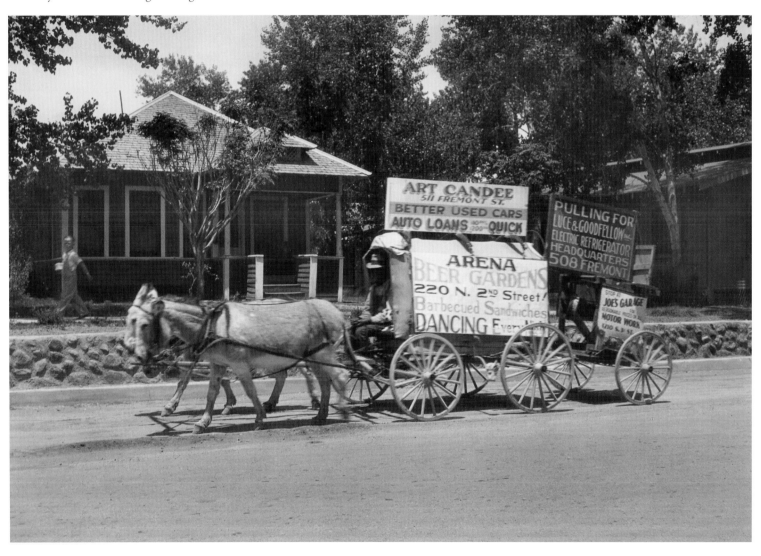

In the early 1930s, auto dealer James Cashman, left, greets movie actress Loretta Young and Colonel Roscoe Turner, a well-known aviator and lead pilot for Nevada Airlines. Turner had just arrived at the new Western Air Express airport in Las Vegas in a Lockheed plane, the Gilmore Lion, owned by California oil man Earl B. Gilmore. Turner was a favored pilot to the stars and made "alimony special" flights for would-be divorcees from Los Angeles to Reno in only 3.5 hours.

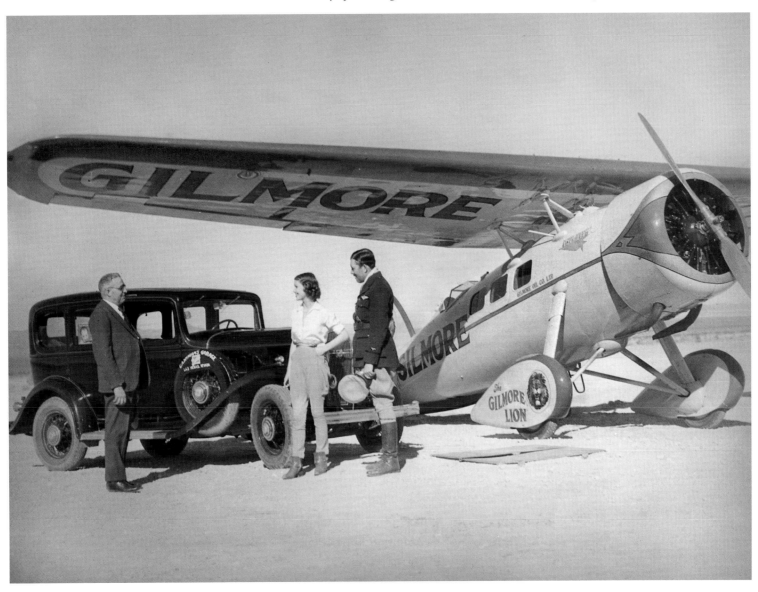

The first Clark County Courthouse was built in Spanish colonial style with granite steps and marble-lined halls at Third and Carson streets in 1914, at a cost of $50,000. It would remain the county's courthouse until 1958.

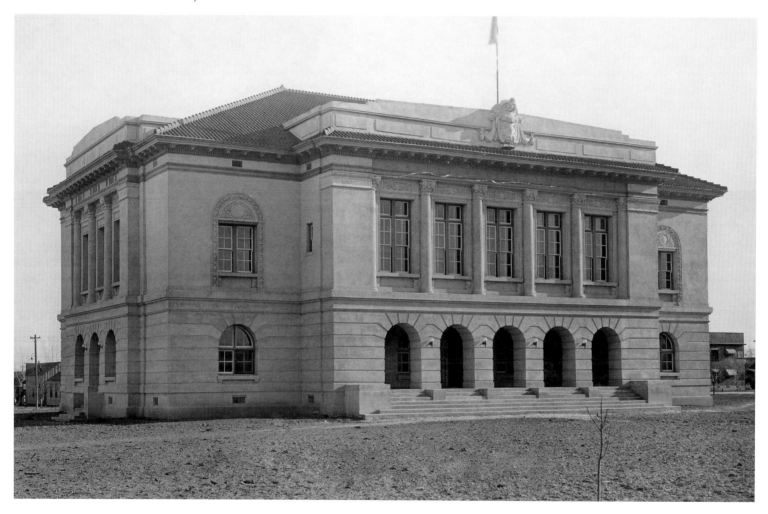

In 1933, the U.S. government completed this federal building and post office on Stewart Street, two blocks northeast of Fremont Street. The building is currently the site of a planned city museum focusing on organized crime.

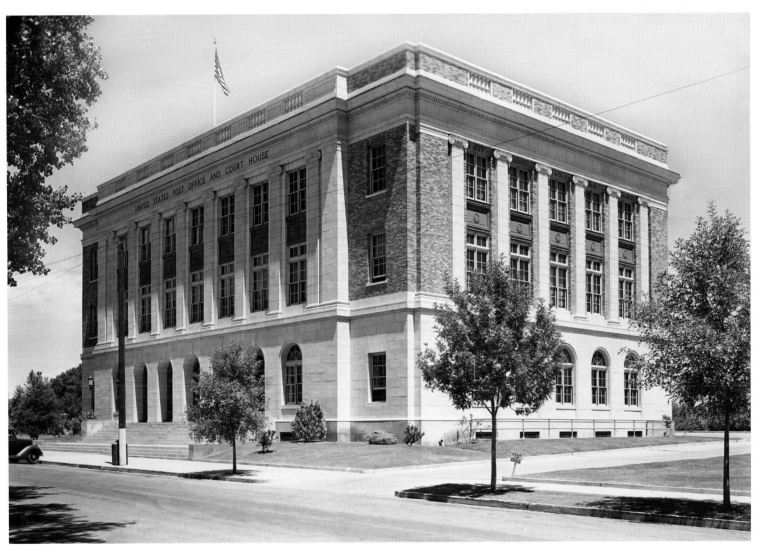

Downtown's finest theater was the El Portal, opened in 1928. Seen here in
1934 showing a Shirley Temple movie, the theater, on Fremont between
Third and Fourth streets, had 713 seats. For a higher admission price,
patrons could sit in a loge section and choose from 84 large leather seats.
The former theater survives today as a souvenir shop.

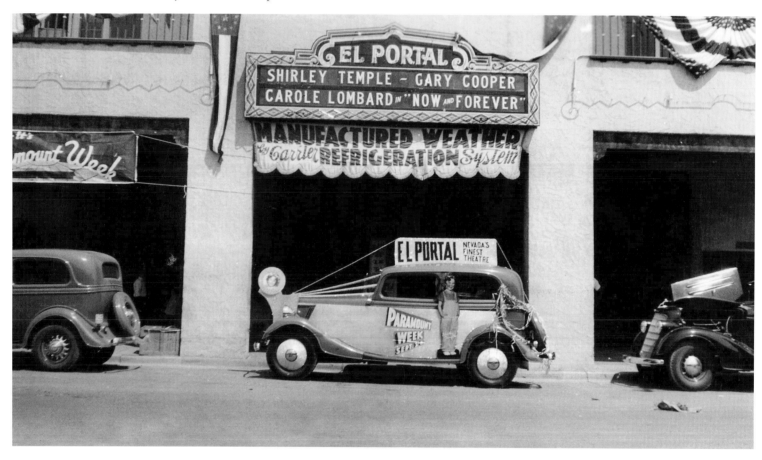

Johnny Roventini, the famous Philip Morris "Johnny the Bellboy," known for his "Call for Philip Morris!" tag line during national radio commercials for the cigarette maker, stands inside a convertible in downtown Las Vegas in 1935, during that year's Helldorado parade. Not widely known at the time was that Roventini had been living in Las Vegas for years. The men to the left are former Nevada Lt. Gov. Fred Alward (far left), and Leonard Arnett, a local drug store owner.

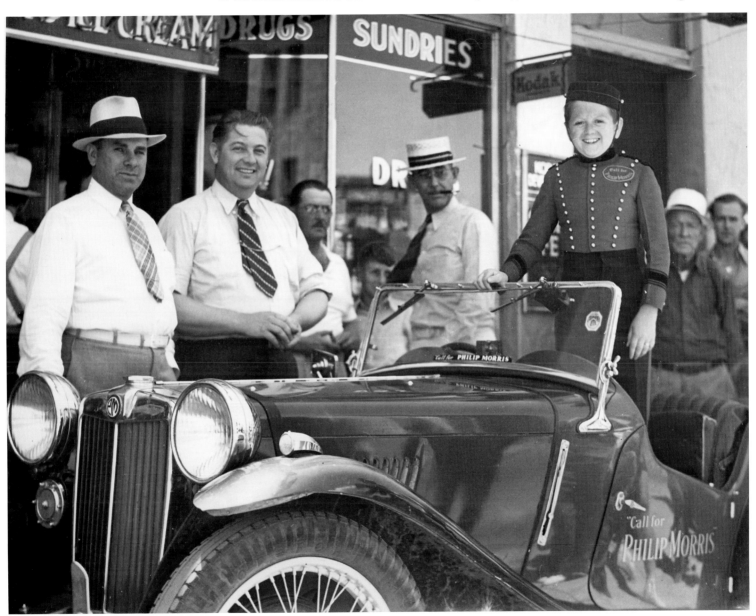

By the mid-1930s, about 300,000 tourists a year were visiting Las Vegas, and the main attraction was Hoover Dam, completed in 1935. In this promotional parade float from that time period, the Las Vegas Chamber of Commerce uses the dam project as proof that Las Vegas had become "The City of an Assured Future."

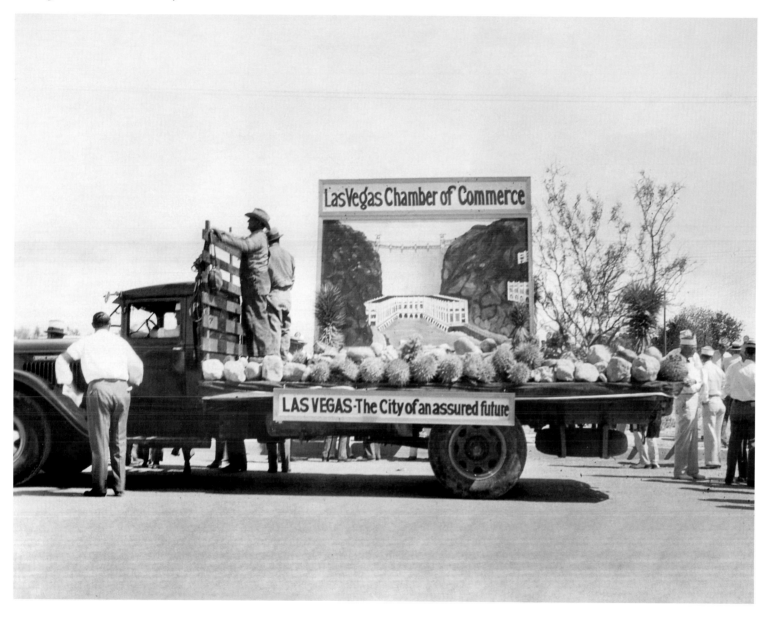

A half-dozen men and a boy holding a horse gather at a local horse-race track about three miles outside of town, near the present-day Las Vegas Hilton. The scales behind the truck might have been used for weighing jockeys.

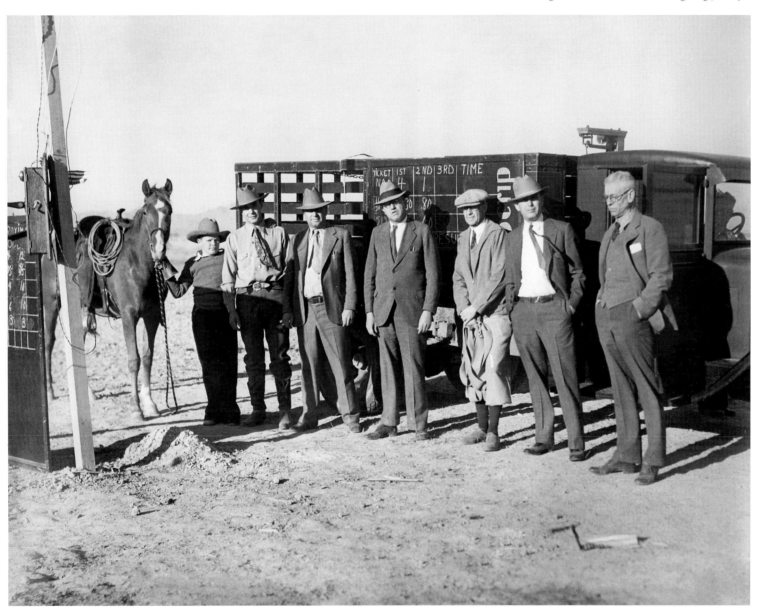

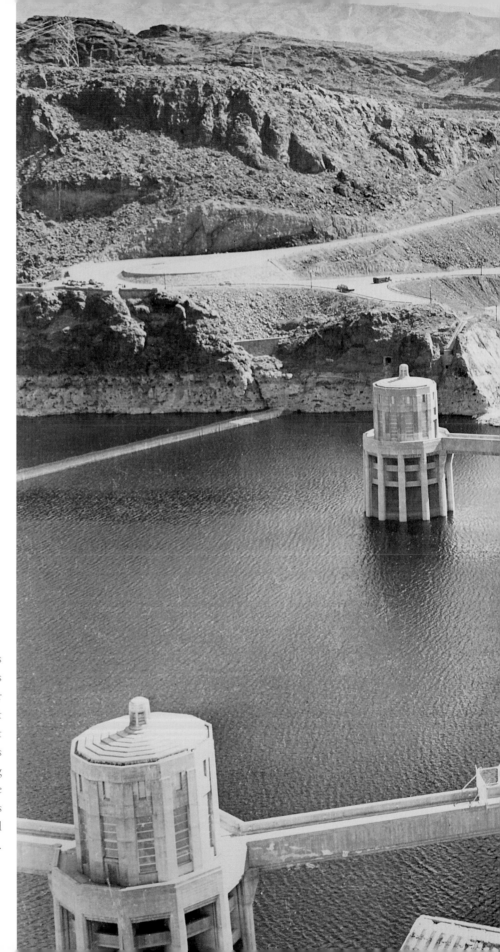

In this aerial picture looking toward Arizona, parked cars line the highway across the top of Hoover Dam after it was completed and dedicated by President Roosevelt on September 30, 1935. The concrete dam was a spectacular achievement in world engineering history. At 1,244 feet long at its crest and 660 feet thick at its base, it is larger than any of Egypt's pyramids. It created the man-made Lake Mead. Water running from the lake through the dam runs turbines to generate electrical power for Southern Nevada and beyond, provides flood control and drinking water for Southern California, and irrigation in Arizona.

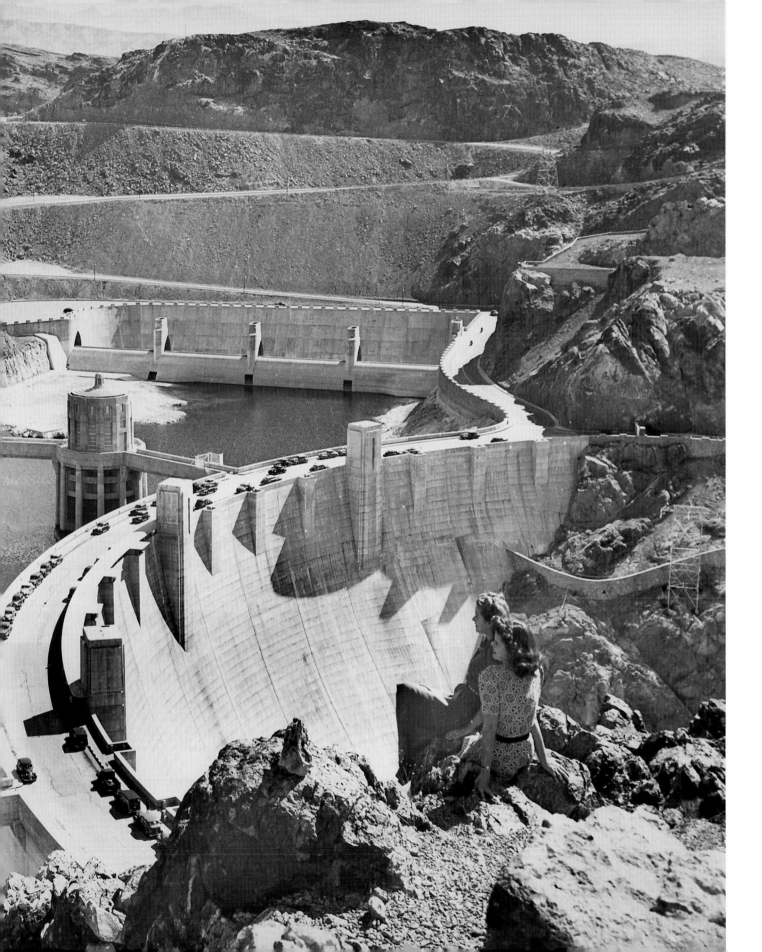

Facing east on Fremont Street in the mid-1930s. At left, the Overland Hotel promotes itself as "air cooled." True air conditioning (better than so-called "swamp coolers" that fanned evaporating water) came to Las Vegas around this time and greatly enhanced the future of the city in the Mojave Desert. The Sal Sagev hotel is at right, and farther down the street is the marquee of the Northern Club casino.

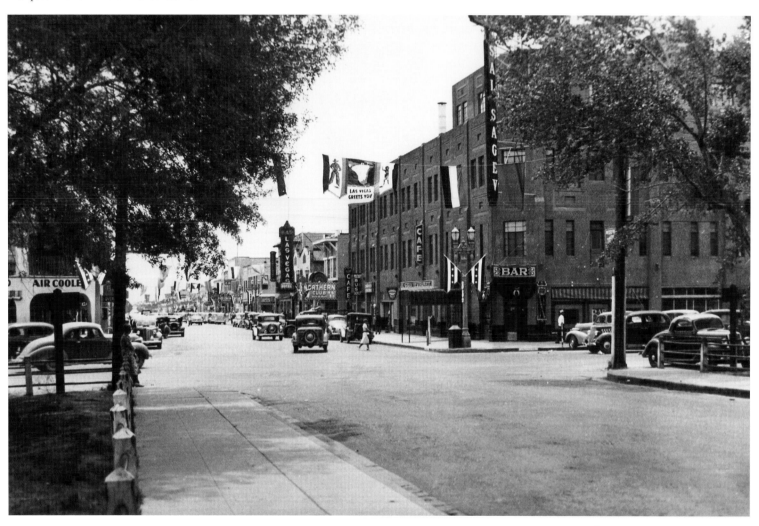

The Las Vegas Club, owned by J. Kell Houssels, on Fremont Street in the mid-1930s. The club was originally a pool hall that served soft drinks before Prohibition ended and Nevada permitted casinos. After repeal of prohibition and the legalization of casinos, early club owners like Houssels took advantage of both. He later bought shares of other casinos and in the late 1950s operated the Tropicana Hotel on the Strip.

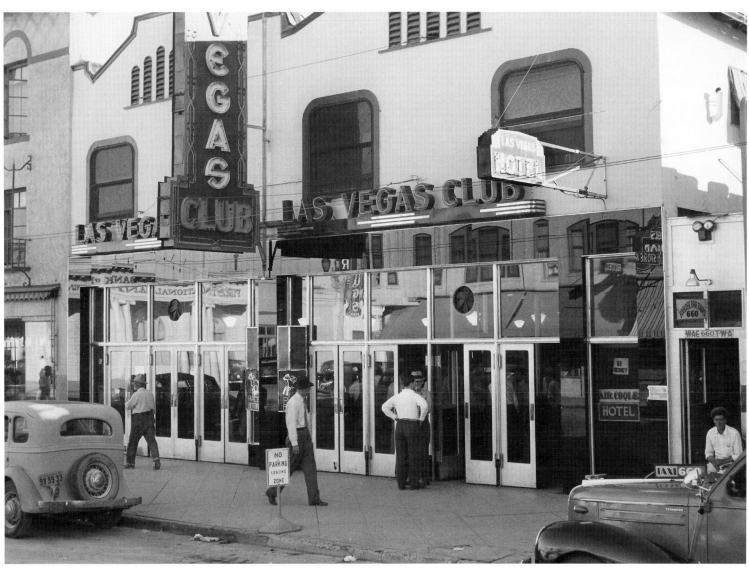

This mid-1930s west-facing view of Fremont Street toward the Union Pacific depot (center) shows, at left, Berkley's clothing store, the Las Vegas Club, the Northern Club, and Sal Sagev hotel. At right are the Las Vegas Pharmacy, a shoe-shine stand, Ethel's Liquor store, the State Café, J. C. Penney store, and the Overland Hotel.

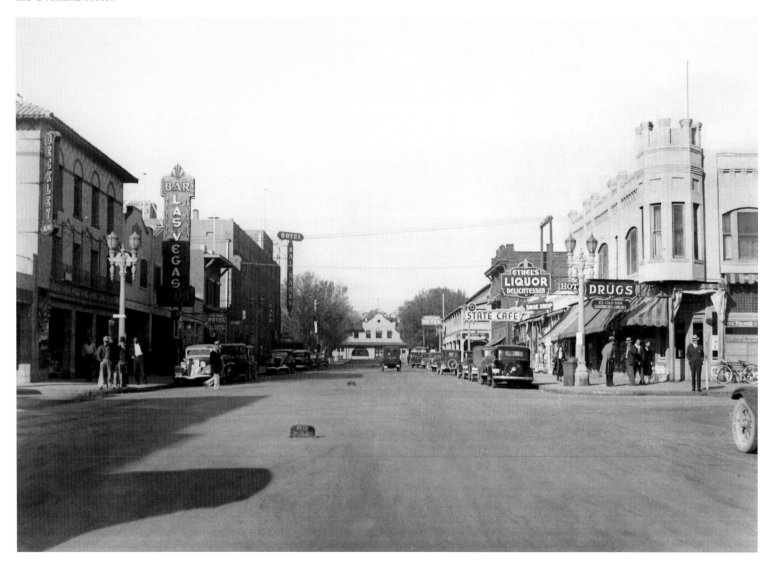

Resting her hands on a washing machine, a woman stands outside the Rockwell Electric Shop, which used a truck for pickups and deliveries in the 1930s.

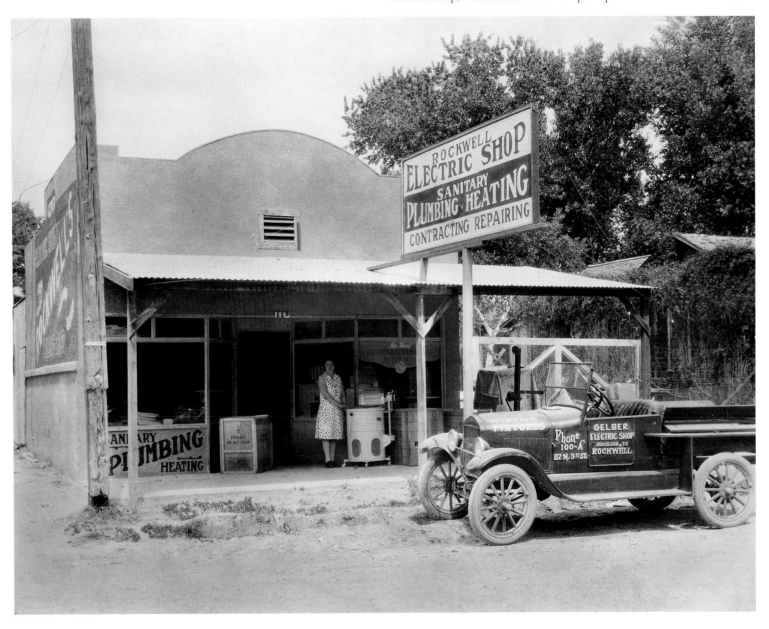

The first Helldorado parade, on Fremont Street in 1935, produced one of the most successful promotions ever for Las Vegas, at a time when the town sought to expand attractions for visitors. Inspired by old mining camps and legends of the Wild West, locals dressed in nineteenth century costumes and drove wagons and stages like this one. Sponsored by the Elks Club, the parade drew spectators and national publicity for Las Vegas as a free-wheeling town with twenty-four-hour drinking and gambling.

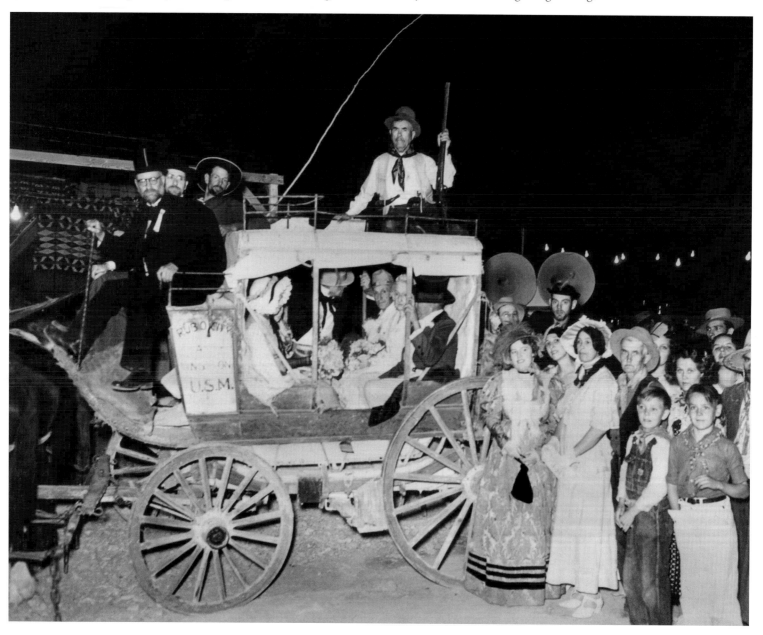

As Europe prepared for war in the late 1930s, many people throughout the United States opposed any involvement overseas by its military. The anti-war fervor reached Las Vegas about 1939, when this group of isolationists, including children, demonstrated during a march on Fremont Street.

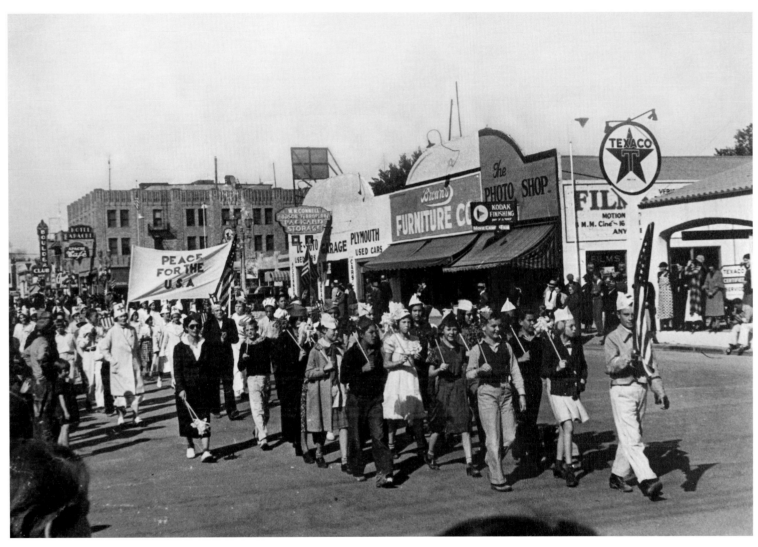

Following Spread: Las Vegas' Union Pacific station was used for on-location filming of the aptly named motion picture *Union Pacific* in 1938. Film director Cecil B. DeMille had the train station decorated as if it were in Virginia instead of Nevada. The movie was released in 1939.

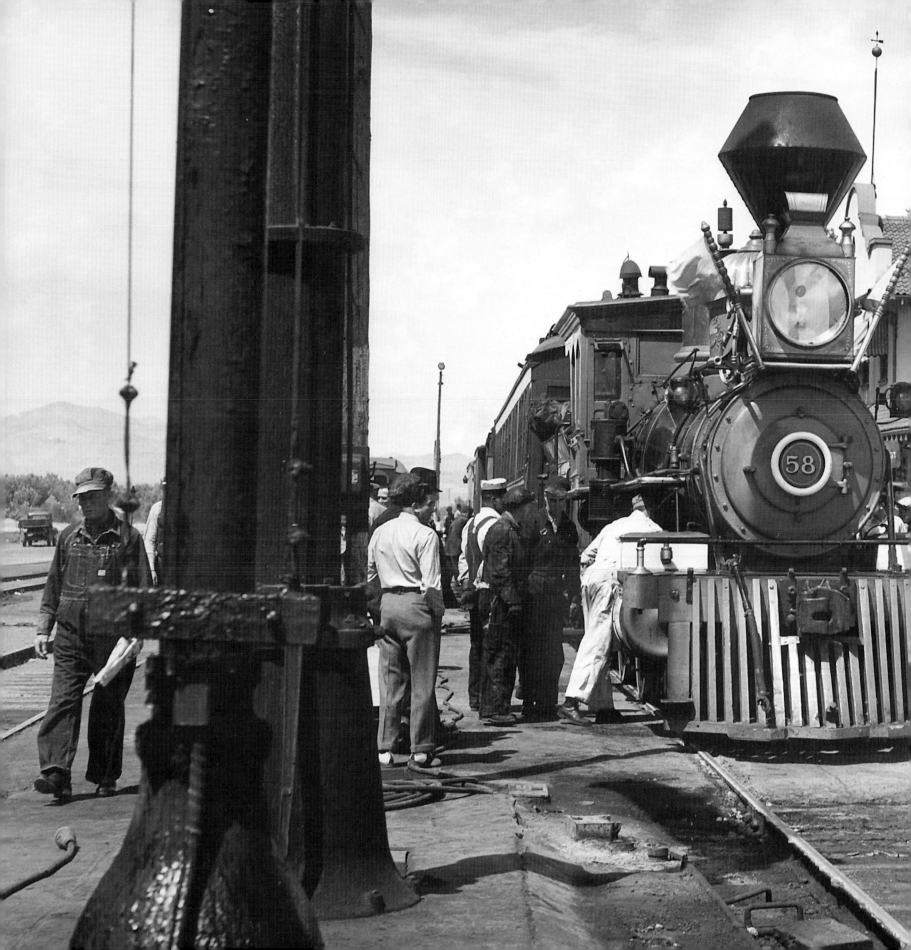

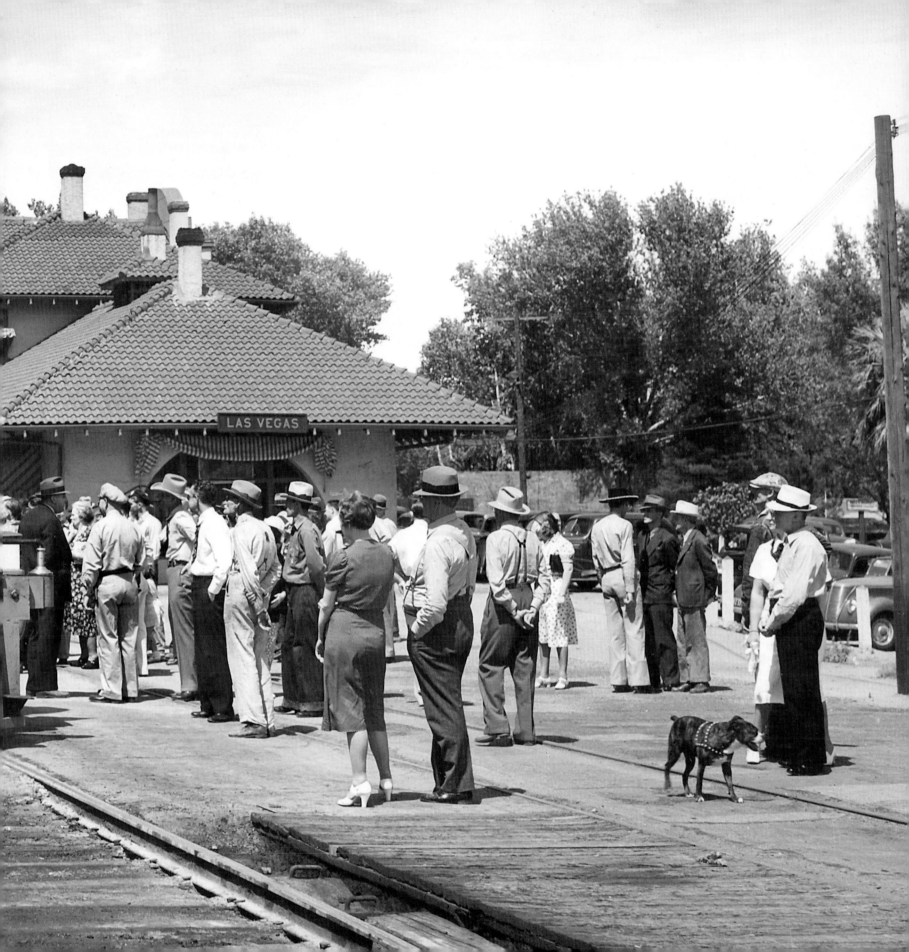

Dozens of well-appointed members of the Las Vegas Rotary Club take time to stand for a picture on Fremont Street during their Christmas Party in 1940. Seated in the Santa's sleigh-like car, next to a costumed Saint Nick, is club president A. C. Grant.

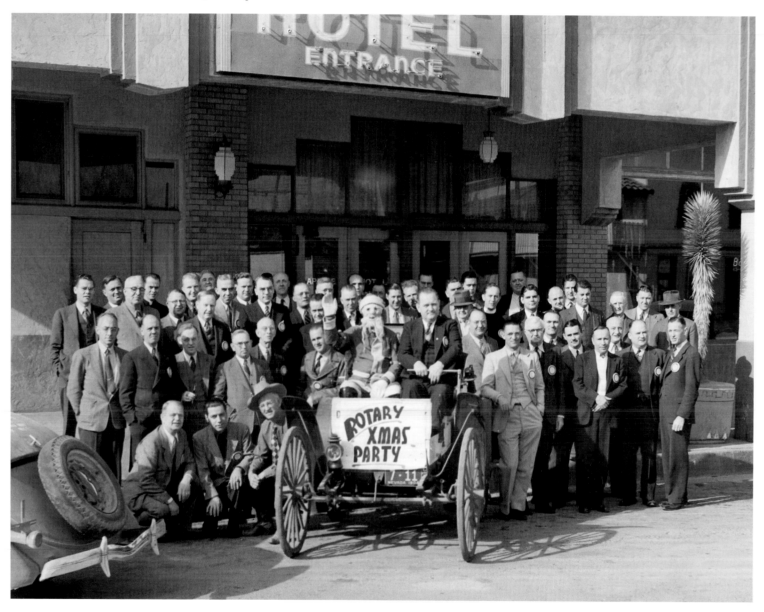

The Sal Sagev hotel and Fremont Street as they looked in 1940.

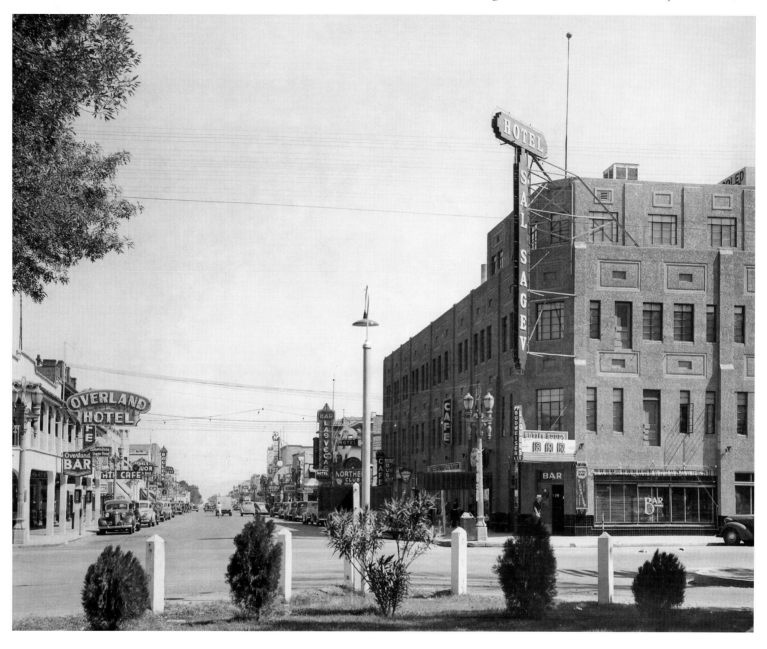

The Bank of Nevada at First and Fremont in 1941, after its operators bought out
the town's pioneer bank, First State Bank, and renamed the building.

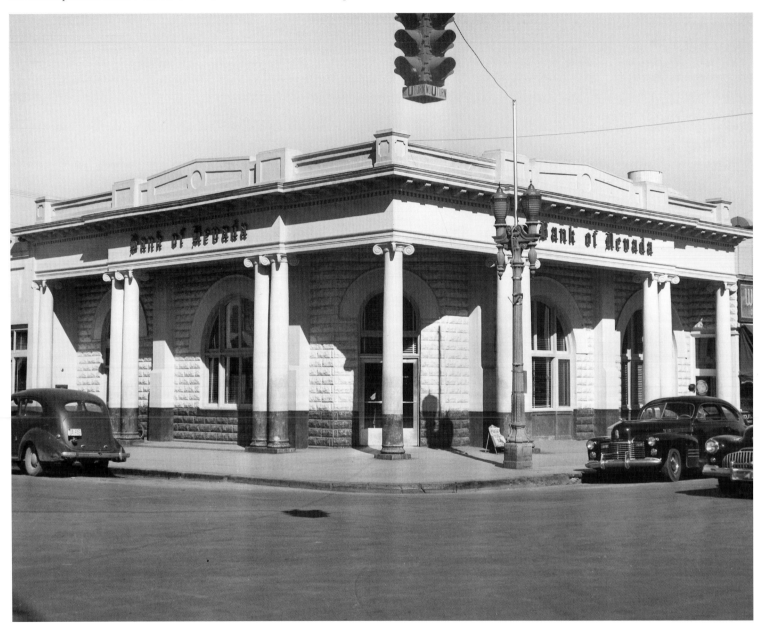

The El Rancho Vegas, about four miles south of downtown on the old Los Angeles Highway just outside the city limits, made history in 1941 as the first hotel resort on the Las Vegas Strip. The El Rancho had a unique windmill tower sign. Built by Thomas Hull, a hotelier from California, it featured a pool, three restaurants, and ample parking—for four hundred cars.

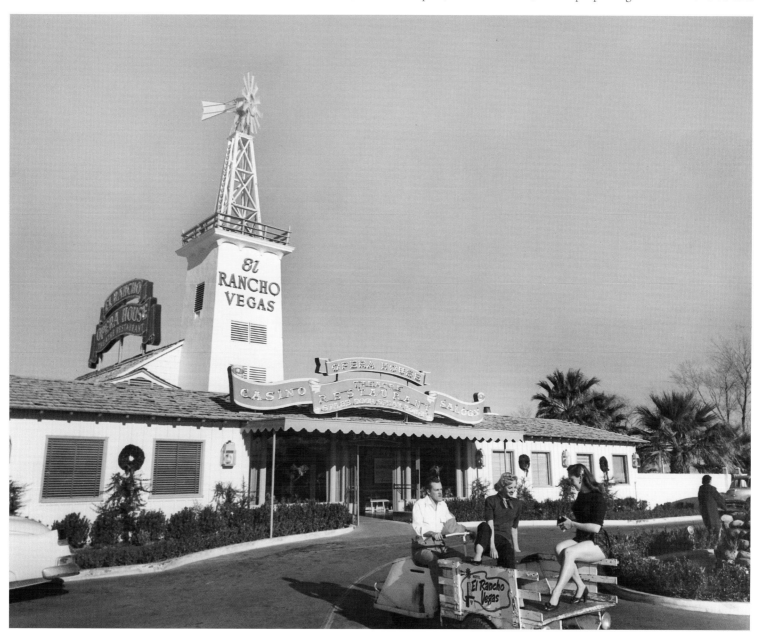

The Eldorado Club became one of the more popular downtown casinos after it opened in 1947 at Fremont and Second streets, with a separate hotel, the Apache, above it. Closed due to owing back taxes, the Eldorado was sold in 1951 to Benny Binion, who turned it into Binion's Horseshoe club.

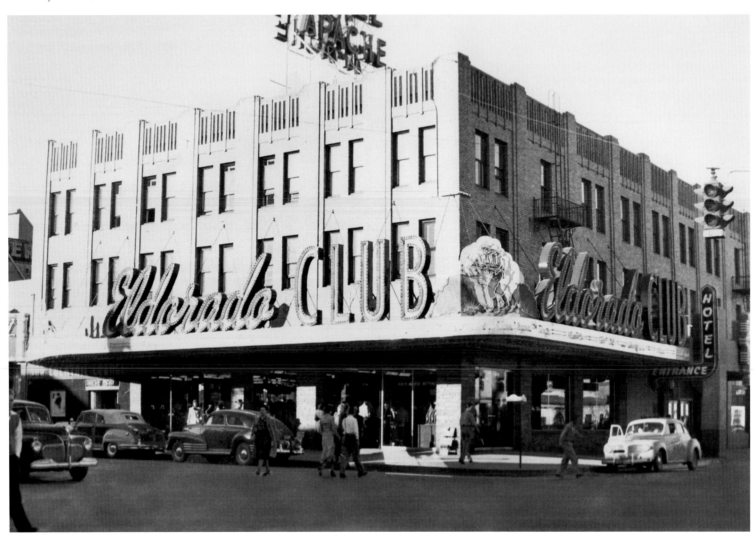

Opened in 1942, the Pioneer (without hotel rooms) was another downtown casino favored by tourists and locals. After this photo was taken in the late 1940s, the Pioneer became best known for the forty-eight-foot tall neon sign installed in 1951, fashioned after a waving cowboy, "Vegas Vic." The moving sign was accompanied for many years by a loud, recorded voice of a man saying: "Howdy partner. Welcome to Las Vegas." Vegas Vic became the symbol of the town for millions of tourists.

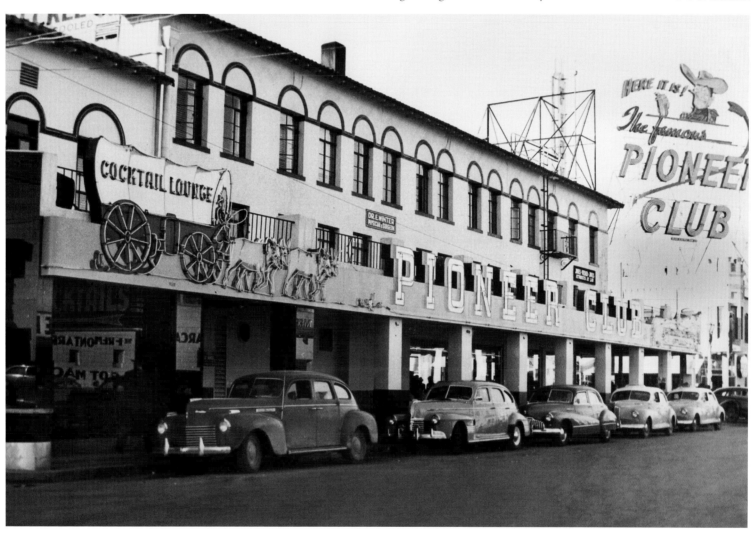

Fremont Street to the west in the late 1940s.

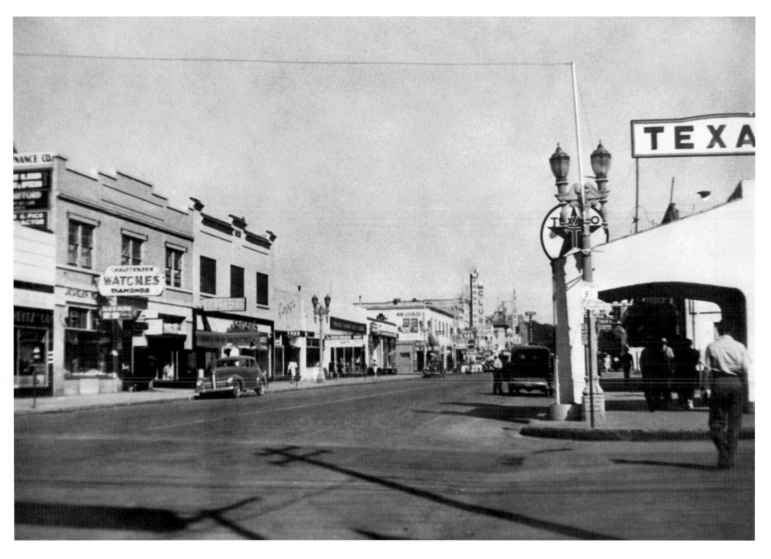

The Little Chapel of the West, which opened with the Last Frontier hotel on the Las Vegas Strip in 1942, is placed on a truck to be moved to a different section of the hotel property in 1954. As was true for other Las Vegas wedding chapels, it would flourish amid Nevada's easy marriage and divorce laws. In 1943, the solid redwood chapel would witness the first of many celebrity couples to marry there—actress Betty Grable and bandleader Harry James. The chapel is still open for business on Russell Road and Las Vegas Boulevard South.

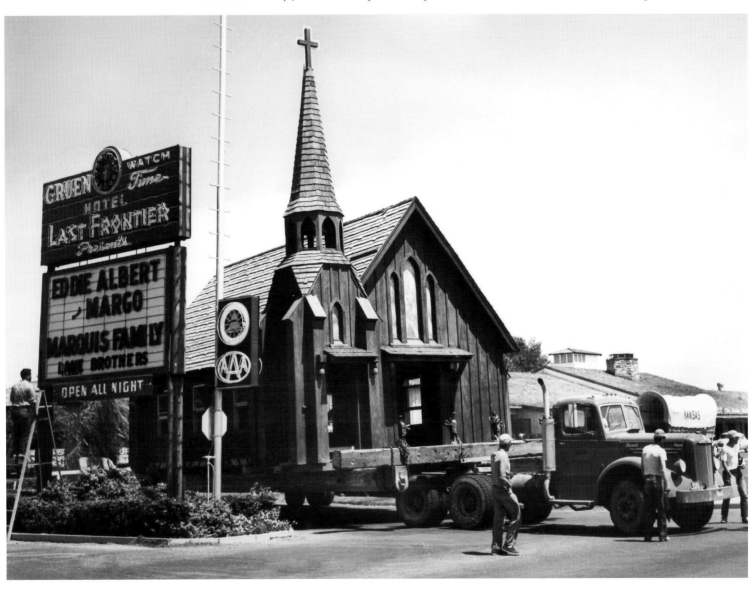

Melting snow made driving hazardous on Fremont Street outside the Overland Hotel, one day in the 1940s.

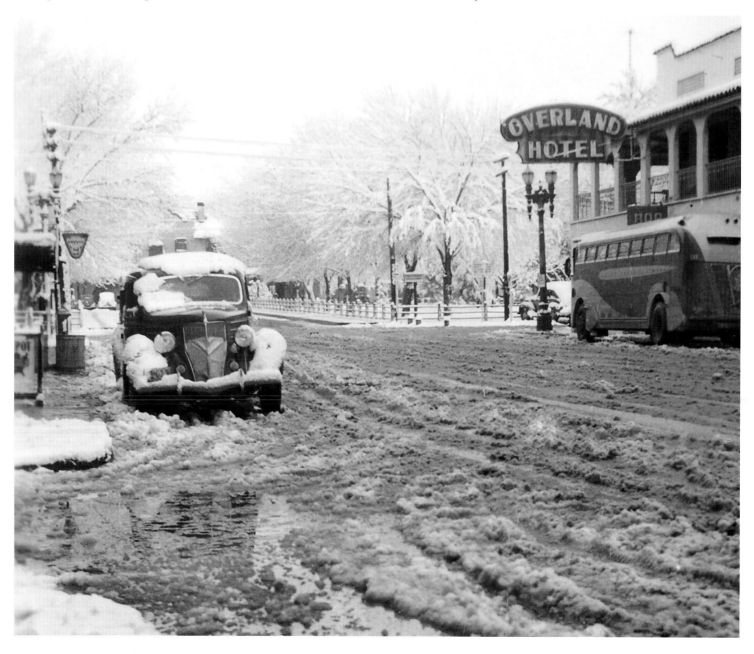

Two kids sit before a "no parking" zone in front of a liquor store on a sunny day on Fremont Street about 1943.

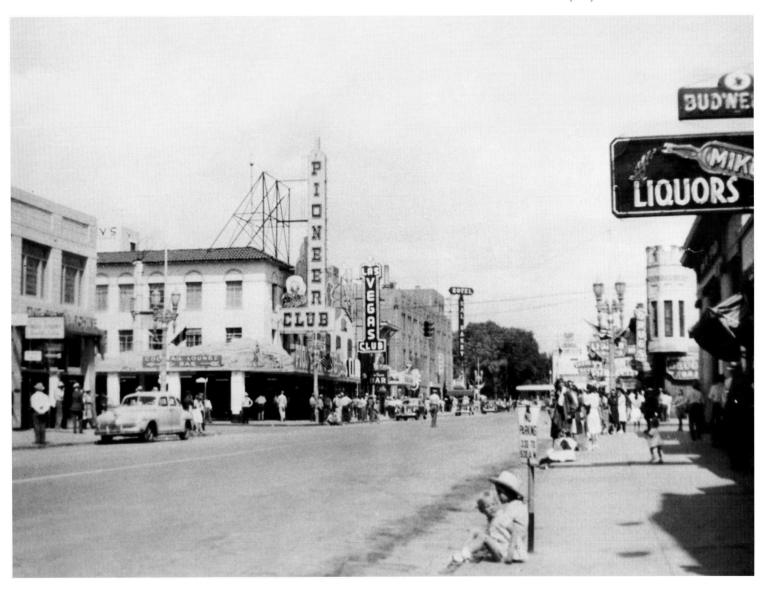

Fremont Street, its sides clogged with parked cars, in the 1940s.

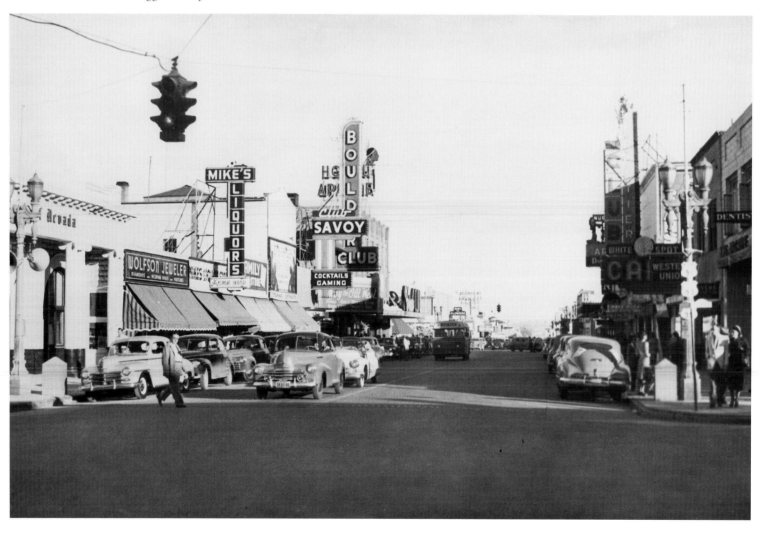

A searchlight highlights the October 30, 1942, opening of the Last Frontier Hotel. Its main attraction was the "Last Frontier Village," an Old West town done up Hollywood style, exhibiting hundreds of vintage western artifacts. The Last Frontier became the second hotel-casino to debut on the fledgling Strip. Owner William J. Moore, trying to outdo the El Rancho, tempted motorists by installing a swimming pool out front. Moore also added a six-hundred-seat banquet facility and parking lots that held nine hundred cars.

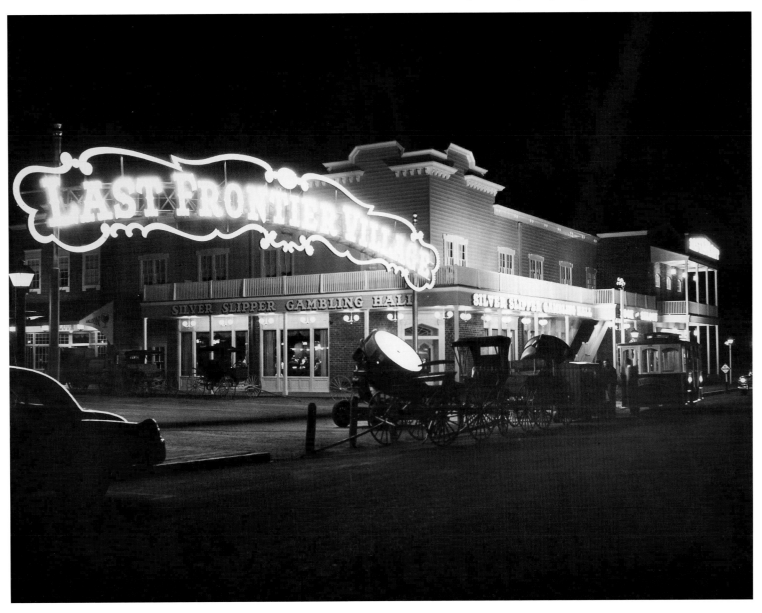

The Turf Club bar and casino on Fremont Street in the mid-1940s.

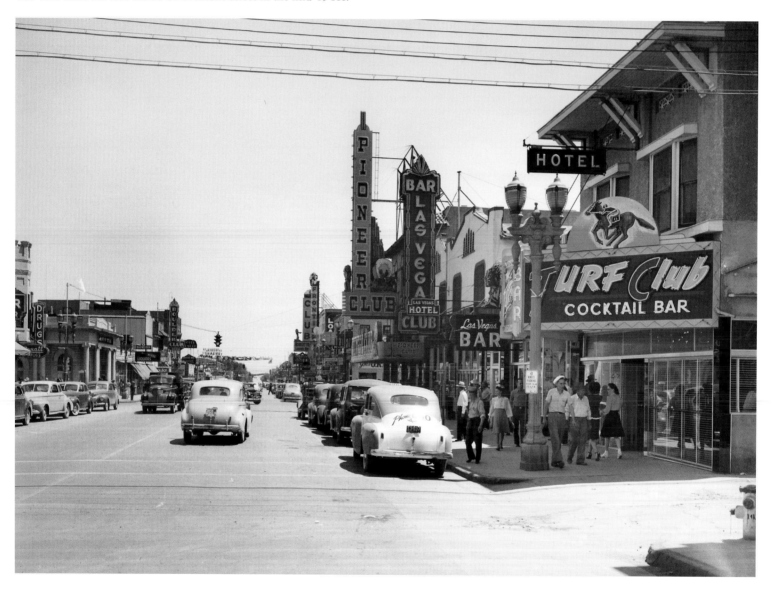

Grounded planes wait for servicing in the Las Vegas Army Air Corps Gunnery School at the local airport northeast of Las Vegas, formerly used by Western Air Express, which sold it to Las Vegas in 1940. In 1941, the Army used part of it to train pilots. It was later was named Nellis Air Force Base, a permanent military training and defense facility.

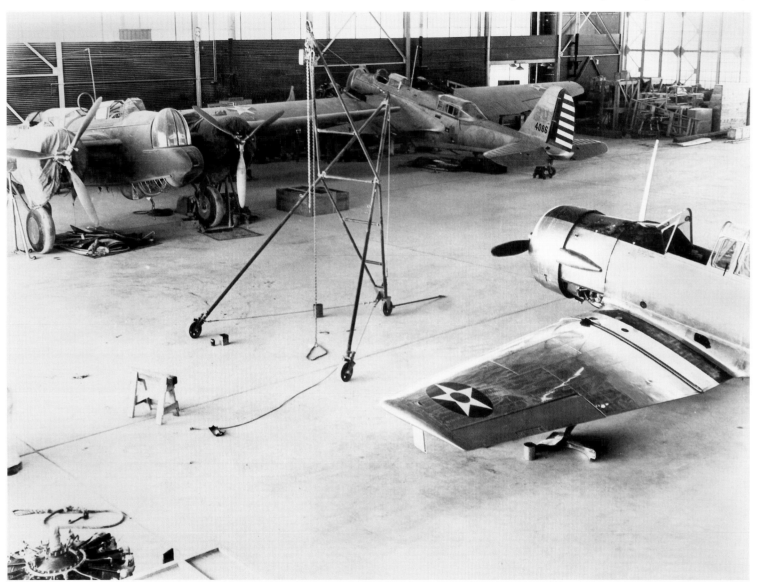

The crew of the *Memphis Belle* B-17 bomber stands beside the famous aircraft at the gunnery school about 1943. The plane was the first to complete twenty-five American bombing missions over Germany during World War II. Flown to the United States, its crew was sent on tour with the plane to sell war bonds. In July 1943, the *Belle* visited Las Vegas, where three of its crew had trained in the gunnery school. The reference to "Basic Magnesium" in the sign was the Basic Magnesium plant, a factory about fifteen miles to the southeast, where magnesium mined in southern Nevada was forged to build airplane parts, thousands of incendiary bombs, and machine-gun tracer bullets used during the war.

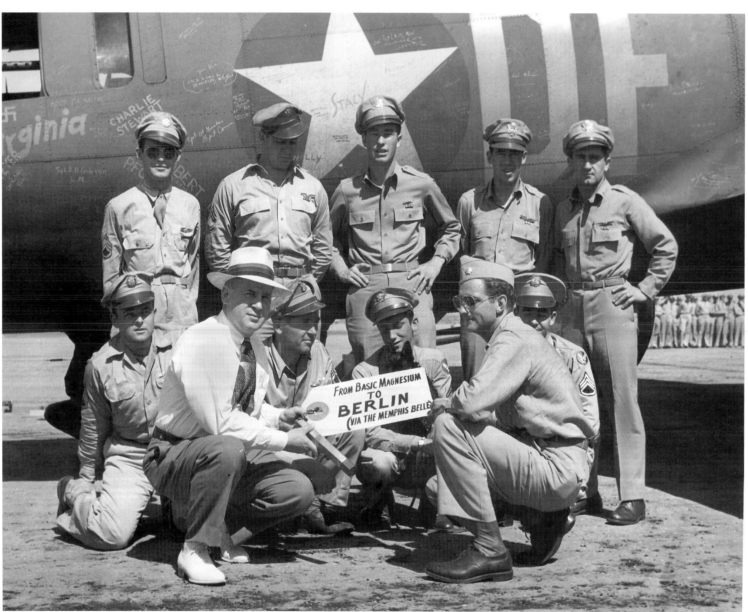

Las Vegas had its share of drives for Series E war bonds to raise badly needed funds for America's defense during the war. This advertisement was over the Frontier Club's neon sign on Fremont Street.

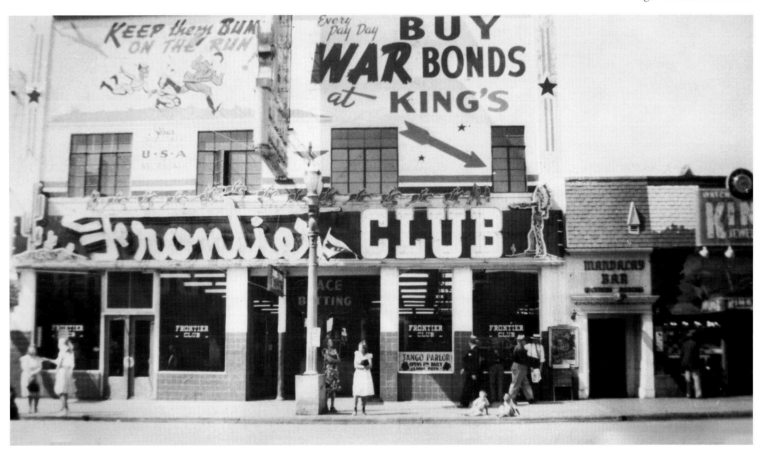

Men in uniform (right) cross Second Street at Fremont in the bustling downtown of the early 1940s, when lucrative defense contracts, such as at the gunnery school and Basic Magnesium Inc., created thousands of jobs, bringing new residents and growth. The BMI plant alone produced 15,000 wartime jobs.

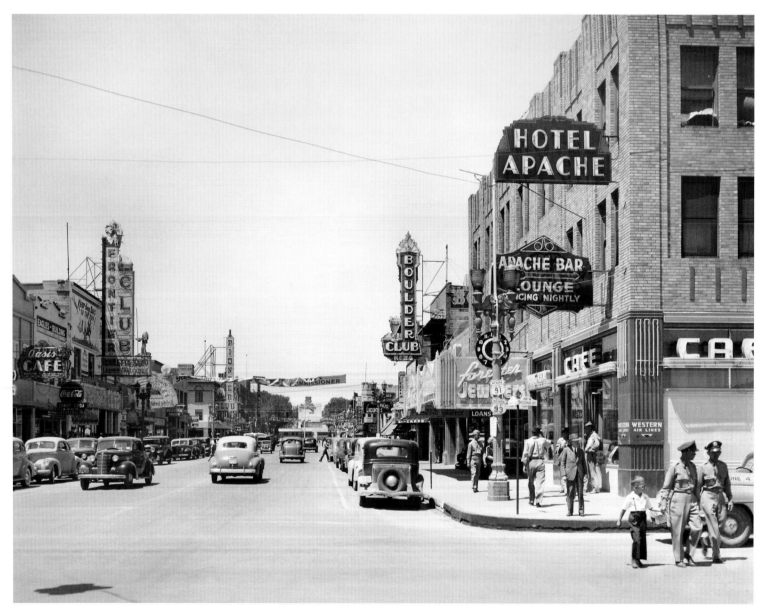

With many local male volunteers and draftees off at war in the early 1940s, women dominated this Veterans Day parade down Fremont Street.

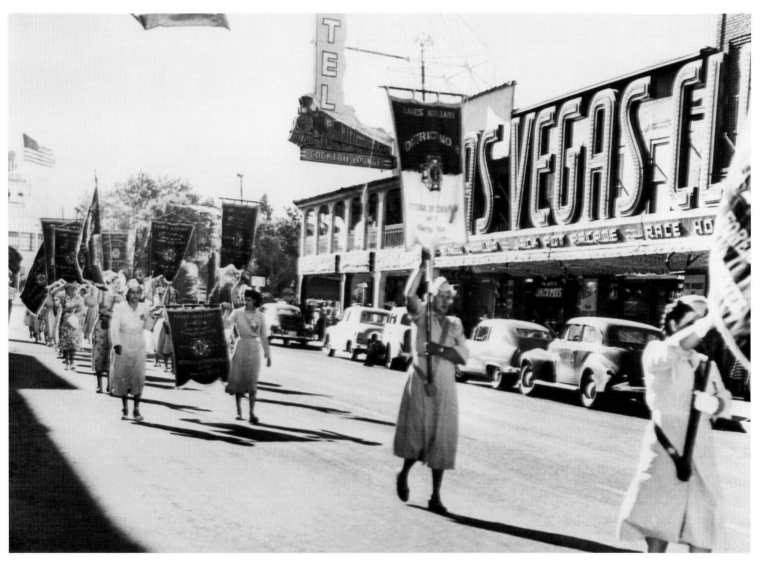

During the holiday season in the war years, a vacant lot at the corner of
Fifth and Carson streets was used to sell Christmas trees.

Last Frontier Hotel owner William J. Moore, who opened the resort on the budding Las Vegas Strip in 1942, waves from a decorated, horse-drawn buggy in his position as "ringmaster" of the Helldorado parade in 1945. Tony Cornero's S. S. Rex Club casino is in the background.

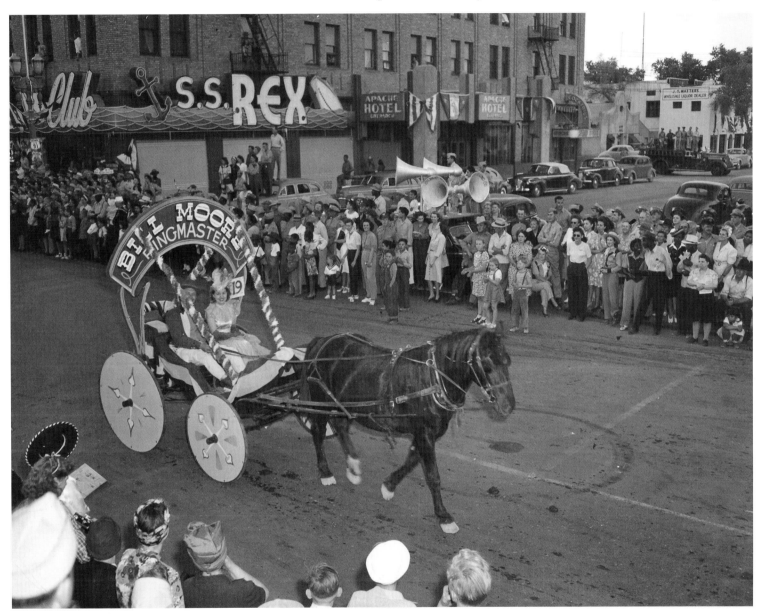

Clark County's Sheriff Glen Jones (center, right) beams while holding an American flag on horseback during the Helldorado parade on Fremont Street, May 18, 1947. James Cashman, the longtime Las Vegas auto dealer, is looking at Jones while riding a horse beside him (foreground).

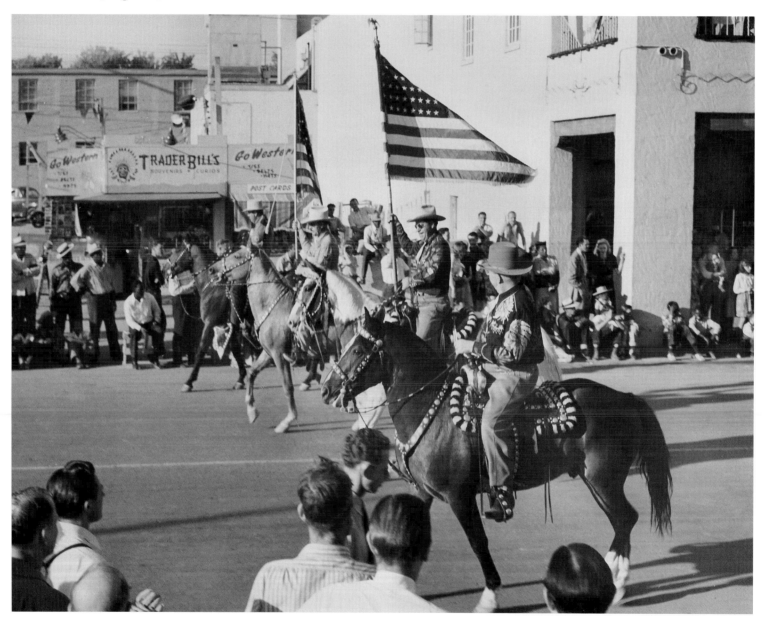

Modern-looking, propeller-driven passenger planes at McCarran Field in 1948. The new airport was named for Nevada's influential U.S. Senator Pat McCarran.

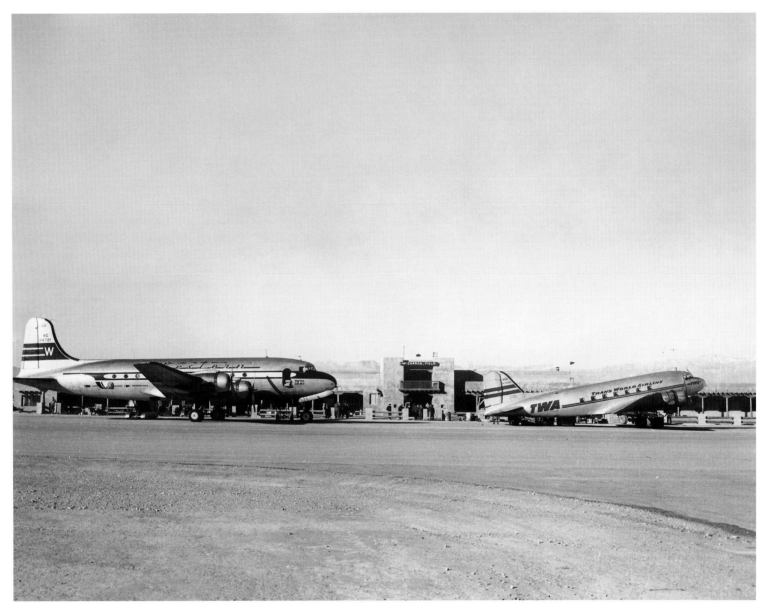

The Golden Nugget casino's enormous, new neon sign stands out
against the rest of Fremont Street in 1948.

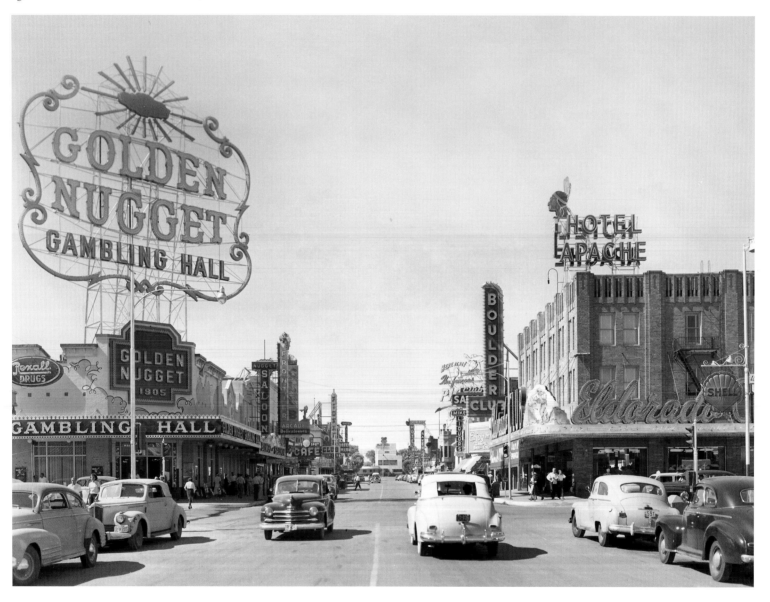

The same scene as on the facing page, shot at night.

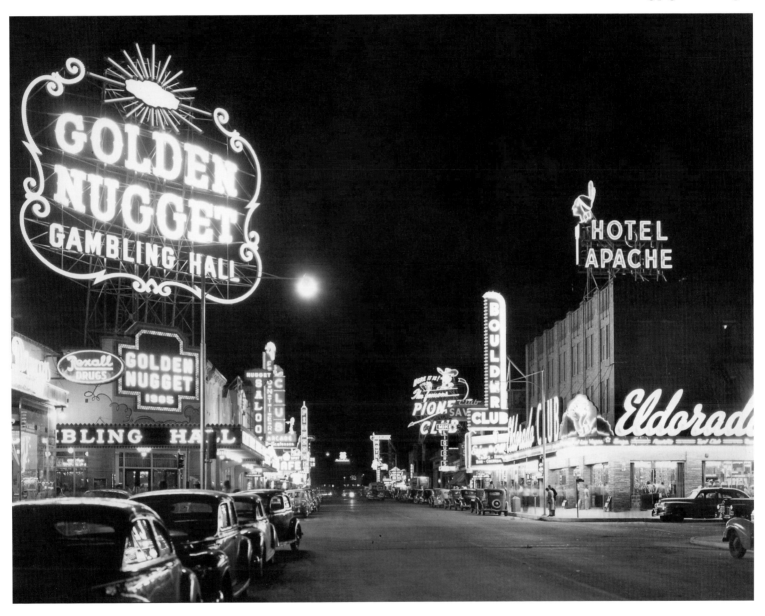

The "bathing beauties," like this one atop an elongated float, were always among the biggest draws at the Helldorado parade. This photograph was taken on Fremont about 1948.

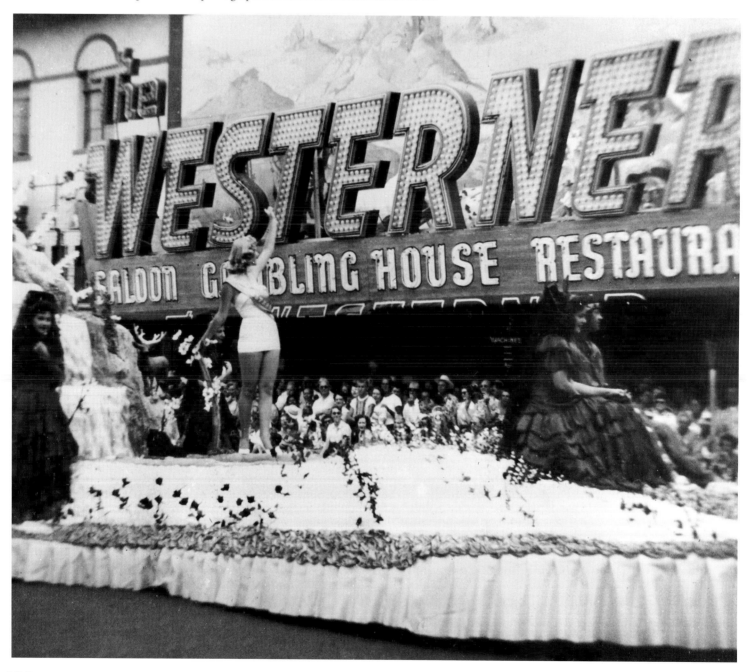

One of the newer neon signs on Fremont Street, for the Monte Carlo Club, is highlighted in this evening view in 1948. The Monte Carlo, owned by Wilbur Clark, was formerly the Northern Club.

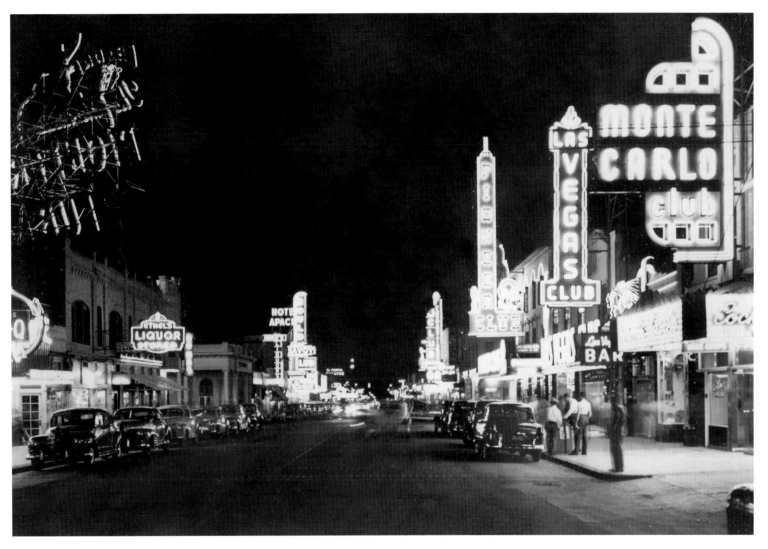

The Pioneer Club's large rooftop neon sign, with the head and hand of its Vegas Vic cowboy character, competes with the other gleaming casino signs at night on Fremont.

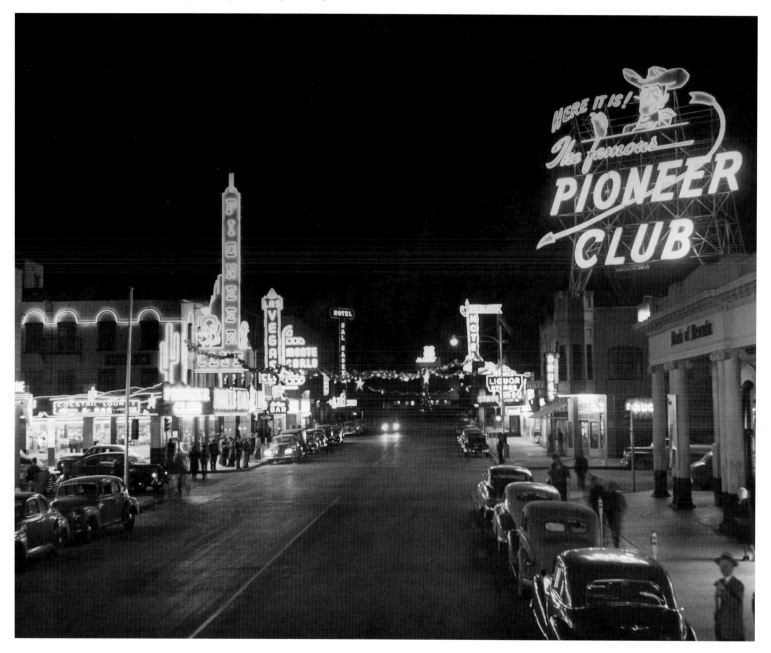

MODERN LAS VEGAS TAKES SHAPE

(1950–1969)

The Las Vegas Strip became a national sensation in the 1950s, with the openings of the Desert Inn (1950), Sahara (1952), Sands (1952), Riviera (1955), Dunes (1955), Royal Nevada (1955), Tropicana (1957), and the Stardust, which ended the decade's resort boom in 1958. Entertainers who were household words were hot commodities—and paid large sums—for bookings at Strip hotel showrooms. But all was not well on the Strip, which was overbuilt by the mid-1950s, leading to lean times or worse for some resorts. The Royal Nevada closed, as did the off-Strip Moulin Rouge, the area's first integrated hotel, which fell into bankruptcy months after it opened in 1955. At the time, African Americans were not permitted in Strip casinos, except performers on stage. Top entertainers in the 1950s and 1960s included Frank Sinatra, Dean Martin and Sammy Davis, Jr. Their antics made Las Vegas a center of American show business.

But as the Strip expanded in the 1950s, Las Vegas also found itself involved in the Cold War's nuclear arms race. The Nevada Test Site, about 65 miles north of Las Vegas, conducted above-ground nuclear-weapons tests throughout the decade, and the mushroom clouds were visible from town. The city's name was featured all over the country in news stories about each test. Casinos and local businesses used the early morning explosions as tourist attractions and fodder for publicity. By 1959, Clark County's casinos took in more than $100 million and had 11,810 hotel rooms, which would almost double by 1965 to 20,500 rooms. Las Vegas also was evolving into a top location for conventions. At one point in the 1950s, the average income among residents, at $5,891, was the second highest in the country. The city also had one of the highest numbers of churches compared to its population in the United States.

By 1960, residential growth allowed Las Vegas to surpass Reno as Nevada's most populous city for the first time (64,000 people, compared to Reno's 51,000). Clark County as a whole was home to 125,000. An overall lull of casino building on the Strip ended in the mid-1960s. Former motel builder Jay Sarno designed and constructed Caesars Palace, which debuted in 1966, and set the new standard for resort opulence on the Strip. Sarno also designed Circus Circus, a unique hotel-casino for adults with kids. Kirk Kerkorian would open what many consider the area's first-ever "megaresort," the International

(later the Las Vegas Hilton), just east of the Strip. With 1,512 rooms, the International, where pop singer Elvis Presley staged a comeback after it opened in 1969, was the world's largest hotel, a distinction Kerkorian would bring to two other Strip hotels in the future.

It was common knowledge in the 1950s and 1960s that many of the hotels on the Strip were built with the aid and money of organized crime, which withdrew casino cash before it was counted by tax collectors. Some in the syndicate got multimillion-dollar building loans from the Teamsters Union Pension Fund, controlled by corrupt labor leader Jimmy Hoffa. The town's bad reputation in this regard was an embarrassment until billionaire Howard Hughes, a longtime visitor, took an interest in owning casinos and paid high prices to buy up six Strip resorts, starting in 1967 with the Desert Inn. Hughes would leave town secretly in 1970 and never come back.

By the end of the 1960s, Las Vegas, which would suffer from a few downturns, was beginning to shed its disrespectable image and evolve into the most popular place for tourists in the country, largely due to its low cost vacations and its long-standing culture of all-day, all-night gambling and drinking.

As popular as ever, the Helldorado parade of 1952 produced crowds that packed the roofs of casinos like the 49'er Club, along with the sidewalks of Fremont Street.

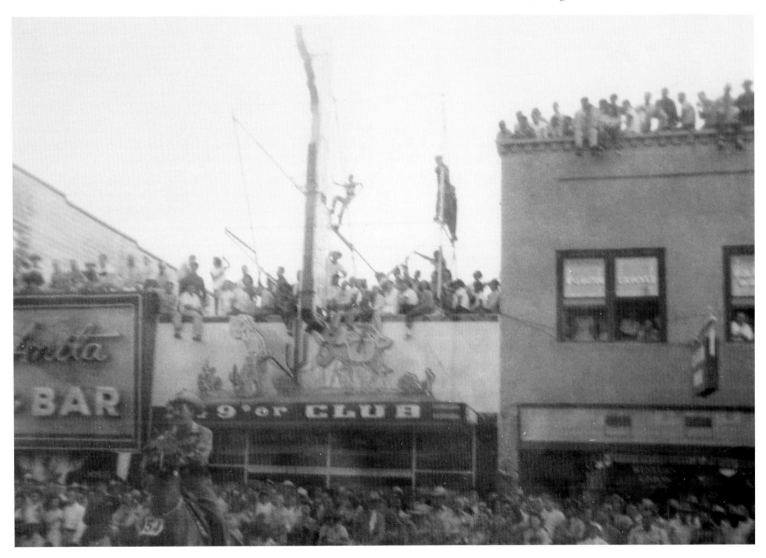

An aerial view of the Flamingo Hotel in November 1952 reveals the remoteness of the largely undeveloped Strip at the time. Infamous mobster Ben "Bugsy" Siegel, using funds provided by himself and his mob colleagues, opened the Flamingo, the third resort hotel on the Strip, in December 1946. He overspent his budget by millions to install fancy touches never before seen in Las Vegas: a large, center swimming pool; a health club; spaces for squash, handball, badminton, and trap shooting; a forty-stable horse corral; nine-hole golf course; and 105 rooms with wall-to-wall carpeting and individual sewers for each bathroom. Cost overruns contributed to Siegel's mob-sanctioned murder in Beverly Hills, California, in 1947.

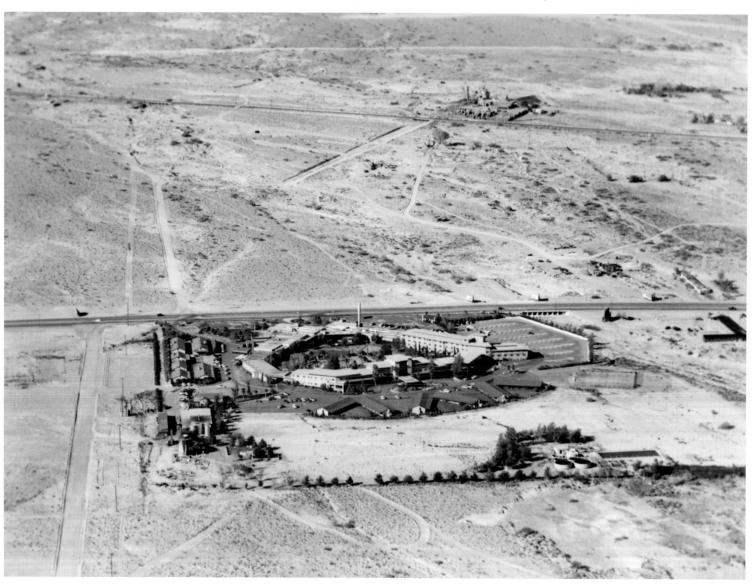

The Flamingo in 1953 added this ten-story cylindrical neon sign, with flashing lights shaped like champagne bubbles, to go with its marquee, this one promoting comedian Joe E. Lewis and singers Della Reese and Sarah Vaughan.

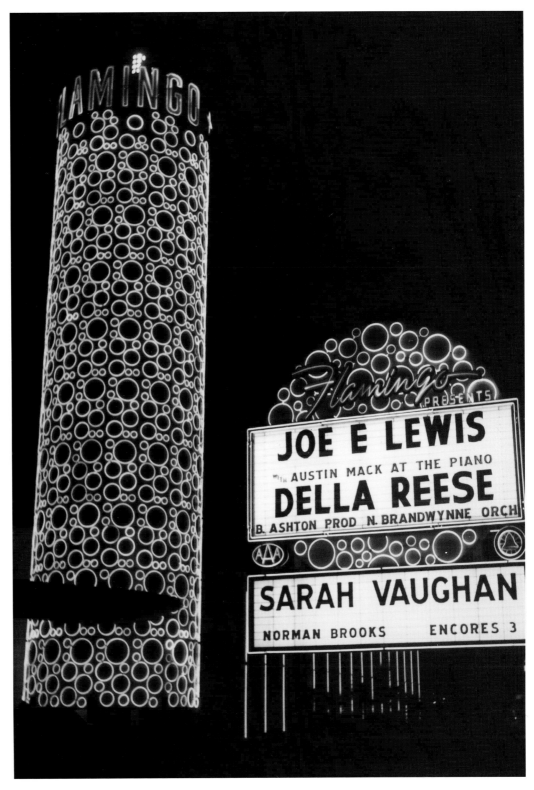

The El Cortez on Fremont and Sixth streets, as it looked about 1950. The cement-block hotel was opened in 1941 by owners John Grayson, Las Vegas Club owner J. Kell Houssels, and its builder, Marion Hicks. They would sell the hotel-casino to a group headed by organized crime figure Ben "Bugsy" Siegel in 1945. William J. Moore, owner of the Last Frontier hotel, later acquired it.

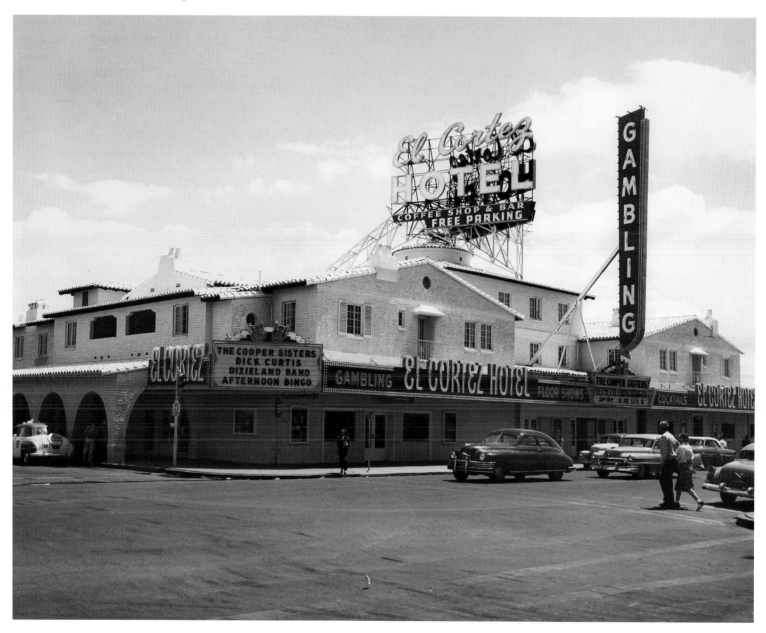

Children line the streets as this Helldorado parade winds down, with a man driving the "Desert Love Buggy" at night on Fremont Street, about 1950.

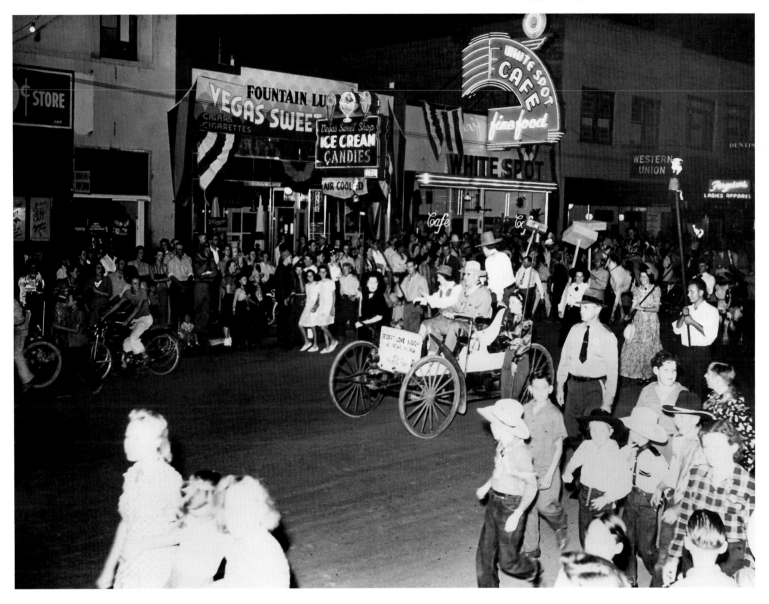

In 1951, the University of Nevada began offering extension college courses in a classroom at Las Vegas High School (previously Las Vegas Academy). By 1957, the Southern Division of the University of Nevada was officially established by the Nevada Assembly. Its first building, Maude Frazier Hall (lower right), was named in honor of the assembly representative and former LVHS principal who led the fight in the legislature to bring higher education to Vegas. Two more buildings had been constructed when this photo was taken around 1959. The school's name was changed to Nevada Southern University in 1965, before becoming the University of Nevada, Las Vegas in 1969.

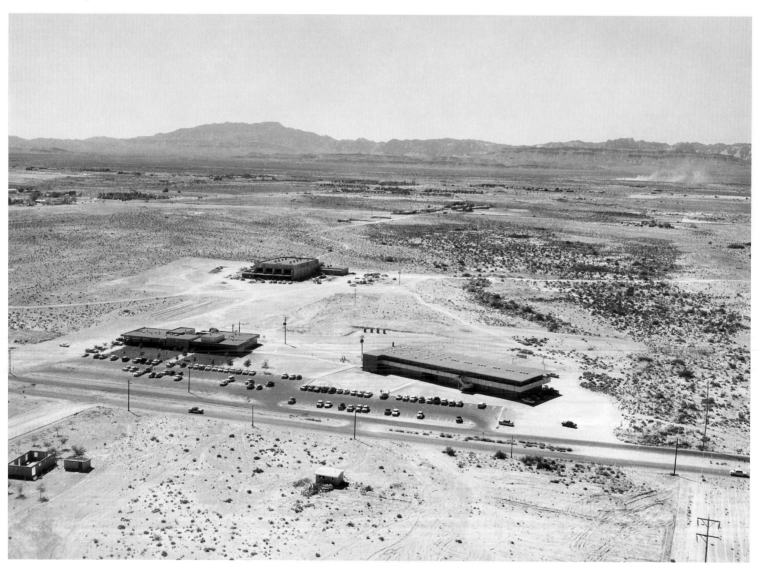

Post–World War II atomic testing during the Cold War took place throughout the 1950s at the Nevada Test Site, 65 miles north of Las Vegas. The mushroom cloud of this test, on April 18, 1953, could be seen between downtown casino signs. Hotel promoters used the scheduled tests as a visitor attraction in the early 1950s. Tourists stayed up until nearly dawn to watch the tests' clouds from hotel rooftops.

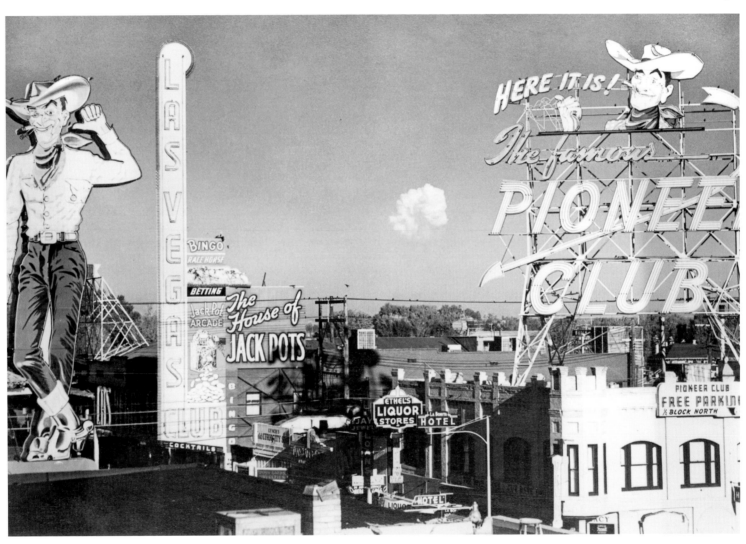

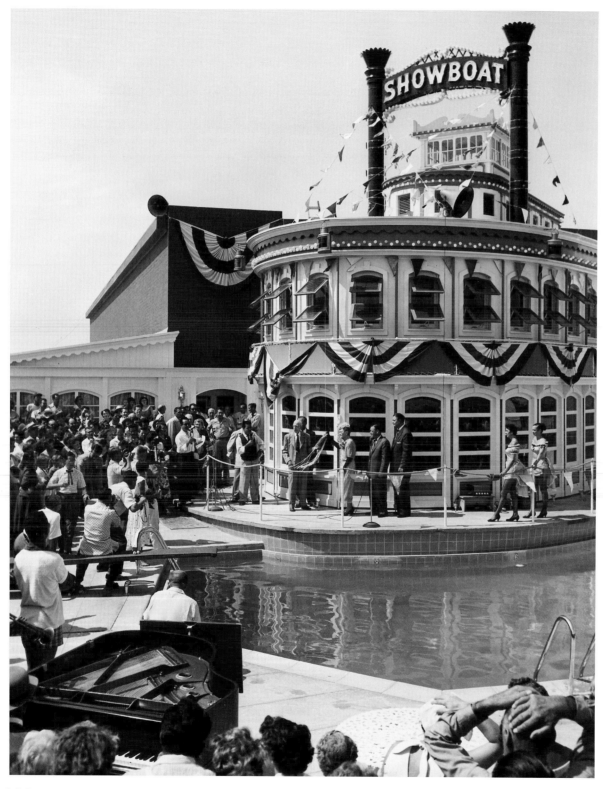

One of the first off-Strip casinos was the Showboat, with a one-hundred-room hotel sporting a facade fashioned after a Mississippi riverboat. Former *Las Vegas Age* publisher Charles "Pop" Squires is seen here cutting the opening ribbon in 1954. The Showboat, on Boulder Highway near Fremont Street, eventually would prove popular with local gamblers. Its partners included Las Vegas Club owner J. Kell Houssels and Desert Inn hotel executive Moe Dalitz.

A member of the Sands Hotel's chorus line, the Copa Girls, practices her dance moves in front of the hotel on the Strip around 1955. The Sands debuted in 1952, and its popularity defined Las Vegas for many people, especially during its golden years as a top entertainment spot and hub for singers Frank Sinatra, Dean Martin, and Sammy Davis, Jr., throughout the 1950s and 1960s. But as was true for many Las Vegas casinos, organized crime figures held concealed interests in the Sands into the 1960s.

Following Spread: Singer Dean Martin, on stage during his opening night at the Sands' Copa Room, March 6, 1957. Martin seems to be reacting to the celebrities sitting at a front table, including Jack Benny, Desi Arnaz, and Lucille Ball. Martin and his "Rat Pack" friends Sinatra and Davis, would make the Sands internationally famous and become major draws for other Las Vegas casinos into the 1980s.

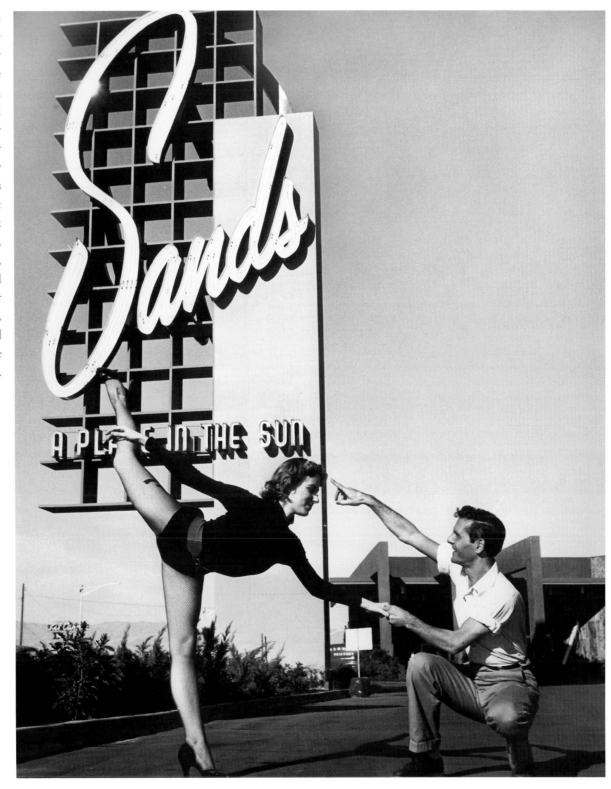

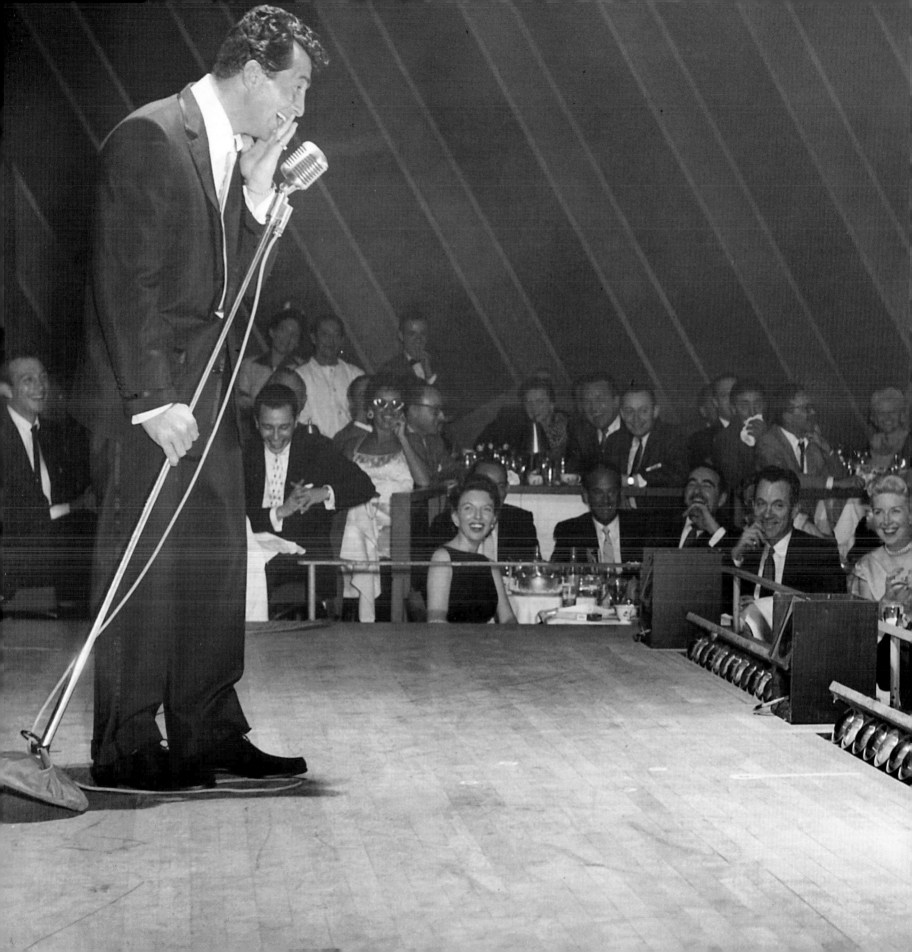

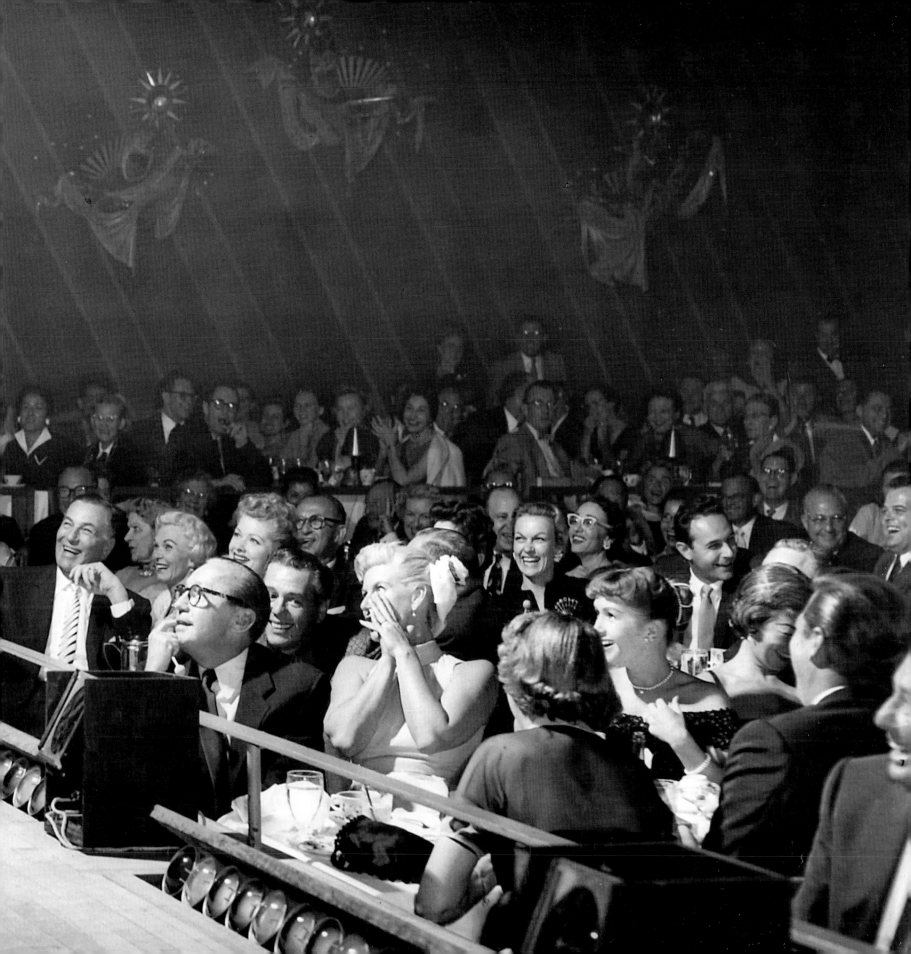

Demand for fancy entertainment venues grew in the 1950s, as represented by the
lavish staging of showgirls and male dancers shown here at the first "Lido de Paris"
stage show at the new Stardust hotel on the Strip in 1958.

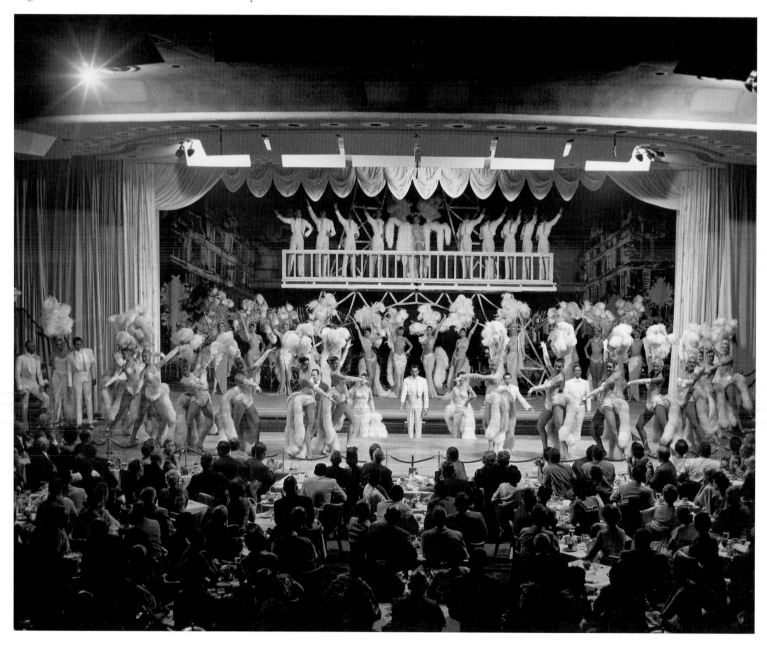

In 1959, designer Betty Willis fashioned this famous piece of Las Vegas neon history, the welcome sign that still greets motorists at the Strip's south end.

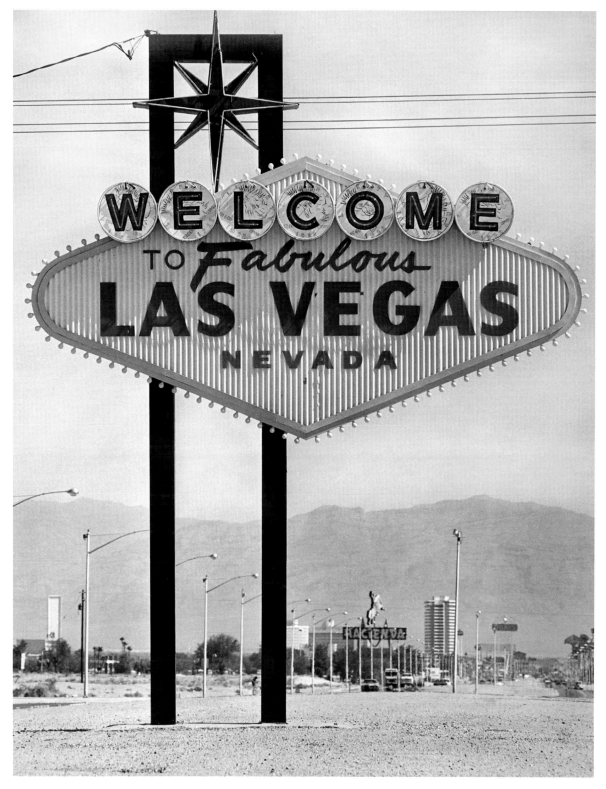

Notes on the Photographs

These notes, listed by page number, attempt to include all aspects known of the photographs. Each of the photographs is identified by the page number, photograph's title or description, photographer and collection, archive, and call or box number when applicable. Although every attempt was made to collect all available data, in some cases complete data was unavailable due to the age and condition of some of the photographs and records.

II **RUGGED LANDSCAPE**
University of Nevada Las Vegas
Libraries, Special Collections
0003_0113

VI **ROULETTE**
University of Nevada Las Vegas
Libraries, Special Collections
0006_0013_OS

X **SURVEY PARTY**
University of Nevada Las Vegas
Libraries, Special Collections
0214_0161_OS

3 **TOWNSITE**
University of Nevada Las Vegas
Libraries, Special Collections
0014_0744_OS

4 **CANVAS BUILDINGS**
University of Nevada Las Vegas
Libraries, Special Collections
0002_0046_OS

5 **BIG SPRING**
University of Nevada Las Vegas
Libraries, Special Collections
0014_0011_OS

6 **FIRST SETTLEMENT**
University of Nevada Las Vegas
Libraries, Special Collections
0104_0086_OS

7 **CLOTHING BUSINESS**
University of Nevada Las Vegas
Libraries, Special Collections
0062_0003_OS

8 **FIRST STATE BANK**
University of Nevada Las Vegas
Libraries, Special Collections
0001_3_2_4_OS

9 **CROWD IN TOWN**
University of Nevada Las Vegas
Libraries, Special Collections
0214_0166_OS

10 **RAILROAD EMPLOYEES**
University of Nevada Las Vegas
Libraries, Special Collections
0197_0001_OS

11 **PASSENGERS ARRIVE**
University of Nevada Las Vegas
Libraries, Special Collections
0204_0024_OS

12 **RAIL DEPOT**
University of Nevada Las Vegas
Libraries, Special Collections
0001_0005_OS

13 **DEPOT GROWTH**
University of Nevada Las Vegas
Libraries, Special Collections
0008_0004_OS

14 **FIRST HOSPITAL**
University of Nevada Las Vegas
Libraries, Special Collections
0003_0003_OS

15 **CLAYSON & GRIFFITH**
University of Nevada Las Vegas
Libraries, Special Collections
0003_0004_OS

16 **McWILLIAMS TOWNSITE**
University of Nevada Las Vegas
Libraries, Special Collections
0204_0011_OS

17 **FIRST STATE BANK**
University of Nevada Las Vegas
Libraries, Special Collections
0097_0032_OS

18 **ARIZONA CLUB**
University of Nevada Las Vegas
Libraries, Special Collections
0104_0087_OS

19 **LAS VEGAS TRADING CO.**
University of Nevada Las Vegas
Libraries, Special Collections
0002_2_9_4_OS

20 **VEGAS HOME BAKERY**
University of Nevada Las Vegas
Libraries, Special Collections
0002_0014_OS

21 **BATH HOUSE**
University of Nevada Las Vegas
Libraries, Special Collections
0104_0051_OS

22 **SCOTTISH KILT BAND**
University of Nevada Las Vegas
Libraries, Special Collections
0002_0021_OS

23 **DRUG STORE**
University of Nevada Las Vegas
Libraries, Special Collections
0104_0084_OS

24 **HOTEL LAS VEGAS**
University of Nevada Las Vegas
Libraries, Special Collections
0097_0035_OS

25 **BLOCK 16**
University of Nevada Las Vegas
Libraries, Special Collections
0003_0006_OS

26 **SUPPLY YARD**
University of Nevada Las Vegas
Libraries, Special Collections
0204_0016_OS

27 **MAIN STREET**
University of Nevada Las Vegas
Libraries, Special Collections
0014_0040_OS

113 Fremont Street
University of Nevada Las Vegas
Libraries, Special Collections
0002_0214_OS

114 Repair Shop
University of Nevada Las Vegas
Libraries, Special Collections
0015_0002_OS

115 Hotel Nevada
University of Nevada Las Vegas
Libraries, Special Collections
0204_0048_OS

116 Union Pacific Depot
University of Nevada Las Vegas
Libraries, Special Collections
0204_0049_OS

117 Army Air Corps Planes
University of Nevada Las Vegas
Libraries, Special Collections
0014_0703_OS

118 Female Pilot
University of Nevada Las Vegas
Libraries, Special Collections
0014_0089_OS

121 Laying Cornerstone
University of Nevada Las Vegas
Libraries, Special Collections
0265_0226_OS

122 Labor Day Parade
University of Nevada Las Vegas
Libraries, Special Collections
0020_0020_OS

123 Fire Department
University of Nevada Las Vegas
Libraries, Special Collections
0015_0006_OS

124 Track to Hoover Dam
University of Nevada Las Vegas
Libraries, Special Collections
0010_0068_OS

126 Railroad Station
University of Nevada Las Vegas
Libraries, Special Collections
0010_0068_OS

127 Berkley's Mens Store
University of Nevada Las Vegas
Libraries, Special Collections
0148_0010_OS

128 Fremont Street
University of Nevada Las Vegas
Libraries, Special Collections
0265_0365_OS

129 Bare-Bones Automobile
University of Nevada Las Vegas
Libraries, Special Collections
0214_0173_OS

130 Floats
University of Nevada Las Vegas
Libraries, Special Collections
0008_0067_OS

131 Frank Waite
University of Nevada Las Vegas
Libraries, Special Collections
0002_0128_OS

132 Snow-Covered Street
University of Nevada Las Vegas
Libraries, Special Collections
0006_0007_OS

133 Gambling Houses
University of Nevada Las Vegas
Libraries, Special Collections
0204_0053_OS

134 Passenger Aircraft
University of Nevada Las Vegas
Libraries, Special Collections
0232_0041_OS

135 Boulder Club
University of Nevada Las Vegas
Libraries, Special Collections
0253_0002_OS

136 The Northern
University of Nevada Las Vegas
Libraries, Special Collections
0265_0213_OS

137 Archway Celebration
University of Nevada Las Vegas
Libraries, Special Collections
0265_0330_OS

138 Labor Day Parade
University of Nevada Las Vegas
Libraries, Special Collections
0265_0327_OS

139 Labor Day Float
University of Nevada Las Vegas
Libraries, Special Collections
0265_0336_OS

140 Burro-Drawn Wagon
University of Nevada Las Vegas
Libraries, Special Collections
0232_0040_OS

141 Gilmore Lion
University of Nevada Las Vegas
Libraries, Special Collections
0013_0012_OS

142 Courthouse
University of Nevada Las Vegas
Libraries, Special Collections
0062_0015_OS

143 Post Office
University of Nevada Las Vegas
Libraries, Special Collections
0020_0004_OS

144 El Portal
University of Nevada Las Vegas
Libraries, Special Collections
0017_0025_OS

145 Johnny the Bellboy
University of Nevada Las Vegas
Libraries, Special Collections
0019_0077_OS

146 Chamber of Commerce
University of Nevada Las Vegas
Libraries, Special Collections
0014_0104_OS

147 Horse Track
University of Nevada Las Vegas
Libraries, Special Collections
0014_0377_OS

148 Hoover Dam
University of Nevada Las Vegas
Libraries, Special Collections
0014_0238_OS

150 Fremont Street
University of Nevada Las Vegas
Libraries, Special Collections
0047_0005_OS

151 Las Vegas Club
University of Nevada Las Vegas
Libraries, Special Collections
0100_0015_OS

152 1930s Street Scene
University of Nevada Las Vegas
Libraries, Special Collections
0001_0022_OS

153 Rockwell Electric
University of Nevada Las Vegas
Libraries, Special Collections
0008_0005_OS

154 Helldorado Parade
University of Nevada Las Vegas
Libraries, Special Collections
0204_0055_OS

155 Isolationists
University of Nevada Las Vegas
Libraries, Special Collections
0108_0009_OS

156 Union Pacific Movie
University of Nevada Las Vegas
Libraries, Special Collections
0020_0003_OS

Just twenty-nine students received degrees during the first commencement at University of Nevada, Las Vegas in 1964, about two years after this picture was taken. Today, the school occupies a 337-acre campus 1.5 miles east of the Strip, offers over 190 degree programs, and has purchased 640 acres in North Las Vegas for expansion.

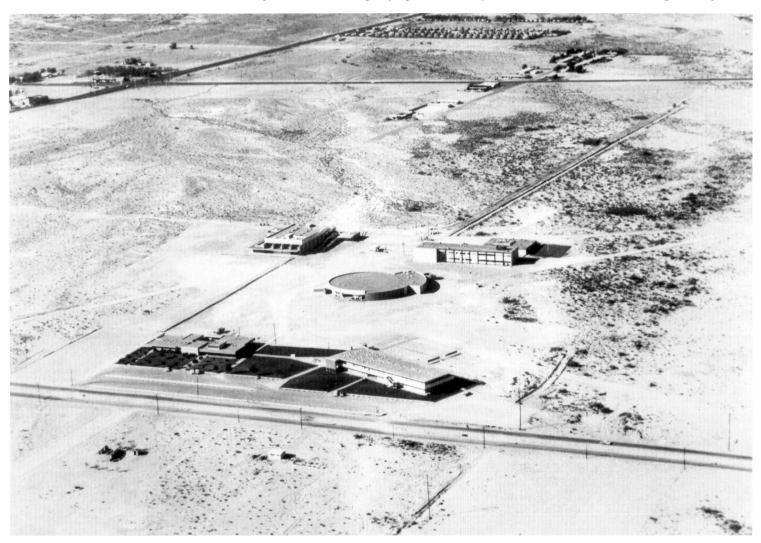